104245

POP ART
AND
DESIGN

WITHDRAWN FROM STOCK

D1610326

Bloomsbury Academic
An imprint of Bloomsbury Publishing Plc

50 Bedford Square 1385 Broadway
London New York
WC1B 3DP NY 10018
UK USA

www.bloomsbury.com

**BLOOMSBURY and the Diana logo are
trademarks of Bloomsbury Publishing Plc**

First published 2018

© Introductions and editorial material,
Anne Massey and Alex Seago
© Individual chapters, their authors

Anne Massey and Alex Seago have asserted their
right under the Copyright, Designs and Patents Act,
1988, to be identified as Authors of this work.

All rights reserved. No part of this publication
may be reproduced or transmitted in any form or
by any means, electronic or mechanical, including
photocopying, recording, or any information storage or
retrieval system, without prior permission in writing
from the publishers.

No responsibility for loss caused to any individual
or organization acting on or refraining from action
as a result of the material in this publication can be
accepted by Bloomsbury or the author.

709.
040
71
POP

British Library Cataloguing-in-Publication Data
A catalogue record for this book is available from
the British Library.

ISBN:
HB: 978-1-4742-2619-6
PB: 978-1-4742-2618-9
ePDF: 978-1-4742-2620-2
ePub: 978-1-4742-2621-9

**Library of Congress Cataloging-in-Publication
Data**
A catalog record for this book is available from the
Library of Congress.

Cover design Louise Dugdale
Cover image © Brian Haynes/Royal College

Typeset by Struktur Design
Printed and bound in China

POP ART
AND
DESIGN

**Edited by Anne Massey
and Alex Seago**

Bloomsbury Academic
An imprint of Bloomsbury Publishing Plc

B L O O M S B U R Y
LONDON · OXFORD · NEW YORK · NEW DELHI · SYDNEY

Table of Contents

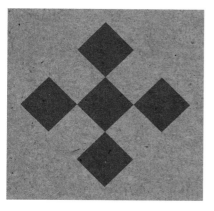

Acknowledgements

The editors and publisher gratefully acknowledge the permission granted to reproduce the copyright material in this book.

The editors would like to express their gratitude to the following people, without whom this book would not have been possible. We would firstly like to thank the contributing authors and thank them for supporting the project from initial proposal to final publication. Their positivity and professionalism has been greatly appreciated. Thanks also to our interviewees, Althea McNish and Rick Poynor. We would like to extend our gratitude to the original contributors to the *Who Was This Pop?* conference at Richmond, The American International University in London in 2013, and those who attended, and made such a welcome contribution to the beginnings of this edited volume. We would like to acknowledge the support of the Art and Design Research Institute (ADRI) at Middlesex University and the London College of Communication (LCC), University of the Arts London for funding illustration and design costs. Special thanks to the Design History Society for generous support from their Research Publication Grant. We are grateful to Valeria Graziano for editorial support during the early stages of the book, and to Clare Barry for editorial support during the later stages. We would also like to extend our thanks to all those we have worked with at Bloomsbury Academic, including Rebecca Barden, Abbie Sharman, Claire Constable and our anonymous reviewers. Thanks to the *Journal of British Visual Culture* for allowing us to reprint Dominic Janes' article: 'Cecil Beaton, Richard Hamilton and the Queer, Transatlantic Origins of Pop Art'.

Every effort has been made to trace copyright holders and to obtain their permission for the use of copyright material. The publisher apologizes for any errors and omissions and would be grateful to be notified of any corrections that should be incorporated in future reprints or editions of this book.

List of Illustrations

Notes on Contributors

Christine Checinska

Christine studied Fashion/Textile Design at the University of the West of England and Fashion at the University for the Creative Arts, earning an MA in 2002. Her PhD, *Colonizin' in Reverse: the Creolised Aesthetic of the Windrush Generation*, was awarded by Goldsmiths, London, in 2009. Between 2013 and 2015 she was a Post-Doctoral Research Fellow at the University of East London. In 2014–15 she was the Stuart Hall Library Animateur at Iniva, London. She is currently an Associate Researcher at VIAD, University of Johannesburg and an Associate Lecturer in Fashion at Goldsmiths, London. Her recent publications include 'Social Fabric' in *The Handbook of Textile Culture*, Janis Jefferies, Hazel Clark and Diana Wood Conroy (eds) Bloomsbury, 2015; 'Crafting Difference: Art, Cloth and the African Diasporas' in *Cultural Threads: Transnational Textiles Today* Jessica Hemmings, (ed.) Bloomsbury, 2015 and 'Second Skins: Cloth, Difference and the Art of Transformation' in *Image and Text*, Leora Farber and Anne-Marie Tully (eds) 2014.

Dominic Janes

Dominic is Professor of Modern History in the School of Humanities at Keele University. He is a cultural historian who studies texts and visual images relating to Britain in its local and international contexts since the eighteenth century. Within this sphere he focuses on the histories of gender, sexuality and religion. His most recent books are *Picturing the Closet: Male Secrecy and Homosexual Visibility in Britain* (2015) and *Visions of Queer Martyrdom from John Henry Newman to Derek Jarman* (2015).

Anne Massey

Anne is Professor of Design and Culture, Associate Dean of Research and Head of the Graduate School at LCC. Her research interests focus on the interdisciplinary history and contemporary significance of the Independent Group and her PhD was awarded by Newcastle Polytechnic on this subject. She has also written two books on the topic, *The Independent Group: Modernism and Mass Culture in Britain, 1945–59* (1996) and *Out of the Ivory Tower: The Independent Group and Popular Culture* (2013) as well as contributing to edited collections, museum catalogues and academic journals. Anne has worked extensively with archives, particularly those of the ICA where she is Research Associate, and published *ICA 1946–68* (2014) charting the first twenty years of the organization's history. She is currently editing *The Blackwell Companion to Contemporary Design*, to be published in 2018.

Catherine Moriarty

Catherine is Curatorial Director of the University of Brighton Design Archives. She has written on the history of British design, on commemoration, and on the relationship between sculpture and design. Professor Moriarty has curated numerous exhibitions and was co-curator of the 2013 Whitechapel Gallery exhibition *Black Eyes and Lemonade: Curating Popular Art*. Her latest book, *Making Melbourne's Monuments: The Sculpture of Paul Montford* (2013) is based on a long-term study of the sculptor's private correspondence and photographic archive. She has recently been appointed co-editor of *Sculpture Journal*.

Alistair O'Neill

Alistair is a Reader in Fashion / Fashion History and Theory Pathway Leader for the Fashion Programme at Central St Martins. His research as a writer and curator deals with the representation of metropolitan fashion cultures, the role of surviving material culture and the medium of photography. *London: After a Fashion* (2007) was his first publication, which considers the relationship between fashion and modernity in twentieth-century London. Alistair has worked as a curatorial consultant for Somerset House Trust since the implementation of its contemporary exhibitions programme in 2008. This has centred on fashion exhibitions including the co-curation of SHOWstudio: Fashion Revolution (2009), Valentino: Master of Couture (2012) and Isabella Blow: Fashion Galore! (2013). More recently Alistair has written on bodies of photographic work that challenge the parameters of fashion photography, and explored the critical reception of the genre as it developed beyond its commercial function. This includes the forthcoming publication, *Photography and Fashion*.

Ann Pillar

Ann is an independent scholar. She read Fine Art at the University of Newcastle-upon-Tyne, in the long shadows of Victor Pasmore and Richard Hamilton. She found employment in the graphic arts where she discovered typography and how to survive as a freelance designer. Tired of working at a drawing board her abiding interests in typography led to The Monotype Corporation where she was appointed Publicity Manager of the Typography Division, charged with setting up and managing a new department at the onset of dramatic advances in digital font manufacturing and output technologies. On Monotype's demise Ann was offered a two-week teaching trial on the HND Typographic Design course at Stafford College. Two weeks extended to ten years, teaching the history, theory and practice of typography.

She subsequently taught the same at the University of Reading, and received funding for an MA on Alfred Tolmer's pioneering book on design, *Mise en Page* (1931). In 2008 Ann was awarded AHRC funding for doctoral research on Edward Wright, whose teaching helped establish graphic design as a profession in the post-war period in Britain. Ann's PhD, entitled 'Edward Wright (1912–1988) artist, designer, teacher' was completed in 1912, on the centenary of Wright's birth. Ann is currently authoring a book on Edward Wright and has spoken about and published articles on his public lettering commissions for important modern buildings, with particular focus on the 1960s.

Rick Poynor

Rick is a writer, lecturer and curator, and Professor of Design and Visual Culture at the University of Reading. He has written extensively on the history of British visual communication and, in 2004, he curated *Communicate: Independent British Graphic Design since the Sixties* for the Barbican Art Gallery, London, the first major survey about this subject. The exhibition travelled to China and Switzerland. He was the founding editor of *Eye* magazine, which he edited from 1990 to 1997, and his articles, essays and reviews have appeared in *Blueprint, Frieze, Creative Review, Metropolis, Harvard Design Magazine, Adbusters, Domus*, and many other publications. In 2003, he was a co-founder of the Design Observer website. His books about design and the visual arts include *Typographica* (2001), *No More Rules: Graphic Design and Postmodernism* (2003), *Jan van Toorn: Critical Practice* (2008), and the essay collections *Design Without Boundaries* (1998), *Obey the Giant: Life in the Image World* (2001), and *Designing Pornotopia* (2006).

Alex Seago

Alex is Dean of the School of Communications, Arts and Social Sciences at Richmond, The American International University in London and former Lecturer in Cultural History at the Royal College of Art. He is a member of the advisory board and is the UK representative of the Salzburg Seminar American Studies Association. His research focuses upon cultural globalization – with particular reference to visual culture and popular music. His *Burning the Box of Beautiful Things: The Development of a Postmodern Sensibility* (1995) focuses on the changing visual culture of the 1950–65 period and has been widely acknowledged as a key cultural historical text.

Sue Tate

Dr Sue Tate is a freelance art historian and Research Fellow at the University of the West of England where until recently she was also a Senior Lecturer in Visual Culture. Her research has centred on women artists with a particular focus on women Pop artists and she is the leading art historical expert on Pauline Boty. Supported by an Arts Council grant she discovered lost work by Boty and had the whole oeuvre professionally photographed for an archive held by the Women's Art Library and a listing at the Arts Council Library. She has brought wider attention to women in Pop and to Pauline Boty through papers, public lectures, publications, and an exhibition curated in 1998. In 2010, she collaborated on Seductive Subversions, the groundbreaking exhibition on women Pop artists that toured the USA, contributing an exploration of women and the British Pop scene (*A Transgression Too Far*) to the accompanying book. In 2013, she co-curated Pauline Boty: Pop Artist and Woman, the first full retrospective in a public gallery of Boty's work; originating at the Wolverhampton Art Gallery the show toured to Pallant House Chichester and to Lodz in Poland. Supported by the Paul Mellon Foundation, she authored a book of the same title, published by Wolverhampton Art Gallery.

Editors' Foreword

Public interest in Pop has never been greater, but the roots of the movement, which evolved in the spaces between art and design, remain comparatively underexplored. This edited collection of eight essays, two interviews and one reprint of a key Edward Wright article, brings together research on the interaction between early British Pop Art and Design for the first time. The book foregrounds the vital role played by architectural, fashion, graphic, interior and product design during the 1950s and 60s in the creation of Pop. It brings together a rich mix of new research by curators and designers, historians and theorists. It offers a design historical approach to a broad range of visual culture and offers a different perspective on Pop, beyond the standard art historical discourse.

Inspired by this new energy of the exhibited object, a conference was held in November 2013 at Richmond, The American International University in London which brought together curators, historians and designers to look again at: *Who Was This Pop?*. This edited collection is the result of this activity.

Introduction

This book offers the first in-depth analysis of the unique relationship between art and design, which led to the creation of British Pop. It contains a detailed, scholarly account of the origins and development of Pop across disciplinary margins. Blurring the boundaries between art and design and their histories, it looks across these two distinct areas and seeks out commonalities and points of connection. Challenging the all-pervasive 'high art', 'low culture' divide, exacerbated by the continued silo mentality of art history and design history, it brings a fresh and holistic understanding of Pop Art and Design during the vibrant era of the 1950s and 1960s. This was an era when commercial art became graphic design, illustration was superseded by photography and high fashion became street fashion. The central argument of this book is that Pop Art relied on and drew inspiration from Pop Design, and vice versa. This close relationship was articulated through the artwork, design work, publications and exhibitions of an interlinked network of practitioners. This book provides a case study in the broader interrelationship between art and design, and presents the first collection of essays to examine this British phenomenon in depth.

As this edited volume demonstrates, Pop in the UK had its roots in interdisciplinary discourse. Exhibitions at the Whitechapel Gallery, events at the Institute of Contemporary Arts (ICA) and the RCA student publication, *ARK*, all featured an open attitude to all aspects of visual culture, be it fine art, advertising, poster art, architecture, fashion, Pop music or industrial design. The writing of the time expressed a novel, all-embracing analysis of a newly emerging visual landscape with a new kind of soundtrack. Writing by key figures such as Lawrence Alloway, Reyner Banham, Barbara Jones, John McHale and Edward Wright reflected a new interest in the professionalization of art and design, beyond the Neo-romanticism of pervading British notions of good taste, or the reforming hegemony of Modernism. What these Pop purveyors sought was a smart, professional approach, which drew on sociology, anthropology and iconology as well as an appreciation of the revolution in science and technology taking place at that time. There was a social class aspect associated with these endeavours which gave them a distinctly British flavour. Most of the guardians of good taste were middle or upper class, as were the guardians of taste at the Council of Industrial Design and the Arts Council. The Whitechapel, ICA and RCA were comparatively less pedantic organizations, and accommodated the views of this loose collection of part émigré, lower middle class and working class Pop protagonists. Operating almost like a subculture, the men and women of early Pop Art and Design in the UK challenged hegemonic norms by introducing a professional attitude to the analysis and creation of art and design, which had been lacking in the predominately amateur dilettante world of art and design before the war (Hebdige, 1983).

But why has it taken so long for this particular history to be researched and published? The answer lies initially with the original participants themselves and the particular disciplinary and epistemological

context in which they were located. Unusually perhaps for a group of creative practitioners, there were theorists and historians closely associated with British Pop Art and Design from the earliest stages. For example, members of the Independent Group were directly involved as practitioners of art history, architectural history and design history as well as art and design criticism with figures such as Lawrence Alloway, Reyner Banham and Toni del Renzio. The creative practitioners themselves were also often erudite communicators in written form themselves – notably Frank Cordell, Magda Cordell, Richard Hamilton, John McHale, Alison and Peter Smithson, Colin St John Wilson and Edward Wright. At first, the account which this group gave of itself was pancultural, crossing all aspects of architecture, art, craft, design and music. As Ben Highmore has argued: 'To treat the IG as a contextual studies programme-in-waiting gets something of the ethos of their concerns and interests.' (Highmore, 2013: 208). Early articles in *ARK*, *Uppercase* and *Architectural Design* were written from the perspective of contemporary, critical practice, whether by the historians, practitioners or theorists. The published discourses fell within the category of contemporary, cultural criticism. Reyner Banham could discuss the design of British and Italian motorbikes, John McHale American kitchen design and Frank Cordell the current popular music scene without any sense of needing to justify their disciplinary position. Indeed, Reyner Banham continued to write perceptive reviews of contemporary culture and design for *New Statesman* and then *New Society* throughout the 1950s, 1960s and into the 1970s without a problem (Banham and Sparke 1981: 143–7). The first mention in print of the Independent Group, beyond the footnote in Banham's article for the Italian design publication, *Civiltà delle macchine*, in November 1955 (Banham 1955: 15), was in *ARK* magazine in Spring 1956. The brief biography of Reyner Banham mentions the Independent Group but within the critical discourse of design:

> Reyner Banham, aero-engine mechanic turned art historian, is currently Assistant Editor (Literary) to *The Architectural Review*, and lecturer in Art History at Central School of Arts and Crafts. He is a sporadic contributor to *Art*, *Art News*, *Design* and author of the catalogue notes for the ICA's exhibition *Man, Machine and Motion*, also former convenor of the ICA 'Independent Group' whose radical aesthetic researches he claims to underlie his irregular attitude to Industrial Design (Banham 1956: 6).

The historiography of British Pop Art and Design took a different turn when the contemporary activities became history – when the meetings of the Independent Group had ceased and the early Pop generation of artists and designers at the RCA were no longer students editing, art editing or featuring in that key publication, *ARK*. When those involved looked back on the Independent Group from the viewpoint of the 1960s, it was

the burgeoning phenomenon of international Pop Art that provided the most compelling framework for interpretation. Emerging from American art criticism, this way of interpreting culture of the recent past allowed writers, particularly Lawrence Alloway and Reyner Banham, to locate the achievements of British Pop Art and Design within the broader category of American dominated Pop Art. Reyner Banham contributed the lead article to the high quality, small circulation graphic magazine *Motif* late in 1962. Entitled 'Who is this "Pop"?' Banham explored the ideas of the Independent Group alongside reprints of American advertising and packaging. In the final section Banham summarizes the Independent Group and its achievements, as he saw them in 1962:

> I.G.: the boys in question were the Independent Group at the ICA, whose activities around 1953–55 are at the bottom of all conscious Pop-art activities in Fine-Art circles. The basic vocabulary, including the words *Pop-Art* themselves (analogy with Pop music), came into circulation *via* the IG, even if they weren't invented by them; so did the systematic study of the iconography of car-styling, science fiction, Westerns, the rock 'n' roll industry, advertising. (Banham 1962: 13)

But it was Lawrence Alloway's contribution, 'The Development of British Pop' which laid the foundations for the dominant reading of the Independent Group as the first chapter in the linear narrative of Pop Art (Alloway 1970). Written in the first person, Alloway wrote the chapter as personal memoir, therefore fine art and links through to media and Hollywood film, science fiction and advertising were included, as understandably this reflected his own interests. By this time he had emigrated to New York, and was genuinely enthused by the vigour of American Pop Art. Also, the disciplinary apparatus of design history had not been developed by this stage, so there wasn't the necessary lens through which to view the contribution of design to the development of Pop (Woodham 2016).

Alloway's account provided the foundation for an authoritative art historical understanding of early British Pop Art in which the vital role originally played by design, and particularly graphic design, in the formation of British pop became sidelined. This meant that all subsequent accounts of the early years of Pop Art and Design are overlaid with and overshadowed by an understanding of Pop, based on the international commercial and institutional success of American Pop Art. This reinterpretation of Pop in which Pop Design was overlooked in favour of Pop Art left out the initial energy of this quirky, distinctly British visual and intellectual subculture, and arguably led to a subsequent veneer of bourgeois respectability.

One result of this emphasis on art instead of design is that accepted histories of Pop Art and Design tend to be a product of an established approach to the history of modern art, initiated by Alfred Barr Jr in which

one avant-garde supersedes the next in a baton passing model of the history of art (Massey and Sparke 1985; Massey 2013; Pollock 1988). Pop Art is the last in a series of art movements, one following on from the next, an approach that also links back to interpretations of earlier periods of fine art. Oddly, this model has also permeated accounts of Pop Design, treated as a separate entity, but still using the art history models with early, mid and late emulating approaches taken from analyses of the Renaissance and the Baroque (Whiteley 1987). Subsequent accounts of Pop Art and Design in Britain have tended to rely on these secondary sources, which have reproduced the binary divide between art and design and as well as placing Pop within a particular trajectory. The history of art and the history of design have been constructed as 'twin spheres' with little interaction. The aim of this edited collection is to return to the original primary sources for both Pop Art and Design and consider their interrelationship from the perspective of the twenty-first century within a variety of unexpected contemporary 'little narratives'. One of the main purposes of this book is to explore and reconsider what might be described as the previously overlooked 'nooks and crannies' of British pop, to make the invisible visible.

The two editors, Anne Massey and Alex Seago, laid the foundations for the study of British Pop Art and Design over twenty years ago with two books, published simultaneously. Massey's *The Independent Group: Modernism and Mass Culture in Britain, 1945–59* (1995) and Seago's *Burning the Box of Beautiful Things: The Development of a Postmodern Sensibility* (1995) chronicled a particular moment in the history of British art and design, Massey through looking at the Independent Group and Seago the RCA student magazine, *ARK*. Previous publications had either considered Pop Art (Lippard 1966) or Pop Design (Whiteley 1987) rather than the mutual interrelationship between the art and design aspects of the Pop movement. Massey and Seago's books are both based on PhD research, building on extensive interviews with the key participants, incorporating the first assessment of primary sources including the ICA archives and *ARK* magazine, and were both published by university presses. The books are now the key sources, the 'go to' publications, for anyone studying the origins of British Pop (Crow 2014: 390 fns 7 and 34; Buchloh 2014: 93).

Whilst presenting overarching narratives, based on extensive primary research, the books are also a product of their times. In terms of production, they were both written using early word processors with a floppy disc for each chapter and dot matrix printouts for delivery to the publishers by mail. This was before the era of digital images, so both authors sourced and posted off huge packages of photographs which constituted the 50 images in Massey's book and 140 in the case of Seago's monograph. In terms of intellectual context, both conclude with a consideration of postmodernism, which reveals much of the climate in which they were produced. Postmodernism promised a new era, when art, design and popular culture would all be considered as visual culture, without hierarchies or

judgement. Pop seemed a perfect precursor of postmodernism, with its similar, pluralistic remit. Every publication is a product of its times, and the postmodern moment has now passed.

Since the publication of these two books, a wealth of publications have appeared which represent in-depth studies of Pop Art, or the individual artists associated with this movement. The flurry of interest about, for example, Richard Hamilton has all been based on an unquestioning acceptance of the established history of Pop Art and a reinforcement of the artists' own sense of self and of individual historical significance (Massey 2013: 10–36). What has been missing from recent exhibitions and publications is a critique of the historiography of Pop Art and Design, an analysis of the interrelationship between art and design in the formation of Pop and reluctance to look at the whole subject afresh. Existing historical constructions appear to be reinforced again and again. For example, the recent exhibition, *POP ART HEROES: Pop, Pin-Ups & Politics* at Whitford Fine Art celebrated British Pop Art in the context of the recent, blockbuster shows *The World Goes Pop* at Tate Modern and *International Pop* organized by the Walker Art Center, which both spread the net widely in terms of what constitutes Pop Art. As the Curator stated in the Whitford Fine Art catalogue: 'In the History of Art, Pop Art can be considered as the last of the real ground-breaking cultural movements....' (Ferman 2016: 2).

There are some signs, however, that this has started to change within the disciplinary boundaries of art history. There has also been a reconsideration of the history of post-war British art, published as a Special Issue of *Art History* in 2012 and the result of a conference at the Courtauld Institute of Art held in 2010 (Corbett and Tickner: 2012). Here, the political context of the history of British art was foregrounded. As Lisa Tickner and David Peters Corbett stated in the Introduction of 'Being British and Going...Somewhere':

> But the contrived hopefulness of the early 1950s could not outweigh the effects of post-war austerity, decolonization, and a loss of standing on the international stage. 'Britishness' was advanced in other terms. Britain was the 'island nation' that withstood invasion, the home of Shakespeare and tradition or – as 'the modern' was invoked in the 1960s – of Quant and the Beatles rather than heavy engineering and nuclear power. An increasingly global economy of transport, finance and culture is evident in the shuttling of Kurt Schwitters, exiled by the War, between Norway, the Lake District and London, Peter Lanyon between St Ives and the US, or Frank Bowling between London, the Caribbean and New York; and institutionally in the rise of international exhibitions, the impact of American painting in Britain from the late 1950s, and the promotion of artists from Henry Moore to the pop generation by the British Council

abroad. British art belongs in these increasingly transnational histories and geographies – before, during and after the disputed moment at which the 'modern' becomes 'late' or 'post' – and the aim of this collection is to situate it in this broader and more comprehensive narrative context. (Corbett and Tickner 2012: 207)

This valuable contribution to the understanding of post-war British art presents a new history, framed by the changing place of Britain within a global context. The focus of the special issue is not, however, the overlaps between art and design in the post-war era and it is hoped that *Pop Art and Design* will add further to this ongoing debate.

Another contribution to a new understanding of Pop Art is a refreshingly novel analysis of the terrain in the recent book by Thomas Crow, *The Long March of Pop* (2014) which succeeds in looking again at the history of Pop Art in relation to design and music. One chapter of Crow's book is devoted to 'Other Worlds in the Pop Universe' and the importance of *ARK* as a vehicle for bringing together Pop Art and Pop Design in London is well covered (Crow 2014: 93–105), but the main focus of the book is American Pop.

As with Crow's approach, this investigation of Pop, which includes design, delves into: '…the undergrowth of visual culture…' (Fallan 2010: 7) and with the very subject matter considered, constitutes a critique of the cultural status quo. Regarding art as equal to design, in the same way as the original contributors did, this collection of essays offers a fresh approach to Pop in its fine art and design manifestations, and everything in between. This book also includes new material on the radical, and overlooked, contribution of gender to Pop Art and Design and embraces the importance of social class as well as regional diversity and aspects of émigré senses of not belonging to the establishment.

What prompted the creation of this volume were not publications about Pop, but rather exhibitions about Pop. Beginning with archival shows devoted to *This is Tomorrow* in 2010 and *Black Eyes and Lemonade* in 2013 at the Whitechapel Gallery, then *Parallel of Art and Life: the Independent Group at the ICA* show at ICA in 2013, the same year as *Pauline Boty: Pop Artist and Woman* at Wolverhampton Art Gallery, *Pop Art Design* at the Barbican Art Gallery in late 2013 and into 2014, closely overlapping *Richard Hamilton* at Tate Modern in 2014, it seemed that the curators had succeeded in presenting material together which challenged the status quo of Pop through an insertion of the feminine and of Pop Design into the established narrative. These exhibitions succeeded in reconsidering the history and role of Pop Art and Design, the Whitechapel, ICA and Barbican exhibitions brought to the fore hitherto overlooked archival objects and examples of mass-produced design. This juxtapositioning of fine art and design was key in reappraising the history of Pop Art and Design. The actual objects spoke of a time when there was free-ranging and open-ended interplay between art and design, issues of *ARK* magazine were shown next to posters, paintings

and album covers. The sheer physicality of the exhibitions took debates about Pop Art and Design in a different direction and prompted the editors to ask new questions.

These questions were posed within the current disciplinary and epistemological framework within which the editors are located.. It is now no longer the moment of postmodernism, which did legitimize and open up new approaches to the history of art and design. In both art and design history there is now an impetus to explore and construct different narratives using the important elements of gender, social class, sexuality, faith, race and to challenge the dominance of Western cultural norms. This impetus that has informed this edited collection.

The Chapters

Gender and a feminist retelling of the history of Pop Art and Design informs the first chapter by Catherine Moriarty. Starting with the curatorial work of Barbara Jones, which has, until now, been marginalized within the history of Pop Art and Design, Catherine Moriarty investigates the activities of this early promoter of a Pop aesthetic in Chapter One: 'Popular Art, Pop Art, and "the Boys Who Turn Out the Fine Arts"'. The seminal exhibition at the Whitechapel Art Gallery, *Black Eyes and Lemonade* in 1951 brought together a visual landscape of everyday culture, which Jones herself referred to as Pop Art. Jones had direct contact with future members of the Independent Group, and involved some in her 'Pop Art' exhibition. The exhibition is familiar to design historians and used as an index to popular taste, however its role in the development of early British Pop has never been the subject of detailed examination until now.

Queer histories of Pop Art and Design are included within this anthology as important additions, and interruptions to, the heteronormative narratives of the subject. Chapter Two by Dominic Janes explores links between queer identities and Cecil Beaton's use of the image in 'Cecil Beaton, Richard Hamilton and the Queer, Transatlantic Origins of Pop Art'. Janes argues that the collage mentality of many British Pop artists could be linked back to the earlier collage practices of Cecil Beaton in his (homo) erotic appropriation of American popular culture. Therefore, the beginnings of British Pop Art could be characterized as: '...queerly intriguing' (Janes 2015: 308). This reading of Pop Art is familiar when the situation in America in the 1960s is considered, but it is an approach which is new to the examination of early British Pop.

Chapter Three considers the work of an important black, female artist, Althea McNish. This is in the form of a series of questions posed by Christine Checinska with answers supplied by McNish's partner, John Weiss. Checinska has also provided a useful overview of the artist's career. She was born in Trinidad and moved to London in the early 1950s and studied at the London School of Printing (now the London College of

Communication) and the RCA. She was arguably the first London-based designer of African-Caribbean descent to achieve international recognition, working for Liberty and then Zita Ascher. She was one of the few black artists and designers working loosely within the context of British Pop Art and Design and her fabric designs represent an important crossover between fine art and design.

We then turn to the role of the institution in the formation of Pop Art and Design, the Institute of Contemporary Arts (ICA) in London. Much credit and attention has been given to the separate members of the Independent Group who met there between 1952 and 1955, but less attention has been paid to the organization itself, its culture and its space and place. Through its gentle, supportive way of working and pluralistic, transdisciplinary approach to all aspects of culture, the ICA was crucial for the creation of Pop Art and Design. The early ICA founders were inspired by modernist principles mingled with a tolerance born of the Quaker backgrounds of many of its early contributors, including its leading founder Roland Penrose (King 2016). Female curators were important here, too, with the guidance particularly of Dorothy Morland, also connected to Quakerism (Massey 2013). The ICA is proposed as a key facet of the development of Pop Art and Design in Britain.

Although very few black artists and designers were involved in the creation of Pop Art or Pop Design, Althea McNish being a notable exception, the influence of black culture, and particularly of black music, on the broader cultural scene out of which Pop visual culture emerged, was subtle yet vital and is worth exploring at this point. Pop Art and Design operated across what Lawrence Alloway referred to as the: '...long front of culture' (Alloway 1969: 41), challenging established cultural boundaries dividing high 'elite' culture from the 'popular' culture of 'the masses'. While this culturally subversive element defined Pop Art in all national cultural contexts, in the British case Pop Art and Pop Design represented a particular challenge to established, social class-based definitions of taste and traditional hierarchies of aesthetic value. Whether imported directly from the USA or produced locally by immigrants from what in the 1950s were then still the West African or Caribbean colonies, black music provided a lively and innovative soundtrack to the early development of Pop Art and Design in London and elsewhere. However, as Joe Tilson has pointed out (Seago 1995: 139), these influences retained subtly different interpretations between what could be described as Pop's 'uptown' and its 'downtown' exponents.

An examination of the chronology of events staged in the 1950s at the ICA, the crucible of the Independent Group's intellectual 'uptown' Pop (see Massey and Muir 2014) demonstrates that jazz, blues, African and Caribbean music became increasingly frequent topics for discussions and debates (as well as entertainment for 'at homes' and parties) as the decade progressed (see Massey 2013). From 1953 onwards more attention

was being paid to black music in the ICA's music sessions than to the work of the modernist avant-garde. During the key Independent Group years of the early to mid-1950s there were frequent discussion sessions organized by the ICA's Jazz Group devoted, to give a few examples, to 'Blues and Jazz' (chaired by Alexis Korner), a six-lecture series on 'Outlines of Jazz' (chaired by Lawrence Alloway, Eduardo Paolozzi and Alexis Korner, amongst others), and an 'Open discussion session on West Coast Jazz' and lectures and discussion sessions on jazz featuring staff writers from *Melody Maker* and the *New Musical Express*. As Massey (2013) explains, there were many informal networks and friendships linking members of the Independent Group, such as Nigel Henderson and Eduardo Paolozzi, with key figures in London's jazz scene such as Ronnie Scott, Benny Green and George Melly.

In addition there were frequent parties featuring the music of visiting and local musicians including Big Bill Broonzy and pioneers of London's African music scene such as Sholake and his African Band.

In an era during which casual racism towards newly arrived black immigrants was common, the ICA's embrace of black music testified to its culturally and politically progressive credentials. Although black culture featured little in the original visual output of the Independent Group a particular openness to black music, promoted for example by the composer, arranger and conductor Frank Cordell, permeated the Independent Group's preference for the more refined and sophisticated sounds of modern jazz (see Massey 2013 for an in-depth analysis of Cordell's musical influence). This taste for contemporary 'cool' black acts such as The Modern Jazz Quartet or the Hollywood-oriented sounds of West Coast musicians such as Chico Hamilton also characterized the ICA/Independent Group-influenced group of RCA students responsible for the crucial issues of *ARK* magazine which were published between 1956 and 1957. Not only did these issues of *ARK* edited by Roger Coleman increase awareness of Pop Art and Design via the publication of articles by Lawrence Alloway, Frank Cordell, Toni del Renzio, Peter Reyner Banham, Peter and Allison Smithson, their contents and layouts also pioneered a distinctly 'uptown', urban, contemporary 'proto-mod' sensibility (see Crow 2015: 95).

At the same time a generation of talented young graphic designers, including Len Deighton, John Sewell and Alan Fletcher, were becoming aware of the jazz album cover art that was being produced by illustrators such as David Stone Martin and the young Andy Warhol as a visual accompaniment to modern jazz sounds on record labels like Blue Note.

While the denizens of the ICA and their RCA-based acolytes were being seduced by the sophisticated sounds and sartorial styles of modern jazz, several of their contemporaries were engaging at street level with the sounds of black London. For Pop artists such as Peter Blake and Joe Tilson and for fellow St Martin's College of Art and RCA-trained illustrator Len Deighton, Soho rather than Mayfair was the place to be in the early to mid-1950s and the best music to be heard there was in black clubs such

as the Abalabi, Club Afrique and the Fullardo which featured bands such as Ambrose Campbell's West African Rhythm Brothers, the pioneers of London's nascent Charlie Parker-inspired modern jazz scene including Ronnie Scott, Tommy Whittle, Don Rendell, Denis Rose, Johnny Dankworth and Hank Shaw and the music of talented Jamaican jazz musicians such as Joe Harriott, Dizzy Reece, Harry Beckett and Wilton Gaynair. These clubs attracted a bohemian clientele rather different from the ICA's arty intellectuals and drawn from a very wide range of social backgrounds – from louche aristocracy to Soho criminal low life.

While black rock 'n' roll and rhythm and blues musicians, such as Bo Diddley or LaVern Baker, were the subject of some of Peter Blake's paintings, what probably had more important implications for the development of Pop Art and Design was the new cultural collage which characterized these Soho clubs – captured in the sounds of bands like Ambrose Campbell's West African Rhythm Brothers with their distinctly London/global fusion of styles drawn from Ghana, Nigeria, Sierra Leone, Trinidad, Jamaica and US modern jazz.

This 1950s Soho melange of race, ethnicity, sexual orientation and social class was a harbinger of the new Pop cultural sensibility characteristic of the style of Pop Art and Design, which emerged at the RCA in the early 1960s. One of the first to recognize this shift was the artist Richard Smith, an artist with a gift for cultural analysis fascinated by the imagery of contemporary commercial communication and a member of a slightly earlier generation of US-influenced RCA students whose analytical, slightly detached approach to contemporary Pop culture was favoured by Lawrence Alloway (see Alloway in Lippard ed. 1966). Writing about the work of David Hockney, Derek Boshier, Peter Phillips, Pauline Boty and Allen Jones in the RCA's student magazine *ARK* in 1962, Smith stressed his young contemporaries' uncritical acceptance of the new cultural landscape of which black music was an important component:

'The field of popular imagery is wide, full of kicks and possibly loaded with pitfalls...a friend met a teenager who was dissatisfied with a Pop record because there were too many cymbals.' 'Too many symbols?' said my ICA-attuned friend. 'Yes, too many cymbals, they make too much noise.' Our attention is riveted on Pop music in a more critical way than perhaps it warrants.... In using this material they are not saying 'We love it' or 'We hate it'. They accept it for what it is (Smith quoted in Seago 1995: 193–4).

As the chapters in this volume by Alex Seago and Sue Tate demonstrate, by the late 1950s/early 1960s the 'downtown' Pop culture of Pop music and fashion had become the natural environment for many young artists and designers. English art schools were becoming the epicentre of a distinct Pop sensibility produced by a new creative class who were active participants in and often the glamorous new 'stars' of the burgeoning 1960s 'Swinging London' scene.

The theme of cultural subversion and hierarchical miscegenation is continued in Alex Seago's Chapter Five on the role of the Royal College of Art's student magazine *ARK* in the creation of the 'symbol happy' world of early British art school Pop. Based on interviews with ex-RCA student editors, art editors and contributors from the 1950s and early 1960s the chapter examines the ways in which much of the energy fuelling early British Pop emanated from a combination of cultural and professional 'little narratives' – often involving combustible interactions between conservative and patrician tutors and a post-war generation of talented and ambitious students, often from working or lower middle class backgrounds eager to establish themselves as professionals in a world of creative visual practice being transformed by mass media and popular culture. Chapter Six, Ann Pillar's 'Prologue' to a facsimile reproduction of Edward Wright's 1957 article 'Chad, Kilroy, the cannibal's footprint and the Mona Lisa' – focuses on the intellectual contribution of a seminal figure in early British Pop who has been routinely (and perhaps, as Pillar implies, deliberately) excluded from the official canon. A charismatic and highly influential émigré 'outsider' who ran hugely influential typographic workshops at the Central School of Art and Design during the early 1950s and who routinely crossed the 'high'/'low' cultural boundaries of fine art/graphic design/typography and was also well versed in contemporary sociological and anthropological theory, Edward Wright's work elegantly blurred cultural and aesthetic boundaries. These attributes are perfectly demonstrated in the 1957 *ARK* article reproduced here. However, as Ann Pillar demonstrates, Alloway appears to have found Wright's creative originality and charismatic influence over the late 1950s/ early 1960s RCA generation deeply threatening and, sensing his professional status being challenged and his personal aesthetic value system becoming an anachronism, proceeded to attack Wright in a series of acrimonious

0.1 (opposite, left)

Joe Tilson's *Glances in the Slanting Rain*, *ARK* 14, 1955. © Royal College of Art Archive.

0.2 (opposite, right)

ARK © Royal College of Art Archive.

reviews and articles in which Wright was accused of violating sacred boundaries between fine art and design as chief of a 'symbol-happy tribe'.

Another important feminist contribution to retelling the history of Pop Art and Design is Chapter Seven, where Sue Tate focuses our attention on the creative practice of a highly significant female artist in: 'Pauline Boty: Pop Artist, pop persona, performing across the 'long front of culture'. The cultural politics of pop in *ARK* typically involved a challenge to the hierarchical privileging of fine art over design, both in terms of creative practice and within the art educational establishment. As Sue Tate's chapter on Pauline Boty reveals, these hierarchies were also involved in deeply gendered distinctions. The patriarchal structures of the art establishment presented particular problems for women artists, particularly those whose work involved an artistic commentary on Pop culture and a simultaneously active participation in that world – in Boty's case as actress, dancer and model. Indeed, as Sue Tate points out, the marginalization of women artists from the history of the 'man's world' of Pop art had much to do with the subjective position of women – particularly 'young, gorgeous' women like Pauline Boty – within contemporary pop/mass culture.

Chapter Eight by Alistair O'Neill, 'A dedicated follower of fashion', considers the interplay between new forms of masculine identity and the importance of the work of Toni de Renzio and Richard Hamilton for the imagery of fashion. This broad account of the overlooked connections between fashion and Pop Art brings a new understanding to the history of British Pop Art and Design. Taking Hamilton's *A dedicated follower of fashion* print as a cue, the chapter explores, for the first time, links between 1960s men's fashion and the construction of masculinity in the era of Pop. Fashion history meets art history in this fresh interpretation of masculine identity.

The edited collection concludes with Chapter Nine, the transcription of an interview between Alex Seago and Rick Poynor, founding editor of *Eye* magazine, Professor of Design and Visual Culture critic, on the rather curious relationship between graphic design and Pop Art in Britain. Based on an examination of a dozen key images produced between the mid-1950s and the mid-1960s and focusing on the development of the Pop poster in particular, this chapter attempts to question the place of Pop Art aesthetics and the relevance of established chronologies of Pop Design within the context of contemporary graphic design practice. The chapter questions widely held assumptions about the 'Swinging Sixties' – particularly the influence of Pop Art and the acceptance of Pop aesthetics within contemporary British graphic design practice and calls for more detailed scholarly research on the topic.

Our intention is that this book reactivates a more informed and complex exploration of Pop Art and Design in its nascent stages in London. We hope that it will provide the basis for more sustained research about the relationship between art and design in the age of Pop. We also hope that you enjoy reading this as much as we have enjoyed editing it.

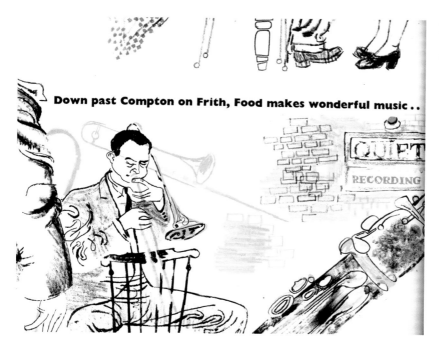

References

Alloway, L. (1969), 'The Long Front of Culture', *Cambridge Opinion*, No 17, 1959 reprinted in J. Russell and S. Gablik (1969), *Pop Art Redefined*, 41–3, London: Thames & Hudson.

Alloway, L. (1970), 'The Development of British Pop' in L.R. Lippard (ed.), *Pop Art*, London: Thames & Hudson, first published 1966, 3rd edition, 26–67.

Banham, R. (1955), 'Industrial Design e arte populare', *Civiltà delle macchine*, 13–15.

Banham, R. (1956), 'Biography' and 'New Look in Cruiserweights', *ARK*, No 16, Spring, 6, 44 and 47.

Banham, R. (1962), 'Who is this "Pop"?', *Motif*, No 10, Winter, 3–13.

Banham, R. and Sparke, P. (ed.) (1981), *Design by Choice*, London: Academy Editions.

Buchloh, B.H.D. (2014), 'Among Americans: Richard Hamilton', *Richard Hamilton*, London: Tate Publishing, 93–124.

Corbett, D.P. and Tickner, L. (2012), Special Issue of *Art History*, Vol 35, No 2.

Crow, T. (2014), *The Long March of Pop: Art, Music and Design 1930–1995*, New Haven and London: Yale University Press.

Fallan, K. (2010), *Design History: Understanding Theory and Method*, Oxford and New York: Berg.

Fermon, A.J. (2016), *Pop Art Heroes Britain*, exhibition catalogue, London: Whitford Fine Art.

Hebdige, D. (1983), 'In Poor Taste: Notes on Pop', *Block*, No 8, 1983, 54–68.

Highmore, B. (2013), 'Brutalist Wallpaper and the Independent Group', *Journal of Visual Culture*, Vol 12, No 2, 205–21.

Janes, D. (2015), 'Cecil Beaton, Richard Hamilton and the Queer, Transatlantic Origins of Pop Art', *Journal of British Visual Culture*, Vol 16, No 3, 308–30.

King, J. (2016), *Roland Penrose: the Life of a Surrealist*, Edinburgh: Edinburgh University Press.

Lippard, L. (ed.) (1966), *Pop Art*, London: Thames & Hudson.

Massey, A. (1995), *The Independent Group: Modernism and Mass Culture in Britain, 1945–1959*, Manchester: Manchester University Press.

Massey, A. (2013a), *Out of the Ivory Tower: The Independent Group and Popular Culture*, Manchester: Manchester University Press.

Massey, A. (2013b), 'The Mother of Pop? Dorothy Morland and the Independent Group', *Journal of Visual Culture*, Vol 12, No 2, 262–78.

Massey, A. and Muir, G. (2014), *ICA 1946–68*, London: ICA.

Massey, A. and Sparke, P. (1985), 'The Myth of the Independent Group', *BLOCK*, 10, 48–56.

Pollock, G. (1988), 'Modernity and the Spaces of Femininity' in *Vision and Difference: Femininity, Feminism and the Histories of Art*, London: Routledge.

Seago, A. (1995), *Burning the Box of Beautiful Things: The Development of a Postmodern Sensibility*, Oxford: Oxford University Press.

Whiteley, N. (1987), *Pop Design: Modernism to Mod*, London: Design Council.

Woodham, J.M. (2016), 'Preface' in L. Farrelly and J. Weddell (eds), *Design Objects and the Museum*, London: Bloomsbury, xii–xv.

Popular Art, Pop Art, and 'the Boys who Turn out the Fine Arts'[1]

Catherine Moriarty

An open notebook, the left- and right-hand pages separated by two lines of perforations. The writer, we can tell, has an assured sense of the space of each page and arranges the text upon them with confidence. On closer inspection, it is clear this is a record of a series of actions. On the left, the details of contacts to be approached in different parts of the country – publishers of 'Good Luck' postcards in Yorkshire and suppliers of Scottish souvenirs in Liverpool – overlaid with the subsequent satisfying tick of a job done. On the right-hand page, we see a list of expenditure, some of it discernible – post, stationery, paper – but what about 'Corn Ds', 'love books' and 'bandanas'? Entitled 'POP ART BUYS', what we see is the itemization of a process, of purchases made, of letters written, of tasks completed. We have found an invaluable window onto the making of an exhibition.

1.1

Barbara Jones's pocketbook, 1951. 11.5 × 17 cm (open). Full of lists, names and addresses, and phone numbers compiled as the planning of *Black Eyes and Lemonade* moved forward, this notebook has the business card of tattooist George Burchett tucked inside, and a note relating to an impending demolition in the East End: 'PUB ABOUT TO GO. "Royal George". Vallance Rd.' (Barbara Jones Archive, University of Brighton Design Archives)

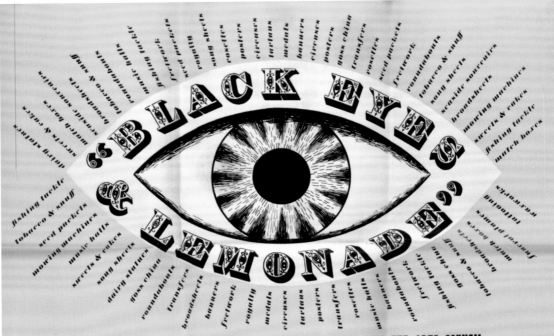

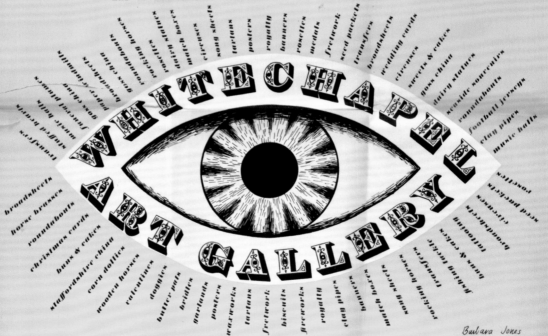

Chapter 1: Popular Art, Pop Art, and 'the Boys who Turn out the Fine Arts' | Catherine Moriarty

The exhibition in question is one that has a significant place in the history of popular art and Pop Art. It was an event that through its planning and execution made visible the ways that knowledge and expertise are shared between makers and consumers and between individuals of different backgrounds and generations. It juxtaposed different kinds of objects – the handmade and the machine-made, the huge and the minute, the singular and the serial, and, importantly, the historic and the contemporary. Intended by its instigators, the Society for Education in Art (SEA), as a didactic exploration of the qualities of folk art and their particular value in art education, it became – to their consternation – quite a different proposition. Its organizer, the artist and writer Barbara Jones, challenged the original remit, and created a testing ground for what contemporary popular art might mean, introducing objects in current production, including the mass-produced, and exploring their visual and material presence in everyday life and popular memory as well as their relationship to equivalents in the nineteenth century. The pages described above appear within a 1951 pocketbook, and the exhibition took place between 11 August and 6 October that year at the Whitechapel Art Gallery.[2]

1.2 (opposite)

Exhibition poster of *Black Eyes and Lemonade*, Whitechapel Gallery, London, 11 August to 6 October 1951. Courtesy Whitechapel Gallery, Whitechapel Gallery Archive. Lists from London Transport in the Whitechapel Archive reveal at which underground stations and in what quantities this poster was distributed. In multiple alignments – for example, six each at Moorgate, Aldersgate and Farringdon – and at consecutive stations, they would have looked spectacular.

1.3 (below)

Artwork for and samples of the *Black Eyes and Lemonade* catalogue cover. Here Barbara Jones's preferred title dominates and the intensity and energy of her design process is tangible. (Barbara Jones Archive, University of Brighton Design Archives)

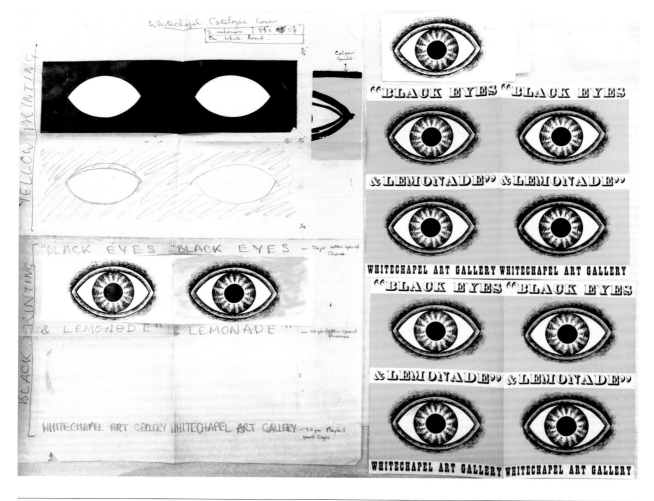

Part of the Festival of Britain programme and supported by the Arts Council, the exhibition was to be entitled British Popular Art, but Jones felt this sounded 'a little dull', failing to convey the appeal of its contents which she considered 'both bold and fizzy' and so she proposed 'Black Eyes and Lemonade' as a prefix (Jones, 1951a). This resonated powerfully, becoming the title by which the exhibition is best known, to the extent that the words British Popular Art – even though they occupied a central place in the poster Jones designed for the exhibition – tend to be overlooked. What also tends to be overlooked, especially in retrospect, was Jones's insistence on the inclusion of the contemporary, as she wrote in the catalogue to the exhibition, 'There are a lot of things here, made this year, that could go straight into an exhibition of modern art.' (Jones, Ingram, Newton 1951: 7)

Writing fifteen years later, in his chapter 'The Development of British Pop' for Lucy Lippard's *Pop Art*, Lawrence Alloway mentioned Jones's exhibition in a footnote that appears at back of the book. Dislocated from the narrative it is easy to miss. He describes the exhibition that Jones produced as a 'gathering of folk art and working-class *objets d'art*', and explains:

> This area is separated from Pop Art by a tendency to view
> Victoriana as something bizarre and amusing, whereas Pop
> artists use newer if not absolutely current objects and images.
> They view popular culture straight, not nostalgically.
> (Alloway 1966: 200)

The placing of Jones's exhibition in the footnotes and the misrepresentation of its scope allowed Alloway to give his own analysis of the development of British Pop Art a later start date. Indeed, the list of significant Pop exhibition catalogues arranged chronologically in the bibliography of Lippard's book begins with *Parallel of Life and Art* held at the Institute of Contemporary Arts (ICA) in 1953. In this way the context, location and protagonists of British Pop are clearly defined. Alloway's is a coherent story that unfolds through the three stages by which he orders its progression. It is a story that through telling, retelling and international dissemination seemed impregnable and which only began to be questioned in the mid-1980s (Massey and Sparke 1985).

This chapter sets out to consider the development of British Pop from a different place and time and with a different configuration of participants. It asserts that Barbara Jones's emphatic use of the term 'POP ART' in 1951 is of great significance in that it adds greater complexity to Alloway's story. Indeed, Jones's approach was not that of someone who was simply amused, instead it was underpinned, as we will see, by rigorous fieldwork and visual analysis. Neither was her approach nostalgic, it was embedded in the mid-twentieth-century experience of British makers, manufacturers and consumers in and around London, but also of those in the regions; people who she knew well through travel, fieldwork, drawing and by way of her own

collecting. Rather than being swayed by a nostalgic view of the past, Jones was absorbed by the migration of images and objects over time and how attitudes towards things evolved:

> England is at this moment crammed with popular art before which most art lovers quail in alarm, but still most of them will ultimately become QUAINT, then CHARMING and at last GOOD. So we have tried to be fair and represent them all, aiding our judgement with consumer research; it will nevertheless be noticed that we are prejudiced in favour of cats and commerce. (Jones et al. 1951: 6)

In fact, this tongue-in-cheek approach with its camp exhortations belied Jones's expertise and erudition; it perhaps helps us to consider what Alloway meant by the ability to 'view popular culture straight'. Certainly Jones preferred it undiluted and many considered her inclusions in the exhibition challenging and close to the mark, but was Alloway in fact implying something else, a prerogative determined by his younger, male associates at the ICA? Whether he knew it or not, several key members of what was to become the Independent Group were, as we shall see, closely involved with Jones's project and so the separation Alloway made by placing her exhibition in a footnote, although a separation that stayed, was in fact of his own making.

This distancing seems all the more remarkable because in the summer of 1951, the Society for Education in Art – an organization founded in 1940 by Herbert Read, Henry Moore, Eric Gill and Alexander Barclay Russell – published a special issue of their journal *Athene* to coincide with the exhibition.[3] Lawrence Alloway, a member of the SEA Council and editor of the journal, contributed a short article. In this piece entitled 'Marine Totems' he refers specifically to Jones's research on the relationship between the carvers of ships' figureheads and the transfer of their skills in the making of roundabout horses[4] (Alloway 1951: 64). Jones had contributed several articles to the *Architectural Review*, and it is the essay 'Roundabouts: Demountable Baroque' of 1945, with its extraordinarily attentive visual analysis of fairground objects and imagery, to which Alloway makes reference (Brown and Jones 1945). Employing detailed annotated drawings in the manner of ethnographic recording, alongside photographs by her co-author Eric Brown, the article reveals the depth of understanding attained by observation in the field. Other topics to which Jones paid equivalent levels of attention include canal boat decoration, the seaside and funeral customs (Jones 1946, 1947, 1949). During 1950, she was busy collating these texts and their accompanying drawings to form the book *The Unsophisticated Arts*, published to coincide with the exhibition in 1951 (Jones 1951b). Indeed, the exhibition itself was an accumulation and culmination of Jones's longstanding expertise on popular art, as well

1.4 (right)

Page from the article 'Roundabouts Demountable Baroque', *Architectural Review*, 1945. (Photo: University of Brighton Information Services)

1.5 (below)

Dust jacket of *The Unsophisticated Arts* by Barbara Jones, 1951. As the exhibition poster exemplifies with its text-formed eyelashes, this book jacket also demonstrates the way Barbara Jones revelled in the play between image, object and text. The sailor-like figure with an articulated jaw, perhaps a ventriloquist's puppet, with the book's title tattooed on its chest and the author's name on its arms, speaks of her interest in tattooing as a popular art, while the back cover delivers all the momentum of Jones' fairground experiences. (Photo: Simon Costin)

the dynamos travel with the machines. Transport is by motor; how long is it since you saw horses pulling the vans? But the mind seems a little surprised at this contemporary equipment, replaces it with something fifty years out of date, and looks with wonder at the sparks flying from the Dodgems, and at packets of Players and American sailor hats as prizes on the shies; though fashions have changed in narrower limits still, and "I'm no Angel" written on the front of the hats has changed to "Get up them Stairs." Red and gold vases are the prizes we are looking for.

Rounding boards are less elaborate than they were before the changes in the road regulations. The big boards rioting against the sky in old photographs have been left behind in sheds at winter quarters and some of them have been lost, with many smaller complications easily left off, but the modern lighter and smaller ones are still very fancy. They usually go up in twelve sections, one between each pair of swifts, and on the flat part of the board which remains on the most closely pruned roundabout, the name of the owner and a description of his stud are painted in heavy, voluptuous lettering. Somewhere under the layers of fat lie the Trajan Column letters, as the lines of the slim Egyptian dogs are hidden in an Old English Sheepdog, or as one can trace an over-stuffed armchair back to Sheraton. The letters are usually in strong relief, richly shadowed and foliaged. Above these flat boards are twelve more, leaning outwards and billowy-edged, supporting lights and flags, while the droppers go all round beneath. The joints between the lettered boards are covered when possible by a carved shield or similar object, and ornaments or horses' heads may be carved out from this on the main boards to enrich the corners round the names and slogans.

On an ordinary roundabout the thirty-six or forty-eight animals and birds give a sufficiently intricate pattern, but on a switchback there will be only four or six cars in one ring and a certain monotony might occur. This is never allowed to happen on the older types of machine (the modern Dodge'Ems are dull enough), as much of the glamour lies in intricacy, so the whole construction is different. A fixed but up-and-down platform goes round the revolving cars; at one of the two dips in the circuit are steps to the ground with fine marbled balustrades sweeping out on to the grass, and the space between the platform and the ground is filled in all round with painted scenes in bowers of roses, dirt-track races or jungles. From here to the rounding boards run pilasters, caryatid figures or pillars wreathed with flowers, monkeys and parrots. These cut up the long toothed shapes of the cars. Golden gondolas with high prows were once very popular but dragons seem to have won the day.

53

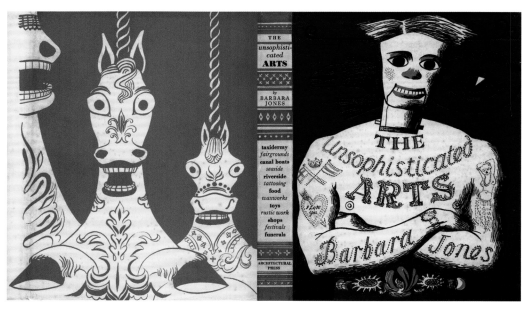

Chapter 1: Popular Art, Pop Art, and 'the Boys who Turn out the Fine Arts' | Catherine Moriarty

as an expression of her interest in its contemporary forms. Through his involvement in the Society for Education in Art, Alloway would have been fully aware of the complexity of debate around definitions of popular art in 1951 and the range of interest in it. An article by Jones, entitled 'Popular Art' appeared in the same issue of *Athene*, a few pages from Alloway's (Jones: 1951c). While adamant about the distinction between popular art and Pop Art and how these terms have meant different things at different times, his eagerness to start the story from a particular point led him to obscure the more nuanced way that Pop Art emerged and its rather longer tail. *Black Eyes and Lemonade* was precisely an exercise in treating popular culture 'with the seriousness of art' (Alloway 1966: 32). Indeed, as well as marginalizing Barbara Jones and *Black Eyes and Lemonade* specifically, Alloway fails to mention the significance of British popular art entirely, or to acknowledge the wide field of national visual and material culture on which British Pop drew, a view which the research of John-Paul Stonard has affirmed (Stonard 2007, 2008). By focusing on contemporary media from the USA, Alloway obscured important elements of Pop Art content, as much as its complex context. In his recent study 'The Long March of Pop' Thomas Crow has re-established the connection to folk art, referring to Alloway arriving in New York in 1961, 'carrying that powerful, one-syllable signifier to New York' as a key moment when the representation of the mass-produced overtook connections to the vernacular. Indeed, as Crow identifies, this moment of severance is linked to the 'expansive, demotic notion' that characterized the early history of Pop in Britain (Crow 2014: viii).

This chapter then, seeks to argue several things. Firstly, that a significant source for the development of British Pop was not only contemporary popular culture and design from the USA, but contemporary and historic British popular culture. It argues, and produces new evidence to demonstrate that artists who were to become members of the Independent Group were not only aware of but allied to efforts that involved the appreciation, investigation and championing of British popular art. They were conscious of the network of experts, enthusiasts and commentators who all, to one degree or another, wished to encourage a more pluralistic way of seeing. It argues that the strategies of the Independent Group, particularly relating to exhibition and display, sequencing and scale had a recent precedent. Their repositioning of the products of popular culture in a new context and in a different relation to one another – be it by means of a slide show, display or collage – was what lay at the very heart of Jones's project at the Whitechapel. Another compelling element is that if Barbara Jones's use of the term 'POP ART' in 1951 is identified as a point of origin, then the work of the artists associated with the Royal College of Art (RCA) no longer has to be shoehorned into an ill-fitting narrative. Indeed, *Black Eyes and Lemonade* is the point from which the trajectories of both members of the Independent Group and the RCA were aligned. As Peter Blake later

recounted, 'I have no doubt that discovering Barbara Jones was one of the more important things that happened to me' (Katharine House Gallery 1999).

Importantly, the rigour of Jones's inquiry has never been acknowledged, partly because her ability to sell a story both visually and verbally obscured, in its seeming effortlessness, the depth of her thinking. The elision from Popular to Pop in art historical narrative has created a disjointed story in which this parallel path with all its rich detail has been obscured. This was, of course, largely the point. However, if we step back to 1951, shift emphasis from the West End to the East End and invite a wider and more inclusive cast of characters, then things start to fall into place.[5]

———————————————————

Barbara Jones is best known as an illustrator of books, as a contributor to the wartime *Recording Britain* project and for her ardent enthusiasm for British follies and waterways. A student at the Royal College of Art in the 1930s, her work tends to be associated with the illustrative style of Edward Bawden and Eric Ravilious who were teaching there and her interests are seen to align with the folk art predilection of an English Romanticist tradition. However, it is important to shift this view and to think about her work in a post-war rather than a pre-war context. We should think of her as a woman in her late thirties with her finger on the pulse, energetic and articulate, with ideas and opinions that inspired a group of younger artists who went on to pursue related themes in the more explicitly progressive context of the ICA or at the RCA. Indeed, Jones even appears to have anticipated this intellectualizing of what she saw as connected cultures of making and consuming. To a great extent the work of artists such as Hamilton and Paolozzi focused on extracting images of things from the original context of their making and consumption and representing them in ways that force us to look at them anew. For Alloway, this was the crucial transition from popular to Pop.

While Jones's approach to popular art was far from objective she appreciated particularly the collective significance of made things. In contrast, those associated with the development of Pop were, as their work makes so explicit, consumed by their subjectivity, their own experience of the present. Instead, Jones appreciated the present as shared, as a hybrid of older things alongside new things, the ephemeral alongside the enduring.

While Jones was the driving force behind *Black Eyes and Lemonade* she shared the work of organizing it with the writer Tom Ingram. In 1954 Ingram would go on to write the book *Bells in England*, which Jones illustrated, and in 1956 he collaborated on another, *Hymns as Poetry* with the young poet and ethnographer Douglas Newton, a book that considered the hymn as a popular, public form. Newton, too, played a crucial role in *Black Eyes and*

Lemonade; he was responsible for producing the catalogue and listing the exhibits under the categories and subsections determined by Jones. Newton also lent to the exhibition, a pair of papier-mâché chairs, a hand-painted valentine, a churchwarden clay pipe and an album of views of the Crystal Palace. Many other associates lent items for inclusion and the catalogue credits reveal an intriguing and diverse social network. Jones's associations, as we shall now consider, were inclusive rather than exclusive. They were formed by interlocking expertise engendered by knowledge (and object) exchanges and as such were horizontal – moving across space, class and time. They included makers of all kinds (fairground carvers), decorators (barge painters), experts (taxidermists/makers of waxworks), as well as collectors (Sydney Cumbers and his figurehead collection in Gravesend, Dr John Kirk and his collection of 'bygones' in York), and regional or specialist collections (such as Henry Willett's collection of popular pottery at Brighton Museum and the Saffron Walden Museum who lent, among other things, a glass dome of wax fruit and a china box in the shape of a cottage). They included the rural and the industrial, craftspeople (Mr Turner of Great Bardfield made the Corn Ds [dollies] itemized in the notebook with which we began) and manufacturers of fancy goods. Jones even included these people in the exhibition – a pavement artist was a huge attraction for the public and

1.6

The banner of the National Union of Railwaymen hangs from the ceiling with the icing sugar St Paul's below it. In the central case are exhibits relating to the theme 'Man's Own Image' including the poster The Human Factory. Installation views of *Black Eyes and Lemonade*, Whitechapel Gallery, London, 11 August to 6 October 1951. Courtesy Whitechapel Gallery, Whitechapel Gallery Archive.

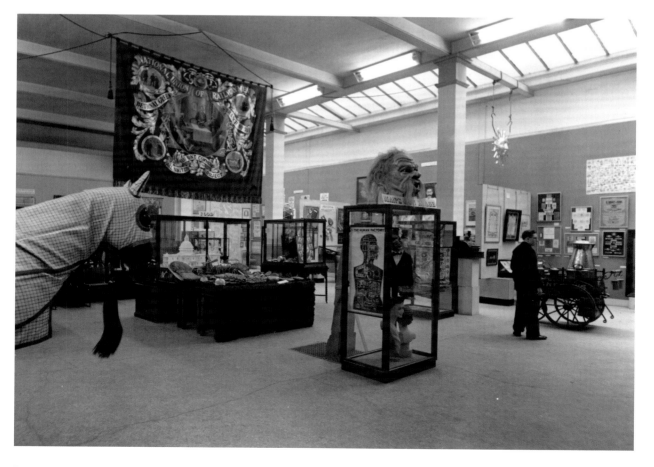

Euston Arch, Barbara Jones, 1943.
Recording Britain (Victoria and Albert
Museum, London).

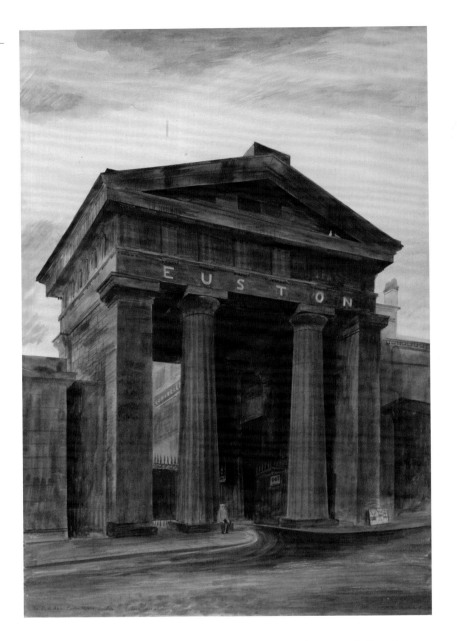

the press – and she featured confectionery constructions, one in the shape
of St Paul's Cathedral, from instructors at the RAF School of Cookery. She
selected the clothing worn by Arsenal football fans rather than the team's kit
because there were so many more fans than players. She included a banner
of the National Union of Railwaymen. This, of course, is in stark contrast
to the highly selective 'group' who saw themselves as 'independent'. For
in their independence they were also isolated. If instead, we consider
interest in the popular as a dispersed landscape of multiple connections
and relationships we arrive at a rather different picture than that presented
by the established historical record; a matrix rather than a lineage. Indeed,
not only did Jones's approach upset the Society for Education in Art, but

other adherents of her generation took a different tack, notably Enid Marx and Margaret Lambert. Certainly, it is the traces of these various tensions and connections in an array of archival records and published sources that convey a diverse, evolving constellation of participants.

Jones's work for Recording Britain during the Second World War had produced a series of watercolours depicting buildings and environments, usually in rural settings, that were inherently about the past. One particularly striking painting of an urban location is that of Euston Arch. Having survived enemy action it was eventually demolished in 1962 and became emblematic of the tension between the interests of post-war developers and the views of preservationists.

Later work of this kind offered a greater sense of mid-century urban experience and the place of the past in the present. Jones's painting of the tattooist George Burchett which was reproduced in her book *The Unsophisticated Arts* was made in 1950 as part of a record of premises on the South Bank that were to be demolished to make way for the Festival of Britain. Items from his shop were included in *Black Eyes and Lemonade*. Tucked in the pocketbook with which we began, there is Burchett's business card with the claim 'CRUDE WORK COVERED OR REMOVED' above the address, which was, of course, by then no more. Another part of the built

1.8 (below, left)

George Burchett, Barbara Jones, c.1950. As reproduced in *The Unsophisticated Arts*, 1951. (University of Brighton Design Archives)

1.9 (below, right)

Colossal bottle covered with beer labels in the 'Drinking' section. Installation views of *Black Eyes and Lemonade*, Whitechapel Gallery, London, 11 August to 6 October 1951. Courtesy Whitechapel Gallery, Whitechapel Gallery Archive.

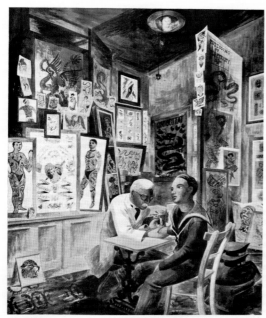

Mr. George Burchett at work. Behind him are paintings by Mr. Burchett himself of two superb examples of all-over tattooing. A fine figure can be almost destroyed by unskilful arrangement of line or emphasis.

103

environment and social fabric of the city that was changing rapidly was the public house, many of which typically contained nineteenth-century fixtures and fittings. Jones viewed it as a descendant of the 'richly fantastic' Victorian gin palace, 'its mirrors and beerpulls sparkle and glitter with reflections of that gas-lit glory' (Jones et al. 1951: 33).

Jones presented this moment of loss not simply regretfully but as a concomitant of optimism and post-war progress, she exhibited Bewick's woodcuts with *Dan Dare*, eighteenth- and nineteenth-century engraved trade cards next to a large lemon advertising Idris lemonade and other contemporary objects alongside earlier equivalents. It was precisely this quality of transitional experience that connected Jones's appreciation of popular culture with Nigel Henderson, who went on to become a member of the Independent Group. Like Jones, he immersed himself in popular experience and they must have discussed their mutual enthusiasms for he was a contributor to *Black Eyes and Lemonade*, lending 'Bookie's Tickets from a Racetrack: 1950'. Henderson shared Jones's interest in the

1.10

Douglas Newton photographed by Nigel Henderson, c.1950. (Estate of Nigel Henderson.) Source: Museum of London.

chance juxtapositions of urban life, the accidental backdrop of posters on hoardings, graffiti on walls, chalk marks on pavements.[6] Henderson photographed Douglas Newton against a hoarding in an image that reveals keen awareness of the visual experience of contemporary Britain and the immersive contact with popular culture in the everyday (Walsh: 2001). Henderson's poetic photographs contrast sharply with the observational methods employed by his wife, the anthropologist Judith Henderson, who was engaged on an official survey of East End life. Yet Henderson, like Jones, could be said to have a broadly 'anthropological' approach to culture, although one that was explorative rather than systematic. Importantly, they both saw the exhibition as a site of enquiry and the curatorial role as investigative rather than didactic. Douglas Newton went on to join the Museum of Primitive Art in New York in 1956, where he established a reputation as an innovator in the display of non-Western art, eventually becoming Curator Emeritus of the Department of the Arts of Africa, Oceania and the Americas at the Metropolitan Museum of Art (Cotter: 2001). Throughout *Black Eyes and Lemonade* long captions were avoided and visitors were invited to purchase the catalogue Newton had prepared. This strategy of accompanying hand list – which suggested an equivalence between things – was a feature of early ICA exhibitions including *Growth and Form*, organized by Nigel Henderson and Richard Hamilton, 4 July to 31 August 1951 (which overlapped with *Black Eyes and Lemonade*) and most notably, two years later, the exhibition *Parallel of Life and Art*. The catalogue structure and arrangement of the show, with items grouped by theme, bears close comparison with that of *Black Eyes and Lemonade*.[7]

So in terms of the kinds of objects they appreciated, their relation to the everyday and the role of the exhibition as a spatial exploration, Henderson and Jones had much in common. It is hardly surprising perhaps, to discover that Jones also had contact with Henderson's good friend Eduardo Paolozzi. An entry in Jones's 1950 diary notes a meeting on Friday 15 September at 58 Holland Road where Paolozzi was lodging at this time with Terence Conran.[8] Paolozzi's passion for science fiction and popular culture from the USA is often cited as heralding the development of Pop Art in Britain, but Jones's and Henderson's unsentimental engagement with British popular art adds complexity and nuance to the understanding of the novelty and allure of popular culture from across the Atlantic as amalgamated in works such as *I Was a Rich Man's Plaything* (1947) and the April 1952 presentation at the ICA, transformed in 1972 into the print edition *Bunk!* (Stonard: 2008). Indeed, Paolozzi's work includes elements that are directly connected to *Black Eyes and Lemonade*. For example, the medical diagram 'The Human Factory' included at the Whitechapel – published by George Phillips & Co in 1931 – was a loan from Louisa Pullar (1884–1967), an artist who had worked alongside Jones on the Recording Britain project and who also lent a nineteenth-century asparagus dish and 'four watercolours of shells and

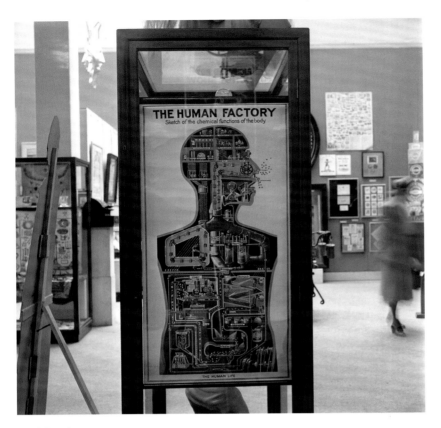

1.11 (above)

The Human Factory, 1931. Published
by George Phillips & Co. (Wellcome
Collection / installation shot from
Vogue Archive)

1.12 (opposite)

From *As Is When*, Wittgenstein in
New York, 1964. Classification: on paper,
print medium: screenprint on paper.
Dimensions: 763 × 538, ©Tate London
2015 / ©Trustees of the Paolozzi
Foundation, licensed by DACS 2016

seaweeds' dated 1805.[9] Derived from the work of the German, Fritz Kahn, it
appears in Paolozzi's 1972 *Bunk!* series as *Man Holds the Key*, from a collage
he assembled in 1950, and it reappears again in his print *Wittgenstein in New
York* from the *As Is When* series of 1964, demonstrating that such a powerful
image was appropriated by those who appreciated such things, be it Pullar
or Paolozzi. One wonders if this is the kind of thing that Jones and Paolozzi
discussed if they did, in fact, meet in the autumn of 1950. Either way, the point
is not who identified it first, but that interest in it was shared.

It is both this extraordinary mixture of objects from different times and
of people of different generations and backgrounds, that makes *Black Eyes
and Lemonade* so unusual. Other significant lenders were the typographer
Charles Hasler whose knowledge of early print processes, especially
woodblock techniques, was extensive; Antony Hippisley Coxe, who lent
circus posters and whose book *A Seat at the Circus* was published in 1951
(Jones was to illustrate Douglas Newton's book, *Clowns*, in 1957); Arthur
Elton the distinguished documentary film-maker who lent objects from the
railways – a collection that, on Elton's death, moved to Ironbridge Gorge;
the artist Edward Bawden and his wife; and architectural photographer
Edwin Smith who lent a nineteenth-century phrenologist's bust and whose
work included images of fairgrounds, advertising hoardings and who evoked
the shared experience of contemporary popular art and media in the built
environment (Elwall 2007: 17). Together, they form an extraordinary group

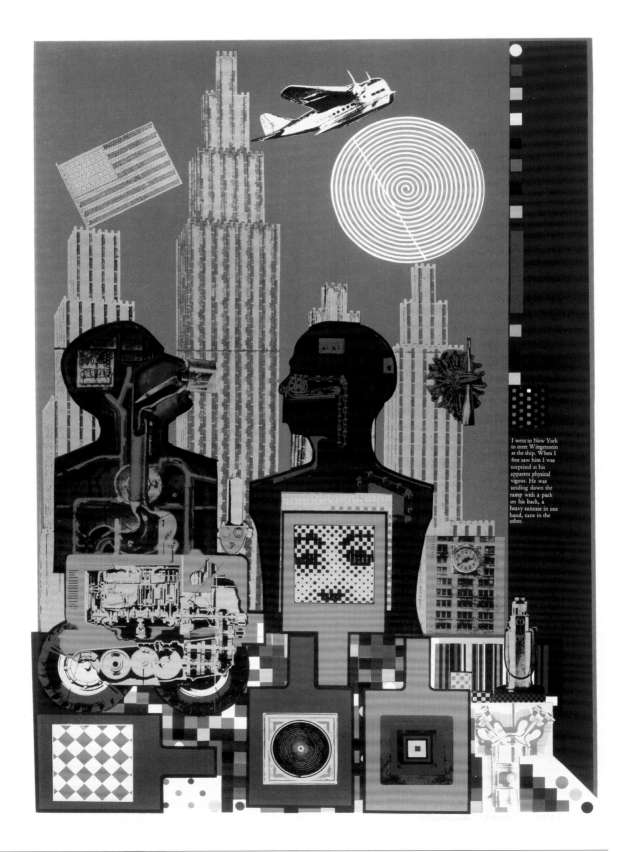

I went to New York to meet Wittgenstein at the ship. When I first saw him I was surprised at his apparent physical vigour. He was striding down the ramp with a pack on his back, a heavy suitcase in one hand, cane in the other.

of people connected by an interest in industrial history, the evolving built environment and the place of makers and communities in British identity. Some of these lenders and their objects had featured in the Festival of Britain and Jones had contributed to the displays – her lion and unicorn for the eponymous pavilion were clearly influenced by a fairground vernacular (Gooden 2011: 97–8). However, at the South Bank these elements tended to be subsumed within a metanarrative that the texts, layouts and structures shaped in such a way that the overriding message was one of national progress through scientific discovery. Certainly the majority of photographs of the Festival tend to focus on the formal properties of the pavilions, rather than their contents. As Kenneth Williams recorded in his diary (the entry is for Sunday 6 May 1951): 'It's all madly educative and very tiring. Beautifully cooked!!' (Williams and Davies 1993: 63; Atkinson 2011; Curtis 1985/6).

In the summer of 1951 the Whitechapel Art Gallery became the focus of an unusual connection between the concerns of different generations when, albeit briefly, their interest in the popular in the present and the exhibition as a site of enquiry were aligned. The evidence clearly indicates that Jones articulated many ideas that would become central to the development of British Pop. As Gillian Whiteley (2013: 41) has argued, 'the 1951 exhibition resonated with the kind of contemporary debates about high versus low culture and the development of populist aesthetics within the Independent Group'.

As we know from careful reading of the archive, Jones was using the term 'POP ART' as early as 1951. In addition to the pages mentioned above, there is another entry in the same diary entitled 'POP ART CASH'. Indeed, this usage cannot be explained away as Jones's own, private designation. Among the records relating to the planning of the exhibition there is a note of a phone call to Jones made by the Director of the Whitechapel Gallery, Hugh Scrutton. It was Scrutton who supported Jones in her disagreement with the Society for Education in Art and who made great efforts to broker an agreement that would enable her to exhibit the contemporary. At the end of the document, below Scrutton's signature, are the words, in his own hand, 'Pop. Art' followed by the date – 24 July 1950 (Scrutton 1950).

While Jones's approach manifested a continuation of accepted ideas about popular art it also extended them.[10] It is precisely how she presented and framed it that links her to what was to happen a few years ahead. Without doubt these connections were, through content, vocabulary and relationships, rather stronger than Alloway admitted. There is another way in which the exhibition heralded what was to come for the appeal of the popular in a commercial culture, and the branding of Britishness can also be traced back to *Black Eyes and Lemonade*. A fashion feature entitled 'Sophisticated and Unsophisticated' appeared in *The Ambassador* – the British export magazine for fashion and textiles – in October 1951. Positioned within the *Black Eyes and Lemonade* installation, models in outfits by British ready-to-wear companies were arranged

alongside figureheads, a ventriloquist's dummy and other exhibits, playing out visually the antithetical tensions of Jones's book *The Unsophisticated Arts*. Photographed by Elsbeth Juda, the audacity and commercialism of this performance and the resulting friction between the old and the young, the live and the inert, pre-dates significantly the Carnaby Street culture of the 1960s. (*Ambassador* 1951; Tickner 2012). This instance of employing the popular arts as a way of branding contemporary Britain by photographers, designers, advertising agencies and other commercial creatives was far advanced by the late 1950s and before the young guns of the ICA and RCA made it their role to explore the phenomenon in a fine art context and before they became part of the brand themselves.

Jones had ended her 1951 catalogue essay suggesting the Victoria and Albert Museum acquire 'a whole glittering roundabout' – they didn't – and

her campaign for a National Museum of Industrial Architecture made little progress in the years ahead (Artmonsky 2008: 75–7). Yet her research on the English fairground, which is, as we have seen, a fine example of visual analysis, heralded the vernacular aesthetic that was so important to the early development of Pop Art. Writing in 1951 she saw the fair as 'canonised by the art boys – but not yet unfortunately by the museums'. Indeed, Jones was intrigued by the ways in which fairground forms themselves were updated with contemporary references, through the inclusion of portraits of film stars or in the naming of rides, as she observed '"Atomic" was painted on the fascias as soon as the first bomb fell' (Jones 1951c: 47). No wonder then, that when Ken Russell was making *Pop Goes the Easel* in 1962, the shots of Boty, Bouchier, Blake and Phillips at the fairground are the most compelling. Alloway, through his knowledge of Jones's writing, knew this better than most, yet his story of Pop prioritized the Independent Group and marginalized the RCA; it prioritized the influence of popular culture from the USA rather than interest in British vernacular forms and spectacle.

In *Black Eyes and Lemonade* Jones exhibited and asked viewers to appreciate objects as popular art in themselves. Yet the IG members were not quite ready to make this shift, they absorbed the material as image, and from it produced their own interpretation. Indeed, Jones herself made a comment about this. A typewritten note in the Whitechapel Gallery Archive reads: 'The things in this exhibition were not made by the boys who turn out the fine arts' (Jones 1951a). This commodification of the essential object is what, at least, the Americans did advertently. Jones was interested in the originators and producers of popular art, she talked to makers and described their tools

and processes, and she knew well (albeit as an outsider) the texture and geography of British manufacturing. Indeed, the many letters in her archive present a map of the fancy goods manufacturers, military uniform suppliers, comic publishers and confectioners that could be found in different parts of Britain in 1951.[11] Barbara Jones drew the objects they produced and that people bought or collected as a way of knowing, as a way to reveal the qualities of the original, to record and to amplify but not to transform it into something else entirely.

Ultimately, the Independent Group were primarily interested in what the objects gave to them as visual stimulus – perhaps this is what Alloway meant by viewing it 'straight'? Jones, on the other hand, recognized the power of the manufactured object and its enduring meaning to makers and its users. The many letters that Jones and Ingram wrote, respectfully requesting loans to manufacturers across the country, and the replies with their embossed and illustrated letterheads – which often depict the factories in which things were made and where so many thousands worked – convey a pride that remains tangible. Likewise, Jones was interested in the importance of things to individuals, as souvenirs and mementoes, as markers of the stages of life. She also recognized the collective appreciation of the mass-produced – the memorable poster, the seaside postcard – or the public spectacle – be it a waxwork, the talking lemon or a stuffed kitten. While Paolozzi absorbed the medical diagram and appropriated it as image, Jones exhibited it as an object with its own biography. Her exhibition drew attention to these things and their meaning in the world whereas the artists put their image, removed from context, in a frame or in what we would now describe as an installation. For Jones, the materiality of popular art was captured in its scale – be it huge or tiny – and the objects were exhibited to reveal this. Though the Pop artists' canvases or collages may have accommodated the real thing it was, unequivocally, extracted and isolated from its original framing. Be it a magazine page, or a ticket, all trace of how it occupied the world was lost. Jones asked us to experience the pervasion of popular art by exhibiting posters intended for huge advertising hoardings to the most intricate miniaturized hatpin ornament. Writing in 1981, Dick Hebdige referred to the emergence in 1950s New York of opposition to 'the modernist consensus' and how, in London, this took the form of an 'ironic sensibility' (Hebdige 1981: 50). Hebdige identifies the Independent Group and the 1956 Whitechapel Art Gallery exhibition *This is Tomorrow,* as signalling this shift, but in many ways, Jones's exhibition five years earlier was a more sophisticated stab at the design elite because the irony was entirely at the expense of the design establishment, and the objects, their makers and consumers, were treated with respect. Jones had assisted with design promotion campaigns, having worked for the Council of Industrial Design on their publications and exhibitions and so she was familiar with their approach.[12] Her dismay at

the imposed livery that would replace traditional canal boat decoration as a consequence of nationalization in 1948 epitomized this tension. As Robert Elwall put it:

> It would be wrong to regard this awakened interest in popular art simply as a product of whimsical nostalgia. While an acute sense of impending loss undoubtedly acted as a spur, many of the movement's adherents regarded popular art as a living tradition that held important lessons for contemporary design. (Elwall 2007: 18)

While Alloway is known for his pluralism and his ideas about the popular and fine art 'continuum', in fact, others were exploring these concepts in equally pioneering ways.

Using the word 'POP' rather than 'Popular' in her notebook is typical of Jones's ability to capture the essence – in both her writing and design. Her prose revels in the onomatopoeic, in the rhythm of groups of words and the impact of single words. It is no wonder she selected the words *Black Eyes and Lemonade* from a poem by the Irish songwriter and entertainer Thomas Moore (Jones et al. 1951: 6). Indeed, her writing is like her use of line in her design work – bold, to the point, emphatic. Her use of words is like her depiction of them – unequivocal and laid out for emphasis. The exhibition poster encapsulates this, her ability to light on a title that represents the 'bold and fizzy', to select yellow and black, to design two huge eyes and to surround them with an array of jaunty type. Looking at it now, it is easy to imagine that if Jones had had her way she might have called the exhibition *Pop Art* – as it was, she settled on something that captured the essential qualities she wished to explore. As it turned out, it made her project more distinct and enduring.

Notes

1 This quotation is from a typed note by Barbara Jones within the documentation relating to the planning of the exhibition *Black Eyes and Lemonade* held at the Whitechapel Art Gallery (Jones, 1951a).

2 Jones's pocketbook was included in the exhibition *Black Eyes and Lemonade: Curating Popular Art* held at the Whitechapel Gallery, 9 March to 1 September 2013 and curated by Simon Costin, Catherine Moriarty and Nayia Yiakoumaki. This chapter develops research undertaken for the exhibition and for the accompanying publication, C. Moriarty, *Drawing, Writing and Curating: Barbara Jones and the Art of Arrangement*, Whitechapel Gallery, 2013. A section of this chapter was presented with Anne Massey at Wolverhampton Art Gallery in September 2013, and at the 'Who Was This Pop?' conference, Richmond, The American International University in London, November 2013.

3 The Society for Education in Art was an amalgamation of the Art Teachers Guild and the New Society for Art Teachers. In 1984 it merged with the National Society of Art Masters to become the National Society for Education in Art and Design. The NSAE launched the *Journal of Art & Design Education* (now the *International Journal of Art & Design Education*) in 1982 with Henry Moore as its founding patron. Available online: http://www.nsead.org/about/about04.aspx (accessed 24 April 2017).

4 Alloway's article is discussed in relation to the understanding of figureheads as popular art in the article C. Moriarty, 'The Museum Eye Must be Abandoned: Figureheads as Popular Art', *Sculpture Journal*, 24.2 (2015): 229–48.

5 Martin Myron, in his important analysis of the way folk art has abetted 'a complex position-taking' in relation to Modernism and established cultural hierarchies, discusses Jones's appreciation of popular art and offers a more nuanced interpretation of her intentions than those offered by Patrick Wright in 1990 and Jeremy Millar in 2005, see Martin Myrone, 'Instituting English Folk Art', *Visual Culture in Britain* 10.1 (2009): 27–52.

6 When preparing his undergraduate dissertation on the Independent Group in 1977, Peter Karpinski records that Henderson, in response to a mention of *Black Eyes and Lemonade*, commented 'Black Eyes & Lemonade at the W'Chapel. Dinner with Barbara Jones etc. Pearly King jackets! Tom?...'. I am grateful to Anne Massey for sharing this reference.

7 The Arts Council advocated the production of affordable catalogues and early examples produced by the ICA adopted a slim, landscape format, at low cost (Massey and Muir, 2014: 17).

8 Paolozzi's *Still Life with Rose* (August 1950) was auctioned at Bonham's in November 2008. The interesting catalogue entry by Robin Spencer describes the context in which it was made, confirms Paolozzi's address as Holland Road, and discusses his relationship with Terence Conran. http://www.bonhams.com/auctions/15888/lot/97/ (accessed 24 April 2017).

9 The Wellcome Collection holds a copy of the 1931 chart produced by George Philips & Co. I am grateful to Nayia Yiakoumaki for pointing out the use of the image in *Wittgenstein in New York*.

10 Peggy Angus employed the term 'Pop History of Art' as part of her teaching. She produced a chart known as 'Necessity is the Mother of Invention' in which the term is included. She also contributed a short article about the Festival Pleasure Gardens at Battersea to the special issue of *Athene* published to coincide with *Black Eyes and Lemonade*.

11 This loan correspondence numbers 248 items, and relates to exchanges with 83 separate lenders. It is held within the Barbara Jones Archive, University of Brighton Design Archives, BJO/1/1/3.

12 Jones illustrated the publication *This or That* written by Wyndham Gooden and published by the Scottish Committee of the Council of Industrial Design in 1947. She created murals for CoID exhibitions, *Britain Can Make It* (1946), *Design Fair* (1948), and the Seaside Pavilion of the Festival of Britain.

References

Alloway, L. (1951), 'Marine Totems', *Athene: Journal of the Society for Education* in Art, 5 (3): 64.

Alloway, L. (1966), 'The Development of British Pop', in L. Lippard, 1966. *Pop Art*, Reprint 1985, London: Thames & Hudson.

Ambassador Magazine (1951), 'Sophisticated and Unsophisticated', 10: 155–61.

Artmonsky, R. (2008), *A Snapper Up of Unconsidered Trifles: A Tribute to Barbara Jones*, London: Artmonsky Arts.

Atkinson, H. (2011), *The Festival of Britain: A Land and Its People*, London: I.B. Tauris & Co.

Bloomfield, B.C. (1999), 'The Life and Work of Barbara Jones (1912–1978)', *Private Library*, Fifth Series, 2 (3).

Brown, E. and Jones, B. (1945), 'Roundabouts: Demountable Baroque', *Architectural Review*, XCVII, 578 (February): 49–60.

Cotter, H. (2001), 'Douglas Newton, Curator Emeritus at the Metropolitan, Dead at 80', *The New York Times*, [online] 22 September. Available online: < http://www.nytimes.com/2001/09/22/arts/douglas-newton-80-curator-emeritus-at-the-metropolitan.html> (accessed 9 January 2013).

Crow, T. (2014), *The Long March of Pop: Art, Music and Design, 1930–1995* London: Yale.

Curtis, B. (1985/6), 'One Long Continuous Story', *Block*, (11): 48–52.

Elwall, R. (2007), *Evocations of Place. The Photography of Edwin Smith*, London: RIBA/Merrell.

Gooden, H. (2011), *The Lion and the Unicorn: Symbolic Architecture for the Festival of Britain*, 1951, London: Unicorn Press.

Guilding, R. (1999), 'Barbara Jones: Paintings and Drawings', *British Art Journal*, 1 (1): 78.

Hebdige, R. (1981), 'Towards a Cartography of Taste 1935–1962', *Block*, (4): 39–56.

Jones, B. (1946), 'The Rose and Castle', *Architectural Review*, C, 600 (December): 161–8.

Jones, B. (1947), 'Beside the Sea', *Architectural Review*, CI, 606 (June): 205–12.

Jones, B. (1949), 'Funeral Customs', *Architectural Review*, CVI, 636 (December): 385–90.

Jones, B. (1951a), Typed note as part of exhibition planning. Whitechapel Gallery Archive, WAG/EXH/2/17/4. London: Whitechapel Gallery.

Jones, B. (1951b), *The Unsophisticated Arts*, London: Architectural Press.

Jones, B. (1951c), 'Popular Art', *Athene: Journal of the Society for Education in Art*, 5 (3): 45–8.

Jones, B. (1953/4), 'Back Street Decorations', *ARK*, 9: 52–9.

Jones, B., Ingram, T., and Newton, D. (1951), *Black Eyes & Lemonade: A Festival of Britain Exhibition of British Popular Art and Traditional Art, Arranged in Association with the Society for Education in Art and the Arts Council*. Exhibition catalogue, 11 August – 6 October, London: Whitechapel Art Gallery.

Katharine House Gallery (1999), *Barbara Jones: Paintings & Drawings*, catalogue of an exhibition held at Katharine House Gallery, Marlborough, Wiltshire, 3–31 July.

Macdonald, S., (2005), *A Century of Art and Design Education: From Arts and Crafts to Conceptual Art*, Cambridge: Lutterworth.

Massey, A. (1995), *Independent Group: Modernism and Mass Culture in Britain 1945–1959*, Manchester: Manchester University Press.

Massey, A. (2013), *Out of the Ivory Tower: The Independent Group and Popular Culture*, Manchester: Manchester University Press.

Massey, A. and Muir, G. (2014), *Institute of Contemporary Arts 1946–1968*, London: ICA.

Massey, A. and Sparke, P. (1985), 'The Myth of the Independent Group' *Block*, (10): 48–56.

Millar, J. (2005), 'Poets of Their Own Affairs' in Deller, J. and Kane, A., *Folk Archive: Contemporary Popular Art from the UK*, 149–53, London: Bookworks.

Moriarty, C. (2013), *Drawing, Writing and Curating: Barbara Jones and the Art of Arrangement*, London: Whitechapel Gallery.

Myrone, M. (2009), 'Instituting English Folk Art', *Visual Culture in Britain* 10 (1): 27–52.

Palmer, A. (ed.) (1947), *Recording Britain Essex, Suffolk, Cambridgeshire and Huntingdonshire, Northamptonshire and Rutlandshire, Norfolk, Yorkshire*, Oxford: Oxford University Press.

Russell, J. (2014), *Peggy Angus: Designer, Teacher, Painter*. Woodbridge: Antique Collectors Club.

Saunders, G. (2011), *Recording Britain*. London: V&A Publishing.

Scrutton, T.H. (1950), Note of phone conversation. [manuscript] Whitechapel Gallery Archive, WAG/EXH/2/17/4, London: Whitechapel Gallery.

Stonard, J. (2007), 'Pop in the Age of Boom: Richard Hamilton's "Just what is it that makes today's homes so different, so appealing?"', *The Burlington Magazine*, 149 (1254): 607–20.

Stonard, J. (2008), 'The "Bunk" Collages of Eduardo Paolozzi', *The Burlington Magazine*, 150 (1261): 238–49.

Thistlewood, D. (1992), *Histories of Art and Design Education: Cole to Coldstream*, Burnt Mill, Harlow, Essex, England: Longman in association with the National Society for Education in Art and Design.

Tickner, L. (2012), '"Export Britain": Pop Art, Mass Culture and the Export Drive', *Art History*, 35 (2): 394–419.

Walsh, V. (2001), *Nigel Henderson: Parallel of Life and Art*, London: Thames & Hudson.

Whiteley, G. (2013), 'Kitsch as Cultural Capital: Black Eyes and Lemonade and Populist Aesthetics in Fifties Britain', in M Kjellman-Chapin (ed), *Kitsch: History, Theory, Practice*, Newcastle upon Tyne: Cambridge Scholars Press.

Whiteley, N. (1987), *Pop Design: Modernism to Mod*, London: Design Council.

Williams, K. and Davies, R. (1993), *The Kenneth Williams diaries*, London: HarperCollins.

Wright, P. (1990), 'Revival or Ruin? The Recording Britain Scheme Fifty Years After' in Mellor, D., Saunders, G. and Wright P., *Recording Britain: A Pictorial Domesday of Pre-War Britain*, Newton Abbot and London: David & Charles.

Cecil Beaton, Richard Hamilton and the Queer, Transatlantic Origins of Pop Art

Dominic Janes

I met my baby in Macy's in Gentlemen's Underwear
I met my baby in Macy's and that's where I learned to care
We looked at a cottage on the Mezzanine
With a toaster and an iron and a washing machine
I met my baby in Macy's in Gentlemen's Underwear.
(Dorsey undated)

The lyrics of 'I Met My Baby in Macy's', recorded by Tommy Dorsey and his Orchestra in 1947, testify to the claims of mid-twentieth-century retail to be able to provide a man with everything he needed for a great relationship. It also testifies to the realization that those claims were fake, because his 'baby' does not return his love and he returns her to 'one of those clothing trees, between the men's cologne and the BVDs'. The woman is reduced to the status of a masculine accessory. But why is this feminine object to be found in the men's underwear department of Macy's store, near the piles of Bradley, Voorhees and Day briefs? And is this 'baby' necessarily a woman at all? After all, 'she' is put back onto a stand of men's clothing. The world of interwar American retail was seemingly designed to suit heterosexual individuals and couples who wished to bring up a family. However, there was always the possibility that individuals of different sexual tastes might shop for a selection of items, which would acquire new and possibly subversive meanings through juxtaposition with one another. This article concerns the way in which such practices fed into the development of Pop Art.

Just What Is It That Makes Today's Homes So Different, So Appealing? has become famous as a source for Pop. It was produced by Richard Hamilton (1922–2011) as part of his collaboration on the *This is Tomorrow* exhibition, which was held at the Whitechapel Art Gallery in London in 1956. The original collage, now in the Kunsthalle Tübingen, originally appeared at this time only in black-and-white reproductions. It was not, in fact, until several years later that it began to be hailed as an artwork in its own right. Therefore, it is important to think about this work in its original role as a promotional image. A deeper understanding of this piece can be

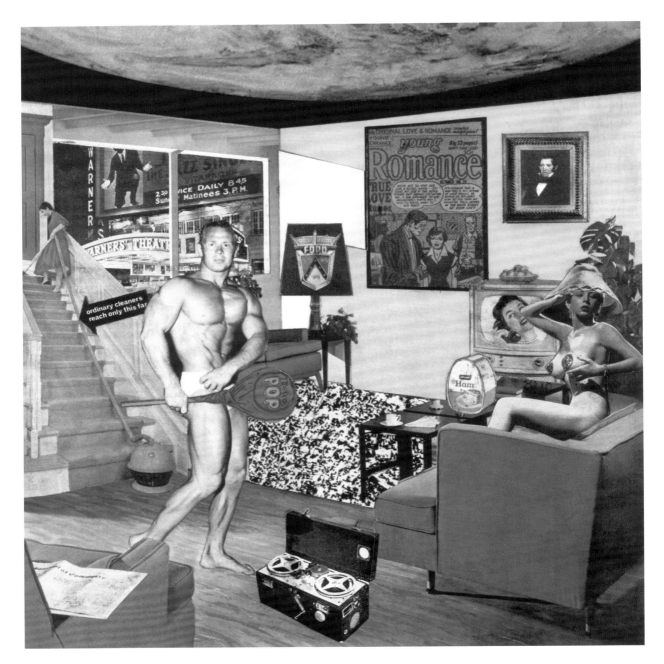

2.1

Richard Hamilton, *Just What Is It That Makes Today's Homes So Different, So Appealing?*, 1956, collage, 26 × 25 cm, Kunsthalle Tübingen, Sammlung Zundel, © R. Hamilton. All rights reserved, DACS 2015.

achieved by contextualizing it within the visual culture not only of the time of its production, but also of its sources of inspiration. In this article I will be looking at a selection of drawings and collages made by the celebrity photographer Cecil Beaton (1904–1980), which focus on many of the same images and reflect related interests in American consumer culture and queer forms of sexual desire. Many of these works were widely circulated in books and they may, thus, have provided direct inspiration for the work of Hamilton and his colleagues. However, even if that cannot be proved it will be argued that they provide evidence of a characteristically British, transatlantic viewpoint that combined irony and appreciation of camp.

A key subject of Hamilton's original collage was consumerism and the American aesthetics of plenty in contradistinction to British rationing (Alloway 1990: 52). If not exactly a direct satire, it problematized the truth claims of the supersaturated imagery of modernity (Hornsey 2010: 248). It was also about British dreams of the future. Looking back in 1987, in connection with a reprise of the exhibition which this collage was used to publicize, Hamilton commented that 'the cabinet of Dr. Voelcker was taking off, filled with brash ephemera, to other planets; a cultural spaceship going who knows where' (Hamilton 1990: 188). He was referring to the 'group two' section of the *This is Tomorrow* exhibition, which he presented together with John Voelcker and John McHale. American popular culture in general and science fiction in particular provided key source materials for these members of the Independent Group, which had formed at the Institute of Contemporary Arts, London, in 1952 (Whitham 1990: 62). These artists noticed American popular culture because it was, to them, foreign and exotic, rather than boringly mundane (Alloway 1966: 28). It was in these circumstances that Pop Art began before it broke through in the USA in the 1960s.

The immediate inspiration for *Just What Is It* appears to have derived from the work of a fellow member of the Independent Group, Eduardo Paolozzi (1924–2005) (Foster 2003; Robbins 1990). When living in Paris after the war Paolozzi compiled his collage book *Psychological Atlas*, having rediscovered what Stonard has referred to as the 'relics of the pre-war Dada and Surrealist movement': 'the psychology Paolozzi surveys in his collage book is that of popular imagery: robots, animals, landscapes, bodybuilders, politicians, ethnographic images, industrial architecture, film stars, and the whole assortment of sensational or exotic material to be found in illustrated newspapers' (Stonard 2011: 51). It was then in his *Bunk!* collages (originally untitled works made in Paris and London between 1947 and 1952) that he moved to incorporate more images from American consumer culture. The word 'pop' first appeared in Paolozzi's *I Was a Rich Man's Plaything* (1947), shown fired from a cut-out image of a gun (Hebdige 1995: 104). These early works were, it is important to stress, not made as public art: rather, 'it was a private language, something to be shown to friends who shared his enthusiasm for low-brow illustrations, for things like comics and soft porn'

Eduardo Paolozzi *Evadne in Green Dimension*, 1952, collage, 30 × 26 cm, © Victoria and Albert Museum, London, CIRC 708–1971 and © the Estate of Eduardo Paolozzi. All rights reserved DACS 2016.

(Myers 2000: 68). He did, however, show many of these in a visual lecture that acted as one of the founding events of the Independent Group at the ICA, although 'there is little indication that Paolozzi was acknowledged or that anyone [outside the group] realized the importance of the *Bunk!* collages for at least another twenty years' (Stonard 2008: 244). It is notable that even today some of these works are classified in contemporary collections as art, whilst others are filed under prints and drawings and yet others are kept in archives.

The collective name of Paolozzi's collages derives from the most well-known example from the set, dating from 1952, which was given the title *Evadne in Green Dimension* in 1972. This references Paolozzi's throwing away of the reproduction of a work with this title by Jack Bilbo whilst retaining the title and the rest of the page. The word 'bunk(um)' most likely references the American industrialist Henry Ford's (in)famous dictum that 'history is bunk'. Paolozzi's collage features the bodybuilder Charles Atlas lifting up a car. This parallels *Just What Is It*, but in the earlier work the counterpart female pin-up is reduced in size and positioned in what appears to be a bladder adjacent to a diagrammatical erect penis. It is as though the bodybuilder as sexualized object is just about to piss her out of the left side of the frame. But this, as I will go on to argue, is far from the only potentially queer aspect of the backstory to Hamilton's collage of 1956.

The role of same-sex desire in the American pop art of the 1960s has increasingly been acknowledged, above all in relation to the work of Andy Warhol (Doyle, Flatley and Muños 1996: 106–35; Glick 2009: 133–60). George Chauncey has explained how a proto-gay commercial culture that had flourished in interwar New York faced a less congenial cultural environment in the context of Cold War suspicion towards the supposed links between communists and homosexuals (Chauncey 1994). Simon Watney has commented that some closeted homosexuals gave Warhol a cold shoulder in the 1950s because 'he was too "swishy", too much of a window dresser' (Watney 1996: 25; Loftin 2007: 587). Warhol created unease at this time through his willingness to take up what was often posited as the feminized position of the consumer gaze, to look seriously at advertising, and think about what he needed for the house. There was good reason to fear homophobic reactions to such an artistic agenda. Sara Doris has noted that 'the association of pop art and camp was studiously avoided in the art-critical press' prior to the (by no means entirely positive) comments of Susan Sontag in 1964 on camp, though there was much critical innuendo that suggests that its potential for queerness was recognized (Doris undated: 151–2; Thomas 1999: 989; Richardson 1966; Sontag 2004). Yet if the work of Warhol and his friends queered the idea of modern art, as Gavin Butt has argued, their ability to achieve this was based on the prior incorporation of related material into earlier British works of what might be termed proto-Pop (Butt 2004: 317).

Lawrence Alloway had, in effect, already queered the birth of Pop Art for those in the know by writing in *The Listener* in 1962 that its story 'begins

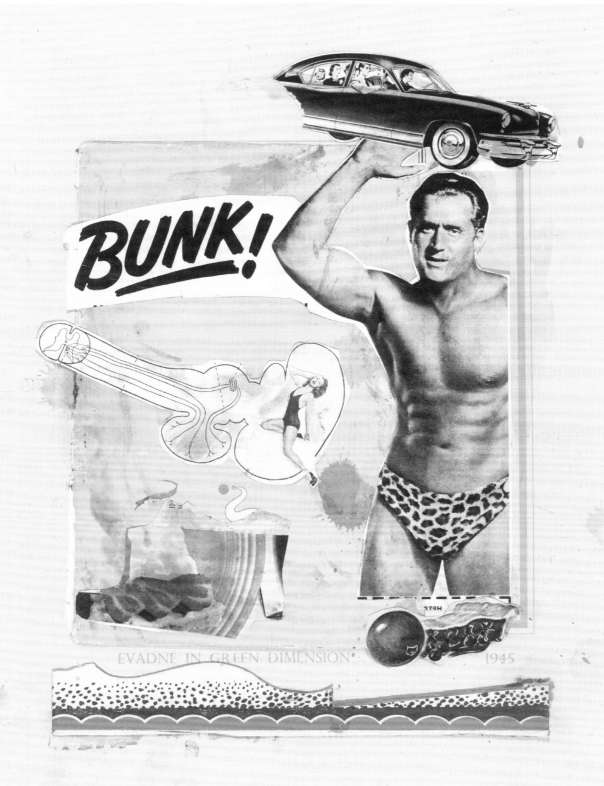

BUNK!

EVADNE IN GREEN DIMENSION 1945

in London about 1949 with work by Francis Bacon' (Alloway 1962: 1085). He was referring to the show that year of Bacon's work at the Hanover Gallery and his argument was based primarily on the painter's use of photographs as source material, something that was seen as remarkable at the time (Hammer 2014: 70). Heavy hints about Bacon's sexual tastes were dropped by Sam Hunter in an article that appeared in the (American) *Magazine of Art* in January 1952 (Hunter 1952: 11,15). Paolozzi would also have been aware of Bacon's sexual tastes, since he often went drinking with him in the post-war period after being impressed on first seeing his work in 1946 (Spencer 2000: 16). In 1954 Bacon was to have a one-man show at the ICA at the time when Alloway was the assistant director there. John McHale was credited with the hang of the show (Hammer 2014: 75). This is not to say that Bacon produced Pop Art, but he did share interests in 'transparency, the erotic, the representation of movement, and the peopling of enclosed space' with members of the Independent Group (Morphet 1970: 14). His work, like theirs, was influenced by popular media and surrealism (he had tried unsuccessfully to be included in the International Surrealist Exhibition in London in 1936) (Cowling 1997: 83–4). Thus, if Hamilton himself was essentially heterosexual, he still worked in the context of artistic peers who were either homosexual themselves or were open to considering queer artistic viewpoints.

However, the idea that some, at least, of Richard Hamilton's Pop Art is queer in itself has recently been proposed by Jonathan Katz. The core of his argument concerns a series of works which explore interlocking forms that blur the boundary between human and machine, penetrator and penetrated. Katz argues that *Just What Is It* also contains queer valences in so far as the figures referred to by Hamilton as 'Adam' and 'Eve' (the bodybuilder and the glamour model) are presented as artificially excessive performances of masculinity and femininity (Katz 2012: 142). The result is that gender, and by implication sexuality, is denaturalized into an artificial performance and the culturally constructed nature of domestic life is revealed. Moreover, the bodies of both the man and the woman are presented as objects of desire in a landscape of fetishized consumer culture that blurs the boundaries between public self-presentation and private space (Katz 2012: 340). The effect of this is to challenge the literal reading of men and women's bodies as naturally distinct and to present them in a continuum of objects open to the gaze of the consumer of unspecified gender. But this, I will go on to argue, was not new in British visual culture, but in fact reflects engagement with practices of transatlantic viewing that were prominent in the interwar period.

Cecil Beaton's New York

Cecil Beaton was one of the greatest society photographers of the twentieth century. He came from middle-class British origins and was, in the language of his time, a flamboyant homosexual. His early work draws on art traditions, notably surrealism, that were themselves influenced by forms of popular visual culture, particularly those deriving from the USA. Beaton first visited New York in 1928 and went back regularly to work and socialize (Albrecht 2011: 13). David Banash has argued that 'the technique of bringing together disparate images and texts into an abstract field is a staple of advertising that predates the avant-garde significantly' (Banash 2004: para 25). Montage as a photographic technique dates almost from the establishment of the medium in the mid-nineteenth century and practices of cut and paste were in widespread use in the first half of the twentieth century. In addition, it is important to appreciate that the aspect of Pop Art that involved cross-readings between European high art and American popular culture was present in a proportion of Dadaist work and interwar continental collage. For instance, the scrapbooks and collages of Beaton, like those of Paolozzi, bear comparison with the 1934 scrapbook of German artist Hannah Höch, which was filled with cut-outs from photographs representing what in her home country was referred to as 'Amerikanismus' (Johnson 2006).

Whilst the cut-up became a central practice of surrealism, the overt homophobia of André Breton has resulted in this movement's being seen as something of a preserve of 'straight' men. However, this elides the role of Marcel Duchamp, who was not homosexual but is now understood to have been in close contact with, and been heavily inspired by, the queer culture of New York and Paris in the first half of the twentieth century. This can be seen, for instance, in his creation of a drag alter ego, Rrose Sélavy (Harvey 2006: 84; Franklin 2000). John McHale was in the process of assembling the magazines and other materials from which some of the images in *Just What Is It* were cut when he met Duchamp at Yale (Massey 2013: 59). The other images were from magazines owned by Magda and Frank Cordell and were cut out by Magda and Hamilton's wife, Terry O'Reilly. Hamilton was involved in thinking about the work of Duchamp throughout the 1950s, having been introduced in 1952 to the Green Box notes for the design and construction of *The Bride Stripped Bare by Her Bachelors, Even* (1915–23). Indeed, it has been suggested that he 'found his voice through Duchamp' (Schimmel 2014: 17). Paolozzi, when asked (in an interview with Alvin Boyarsky in May 1984) where the use of collage in Pop Art had come from, replied that it had come straight from the surrealists (Spencer 2000: 315). It is thus notable that strikingly similar image juxtapositions can be found in surrealist-influenced, interwar collages – some of which were published in bestselling books – made by Cecil Beaton (Gibson 2003: 54; Pepper 2004: 12; Francis 2006: 99–100; Walker 2007: 149–51).

At the time when Duchamp was disgusting the worthies of New York by presenting a urinal, evocative to those in the queer subculture of

2.3

Cecil Beaton's Scrapbook, c. 1936,
reproduced courtesy of the Cecil Beaton
Studio Archive, Sotheby's, London.

'cottaging' (seeking sex in public toilets), as art, similarly transgressive
values had found a prominent commercial niche in the pages of American
Vogue. In particular, the work of Baron Adolph de Meyer, who worked
at *Vogue* from 1913 to 1922 and made abundant use of 'affective excess'
(one might just as effectively say 'camp'), collided European aristocratic
decadence with American commercial amorality. The results were much
admired by Beaton and inspired him when he began his work with the
magazine (Brown 2009: 254). What Christopher Reed has called the
'amusing style' of British *Vogue*, one that relished witty subversion of
old gender norms as evidence of being bang up to date, was fostered by
Dorothy Todd, a lesbian who was the magazine's editor from 1923 to 1926
(Reed 2006b: 396). It was quite in keeping with the tone of the publication
that Beaton's first contribution featured cross-dressed Cambridge
undergraduates (himself included) putting on John Webster's *The
Duchess of Malfi* in April 1924 (Reed 2006b: 401 n.38). Amusing the style
may have been, but its influence was considerable, since it propagated
the notion that it was stylish to be seen as 'destabilising institutionally
sanctioned hierarchies' (Reed 2006a: 59) to the extent that it has been
read as having offered tutorials in 'queer perception' (Reed 2006b: 378;
Cohen 1999: 151).

Cecil Beaton, like Höch and Paolozzi, was an ardent creator of
scrapbooks. Two main sets of these survive; one held at the Victoria and

Albert Museum, London, which consists substantially of press cuttings concerning his own career, and another held in the Cecil Beaton Studio Archives at Sotheby's, London, which includes vast numbers of photographic montages.[1] Beaton also created collages as items for public perusal, as in 1937 when *Cecil Beaton's Scrapbook* was published to a fanfare of publicity on both sides of the Atlantic. The popular excitement about this book was largely down to his inclusion of sensational articles concerning the private lives of film stars that he had photographed, and these were widely syndicated in the press. Beaton's enthusiasm for living and working in the USA in the 1930s may have been fostered by the greater financial rewards available there, but also by the increasingly conservative tone of British periodicals. Magazines for women became notably less flamboyant and those few that were aimed at men courted the pink reader in the most mildly 'amusing' of ways. *Men Only*, for instance, on the one hand tried to stress its straight credentials whilst, on the other, featuring the occasional slightly racy cartoon of the young pansy about town (Bengry 2009).

The 1937 *Scrapbook* includes a drawing by Beaton, *New York Impressions*, the original of which is now in the National Portrait Gallery in London and which bears direct comparison with Hamilton's *Just What Is It*. The photographic materials from which *New York Impressions* was constructed can be seen pasted into one of the Sotheby's volumes. In the midst of a cloud of references to jazz, brand names and consumer luxuries, the posing figures of an underwear model (wearing Bradley, Voorhees and Day underwear as sold at Macy's department store), a heavily muscled prizefighter and Mae West, in pretty much the pose of Hamilton's 'Eve', embody the fleshly delights of New York (Beaton 1937: 65). What is being evoked here is a dream world in which 'every imaginable appetite can be satisfied instantly', with the application, of course, of sufficient funds (Smith 1990: 31). That this is not simply a celebration of conventional gender values is apparent from the fact that the figure of neither the fighter nor of Mae West was, by any means, a typical embodiment of American domesticity. If Mae West's stage role was to function as a sultry odalisque, her act was honed within the queer culture of the 1920s, as can be seen from her plays *The Drag* (1927) and *The Pleasure Man* (1928). The latter work queers the connections between the jazz performance of Al Jolson and fellatio with such lines as 'Oh, I get down on my knees – and sing a couple of Mammy songs ... you see I'm a character imperson-eater' (Reay 2010: 148). Not only does Hamilton similarly pair a muscled man and a female glamour pin-up but he also implies the artificiality of such performances. For example, impersonation and supplication is on offer at the theatre across the dark street in Hamilton's 1956 collage. The link between the black-face jazz singer and the camp homosexual as performers for the entertainment of the straights was, moreover, recognized by John Richardson, who was one of the first critics to draw attention, as early as 1966, to the links between, as he titled an essay, 'Dada, Camp and the Mode called Pop' (Richardson 1966: 549).

In addition to possessing a queer eye for gendered performance, Beaton also took a related interest in fashion and consumer culture. Since the time of the First World War, some American retail outlets had been touting, if tacitly, for the dollars of the queer consumer (Bronski 2011: 140). Coded references began to appear in marketing in the form of advertisements that 'exemplify the workings of the open secret in ways that attract attention and suggest daring sophistication by allusions to the taboo, without affirming – or even explicitly acknowledging – homosexuality' (Reed 2001: 145; Branchik 2007; Lears 1994). Of particular prominence was the work of J. C. Leyendecker, whose artwork for the Klosed Krotch Kenosha in 1914 featured in the first national print advertisements for men's underwear in the USA (Cole 2010: 65). In his creation of the famous 'Arrow Collar' man he was simply painting his life partner, Charles A. Beach (Cutler and Cutler 2008: 14; Joffe 2007: 39–51). Carole Turbin has pointed out that shirts, to which stiff collars were attached, were treated as undergarments in the nineteenth century. The soft, integral Arrow Collar was more comfortable, but for that very reason was considered by some to be unmanly. Leyendecker's imagery, by contrast, advanced an image of comfort and ease as an attribute of modern manliness as embodied by the 'white collar' worker (Turbin 2002: 471, 482, 488). Such men displayed their masculinity through the forms of their muscular bodies and were thus unafraid to appear in what their forefathers would have thought of as indecorous states of undress.

Many of the other brands included in Beaton's drawing were directly involved in these processes. John Wanamaker was a pioneer of retailing and marketing techniques and, in particular, brought in the practice of displaying underwear by piling it up on tables (Bradley 1998: 27). Coded homoeroticism was used by Bradley, Voorhees and Day to sell their BVD brand of underwear. In 1929, the Olympic swimmer Johnny Weissmuller, who went on to play Tarzan, was hired by the company to model the BVD brand of swimsuits (Joffe 2007: 61–72). This actor was also, it should be noted, the subject of a particularly smouldering set of images by Beaton taken on a film set in 1932. The use of overt sex appeal to sell men's garments was much more prominent in the USA than it was in Britain. It is, therefore, perhaps not surprising that the world of American consumer culture was eroticized by a proportion of British homosexuals, as Dennis Houlsworth recounted in relation to Y-fronts in the Brighton oral history project 'Daring Hearts': 'I thought [they] were ever so outrageous. I'd seen them advertised in American magazines, because they came over from America. Apart from that all you had was horrible flannel things' (Dennis 1992: 52). He was speaking with reference to the years after the Second World War, but there had, in fact, been a limited degree of tacit appeal to the queer consumer of men's underwear in Britain in the 1930s. The style by which this was conveyed in British advertising relied, however, more on camp inflection than overt eroticism (Jobling 2005: 127).

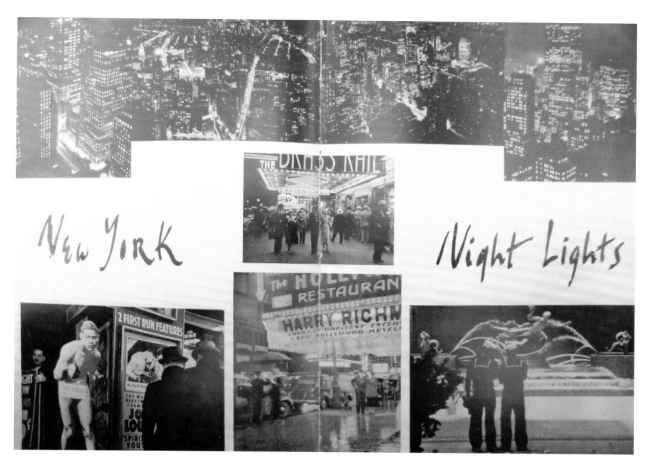

Although *New York Impressions* is a drawing with only minor elements of
collage, its composition has clearly been the result of thinking with the forms
and results of montage. This technique offers the opportunity to use strategic
juxtaposition to change the meaning of individual components of the image.
The effect of this is that, in both this drawing and *Just What Is It*, the muscled
man in his underwear becomes an object of the desiring and consuming
gaze. Moreover, the specific homoeroticism of Beaton's presentation of New
York (despite the depiction of a woman in the scene, albeit a woman who was
well known as an impersonator of a man impersonating a woman) is clear
by comparing this drawing with the photographic spread *New York Night
Lights* that appeared in another book, *Cecil Beaton's New York* of 1938 (Beaton
1938: 16–17). In this spread our gaze is directed away from the lights into the
darkness of the city's streets where men stand in pairs looking at the bodies
of other men. Two figures consider advertisements for a boxing match and two
sailors, their arms lightly touching, stare at a nude, male sculpture that is part
of a fountain. This latter work is Paul Manship's *Prometheus* (1934), which was
installed in the Rockefeller Center in Manhattan, but its juxtaposition in this
spread leaves the viewer assuming that it is placed somewhere out in a park.
That there was something specifically homosexual about this presentation of

2.4

Cecil Beaton, 'New York Night Lights', in
Cecil Beaton's New York, published 1938,
116–17, reproduced courtesy of the Cecil
Beaton Studio Archive, Sotheby's, London.

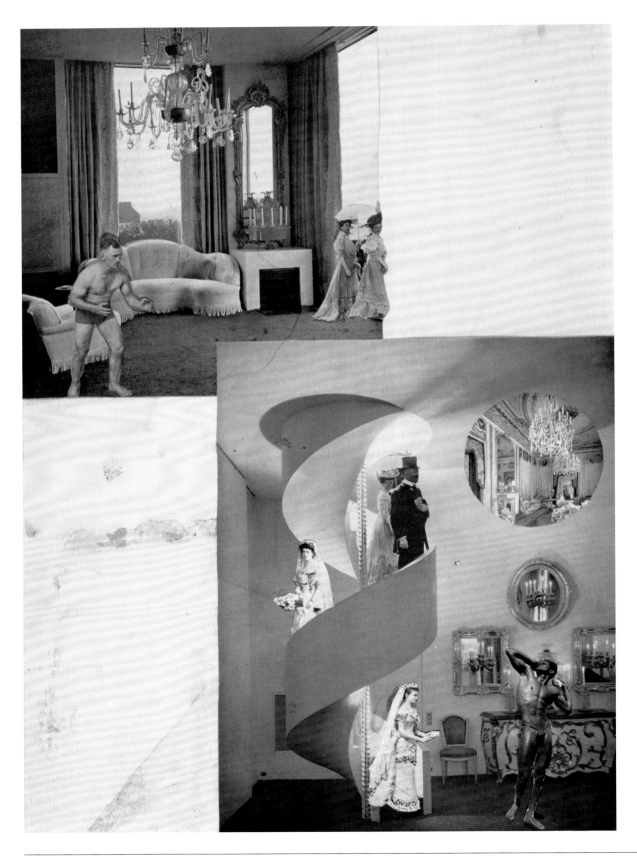

the city is implied by the fact that Charles Henri Ford, whose name appears in *New York Impressions*, was thanked by Beaton for 'his enthusiasm on sightseeing expeditions' (Beaton 1938: vii). Ford, co-author of the scandalous, queer novel *The Young and Evil* (1933), was one of the most controversial creative figures in New York at this time (Howard 2011: 100). It is in this context that we can understand the sexual significance of Beaton's statement that the city could provide 'everything a bride could desire' (Beaton 1938: 133). The darkened streets of the city in *Just What Is It*, therefore, imply possibilities of sexual fulfilment even beyond those available in Hamilton's excessive domestic interior.

There is one further way in which Hamilton's 1956 collage appears to reflect Beaton's significantly earlier queer and camp interests. The portrait of a man in nineteenth-century dress stands out amidst the signs of modernity on the back wall of the room in *Just What Is It*. This provides a similar stylistic jolt, albeit one delivered with considerably more subtlety, to that found in Beaton's collage, *Brides, Bodybuilders, and Ladies in Edwardian Dress, and a Gentleman in the Apartment of Monsieur Charles de Beistegui* (c. 1939). This was included in a set of photographs purchased by the Victoria and Albert Museum and was clearly intended as an artwork in itself. The apartment depicted in this work had originally been designed by Le Corbusier, who had once talked of the 'abominable little perversion' of ornate decoration (Le Corbusier 1987: 90). The flamboyant, unmarried and sexually indeterminate De Beistegui then perversely filled it with baroque furniture. Beaton, in his reproduction, added a selection of Edwardians, a wrestler and a posing bodybuilder (Lord and Meyer 2013: 96).

By juxtaposing very overdressed, outdated figures with very underdressed, contemporary counterparts, Beaton made both of these states seem queerly excessive (Ellenzweig 1997: 66; Tamagne 2006: 252). Feminine presence, in this imaginative construct, constitutes an alibi of supposed heterosexuality that in turn allows the secret enjoyment of homoeroticism. Yet masculine display is also effeminized in this collage by its material culture context. The same imaginative process can be seen at work in the writings that accompanied Beaton's photographs of movie stars in works such as his *Scrapbook*: for instance, we hear that Gary Cooper 'with agate eyes, huge shoulders, hairy chest, flat cardboard flanks' was soon found with 'greasepaint covering his Adam's apple', and learn that where once he had been a naïve young boy getting up early to work in the cattle ranches, 'maybe he now lies late in the large bed of apricot pink crushed velvet' (Beaton 1937: 34). The camp aesthetic here was the same as that displayed in Beaton's *faux* memoir *My Royal Past* (1939), in which he photographed a selection of his friends cross-dressed. The homosexual art collector Peter Watson, with whom Beaton had long been infatuated, said of this volume that 'it is in fact a masterstroke even to see the book with its sinister undercurrents of sex, perversions, crass stupidities and general dirt, beaming severely from Maggs Bookshop in Berkeley Square' (Clark

2.5

Cecil Beaton, *Brides, Bodybuilders, and Ladies in Edwardian Dress, and a Gentleman in the Apartment of Monsieur Charles de Beistegui*, c.1939, collage in scrapbook, 42 × 31 cm, © Victoria and Albert Museum, London, PH.195–1977, X980 box A, 2006 BC4971 and reproduced courtesy of the Cecil Beaton Studio Archive, Sotheby's, London.

and Dronfield 2015: 45–9; Vickers 1985: 231).[2] Watson was also to play a key post-war role as the patron of a number of homosexual artists, including Francis Bacon. He also supported Toni del Renzo, who together with Paolozzi's wife Freda, put on the *Tomorrow's Furniture* exhibition at the ICA in 1952 (Massey 2013: 46–7).

A further underlying, subversive implication of *Just What Is It* was not simply that yesterday's fashions were distinctly campy and amusing but that those of tomorrow would be no less so. Richard Hornsey has argued in connection with Hamilton's *Just What Is It* that 'now irrevocably infiltrated by the dynamics of consumerism, the contemporary home has become the setting for a much queerer – and profoundly urban – mode of domestic performance' (Hornsey 2010: 248). This may have been so in New York but the images arranged by Hamilton were of items that were 'not readily available in London' (Massey 2013: 58). American muscle had been alien and spectacular to food-rationed Brits. In wartime, the USA had signified not simply foreign prosperity but also erotic potential, as in the phrase used of American GIs in Britain, 'overpaid, oversexed and over here'. Thus, in the recollections of Quentin Crisp the bodies of US soldiers 'bulged through every straining khaki fibre toward our feverish hands … Never in the history of sex was so much offered to so many by so few' (Crisp 1968: 152). The muscled male as the man of the future was prominently promoted by American science-fiction periodicals of the time, such as *Astounding Science Fiction* (founded in 1930 as Astounding Stories), which provided source material for some of Paolozzi's *Bunk!* collages (Stonard 2008: 243 fig.32; Campbell 1947: 138; Curcio 2000: 624, 658; Sherman 1940).

The possession and depiction of heroic muscularity was, it can be argued, a practice that always involved a degree of sexualization. For example, one could pay to touch the body of Eugen Sandow who, from being a circus strongman, moved in 1897 to open his Institute for Physical Culture in London. If his public message was one of manly development through the cultivation of health and strength, this did not stop photographs of him circulating as items of erotica. A variety of interwar bodybuilding publications on both sides of the Atlantic catered, if tacitly, to a minority market of queer men. But, around 1950, a new phenomenon appeared in the USA: the physique magazine that overtly presented men as objects of aesthetic appreciation (Lahti 1998: 191; Bronski 2011: 137, 145, 150). The most famous of these was *Physique Pictorial*, but there were a number of others, such as *Adonis* and *Tomorrow's Man*, which often employed poses derived from classical Greek art so as to disguise erotic intent (Bronski 2011: 150; Massengil 2010: 128–9, 164; Richlin 2005; Wyke 1999). These magazines, apart from functioning as soft porn, can be understood as providing homosexuals with examples of masculine deportment or, more subversively, of ways in which to appear both queer and masculine (Loftin 2007: 585). The magazine collections from which the images for *Just What Is It* were cut must have contained at least one of these physique magazines, because the

bodybuilder in the resulting collage has been identified as Irwin Koszewski posed in a 1954 edition of *Tomorrow's Man* as 'the cream of the crop' (Stonard 2007: 618–19 and fig. 28).

The 1950s were a time when, as Simon Ofield has commented in his discussion of the ambiguous scene of sex and/or wrestling that is shown in Francis Bacon's *Two Figures* (1953), 'the comportments of masculinity and the sites of representation, interpretation and encounter had just begun to be identified with a recognisable community of men with shared social, sexual, commercial and aesthetic interests' (Ofield 2001: 130). But it was in a similar context and with similar homoerotic intent that Beaton had already used collage to reinscribe the meanings of images of wrestlers and bodybuilders in the 1930s. He also juxtaposed hyper-masculinity with over-the-top femininity and so evoked the notion of gender performativity by hunks and divas alike (Dyer 1987: 178–86). The result was a depiction of the fashionable, urban body as 'fancy dress, as drag, as melodrama' (Snaith 2003: 83). These visual practices also involved the queer appreciation of the female film star, in Beaton's case Mae West, via the phenomenon of diva-worship. Thus, as with his sometime passion for Greta Garbo it was not quite clear whether Beaton wanted to possess the diva, or take her place (Farmer 2005). To be tomorrow's man in such a world was, by implication, to be queer. Whilst the legal situation meant that Beaton had to live partly in the closet, he was able to hint at his sexual tastes through the use of bricolages of images (Albrecht 2011: 16). Nonetheless, it is important to stress that, just as I have presented Beaton's work as a contextual case study which helps us to understand Hamilton's 1956 collage, so this earlier set of materials can itself be situated within the wider visual culture of its times. Beaton did not invent the queer, eroticized viewing of the muscular male nor pioneer camp performativity (Brady 2014). However, he did exaggerate latent, queer qualities in contemporary American popular culture in a number of his works in ways which prefigure many of the themes and preoccupations of Hamilton's collage of 1956.

Just What Was It That Made American Homes So Different, So Appealing?

The USA was widely imagined in twentieth-century Europe as a place of youthful, masculine energy (Hearn and Melechi 1992: 220). Furthermore, the queer appeal of post-war American culture was, according to the artist and film director Derek Jarman, apparent to many of the British post-war generation. Writing in the first volume of his autobiographical writings, *Dancing Ledge* (1991), he commented that 'growing up in the 1950s we dreamed the American dream. England was grey and sober. The war had entrenched all the virtues – Sobriety and Thrift ... Over the Atlantic lay the land of cockaigne: they had fridges and cars, TVs and supermarkets. All bigger and better than ours... Hamilton... realised the dream with the cunning of an ad-man and invented Pop' (Jarman 1984: 60). Jarman referenced the impact that was made on him as an art student by Hamilton's *Just What Is It* by reproducing it in his own book. It is easy to understand that the presence of a handsome male bodybuilder and a tackily camp 'glamour' girl in Hamilton's work may have inspired Jarman to appropriate this collage and incorporate it into his own queer narrative. But it is also clear that the USA represented opportunity, including sexual opportunity, for several generations of British homosexuals who both admired and patronized its culture (Linkof 2012: para 14). *Just What Is It* can, therefore, be read as being a work that engaged with consumerism and the body by drawing on themes that had preoccupied various men who sought sex with men since earlier in the twentieth century. But was that simply an inadvertent result of the collage's complex process of construction? I would argue that it was not.

When Hamilton reworked this piece in 1993–4 he can be argued to have produced a more overtly queer version of the collage through the replacement of the male bodybuilder with a female one and his inclusion on one wall of *AIDS*, an artwork produced in 1988 by the Canadian artists, General Idea (Hamilton 2006: 17; Manchester 2007). Moreover, something similar took place when he produced a reworked version of the *Cinemascope* mural that was also included in the 1956 *This is Tomorrow* exhibition. In *Technicolor*, the later, retitled version produced for the opening of the Clocktower Gallery in New York in 1987 as part of the exhibition *This is Tomorrow Today: The Independent Group and British Pop*, Hamilton partially replaced his earlier landscape of Hollywood divas with a giant image of Kirk Douglas kissing another man, and of Moses holding the tablets of the law (a reference to Christian condemnation of gay sex in an age of panic concerning HIV) (Leffingwell 1988).[3] Seen in this light the single, silhouetted figure of a man in the top left-hand corner of the 1956 piece takes us back to the world of Beaton's *New York Night Lights*.

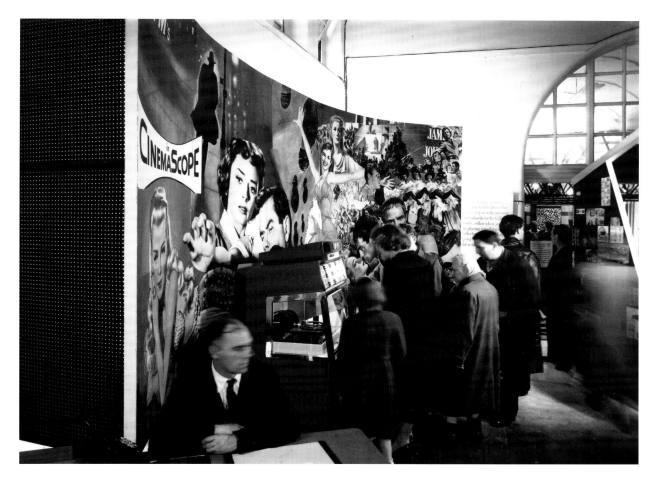

2.6

Richard Hamilton, *Cinemascope*, 1956,
collage screen of the Group 2 exhibit,
'This is Tomorrow' exhibition, Whitechapel
Art Gallery, London, © John Maltby/RIBA
Library Photographs Collection and
© R. Hamilton. All rights reserved,
DACS 2016.

Therefore, what Hamilton presents in *Just What Is It* can indeed be viewed as 'a parody of an idealized, presumptively heterosexual, pair of inhabitants – one from a "beefcake," the other a "cheesecake" magazine' (Butt 2006: 34). But this was not a work that simply mocked its subjects even as it appears to 'communicate the slightly arch, detached, possibly even ironic perspective of the knowing consumer' (Philo and Campbell 2004: 286). The post-war UK was to become a place in which the consumer market increasingly positioned the male body as a site of consumer desire. Hamilton appears to have shared an interest with many British homosexuals of the time in American men's underwear, as can be seen from such works as *Towards a Definitive Statement on the Coming Trends in Men's Wear and Accessories – Adonis in Y-Fronts* (1962–3). To some critics such preoccupations merely show that Hamilton was interested in critiquing commercial culture in some general sense (Maharaj 1992: 41–3). To others his main concern was to reveal linkages between consumption and its abject twin excretion (and thus with anality), such as appear in later pieces including *Soft Pink Landscape* (1980), a work that was inspired by marketing

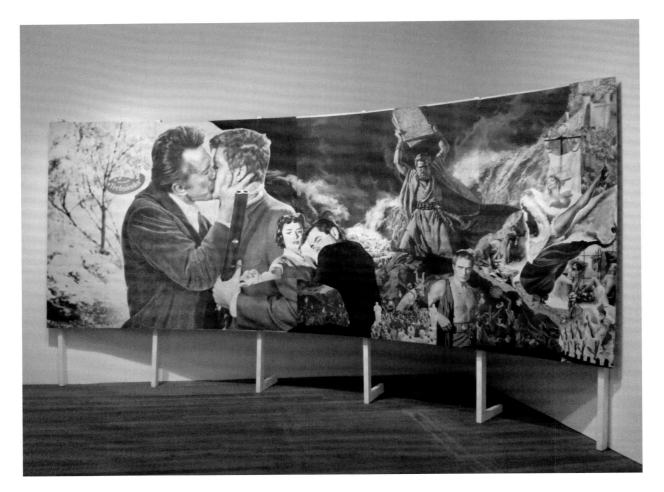

2.7

Richard Hamilton, *Technicolor*, 1987,
collage screen, photographed by the author
when exhibited at Tate Modern, London,
2014, owned by Institut Valencià d'Art
Modern, © R. Hamilton. All rights reserved,
DACS 2016.

Chapter 2: Cecil Beaton, Richard Hamilton and the Queer, Transatlantic Origins of Pop Art | Dominic Janes

strategies for toilet tissue (Maharaj 1992: 345). The implication of Jonathan Katz's revisionist work, however, is that Hamilton was also interested in anal eroticism, such that when he produced *Epiphany* (1964), which reads 'slip it to me', the artist 'actually meant it' as a same-sex come-on (Katz 2012: 353). Whichever view you prefer, it is clear that the question of the queer antecedents of Pop Art bears further examination through a wider exploration of British and American visual culture. After all, if Beaton's *New York Impressions* (Figure 2.3) appeared as a book illustration rather than as a piece of art, it is important to remember that, as I stressed in my introduction, *Just What Is It* was produced as a promotional image for the 1956 exhibition's posters and its catalogue. It was not exhibited as a work of art until 1964, the year that the pivotal US exhibition *The American Supermarket* was held at Paul Bianchini's Upper East Side gallery and Richard Hamilton, according to Katz, had his sexual epiphany.

Why then has the queerness of Hamilton's collage gone widely unrecognized? I would suggest that two reasons are particularly significant. The first relates to the use of homoeroticism in American consumer marketing. Leyendecker, as has already been indicated, was able, in the words of Richard Martin, to link 'consumerist craving' to 'erotic passion' in a 'non-exclusionary' way (Martin 1996: 467). In other words, his idealized male figures are deliberately left open to both heterosexual and homosexual appreciation at a time when well-developed masculine physiques were widely assumed by the former group to confirm sexual 'normality'. This meant that the potential for queer readings of such imagery, which I have argued came to be appreciated by Hamilton, could easily be missed by others who had limited conceptions of what homosexuality was or could be (Turbin 2002: 480). Indeed, it may be that even Hamilton had not been fully cognizant until the 1960s of the implications of his earlier work. The second reason relates to the operation of snobbery and homophobia within the art establishment. It was precisely the innovation of Pop to bring kitsch, vulgarity and camp back into the scope of what could be valued as art. As Ryan Linkof has argued, 'in making use of elements of low culture, Beaton was out of step with many of his contemporaries who more rigidly adhered to modernist artistic principles' (Linkof 2001: n 14). It was that aspect of homosexual sensibility of the mid-twentieth century that relished the ironic viewing of popular culture, including that of the working-class male, that has been seen, in this article, as prefiguring the ethics and aesthetics of pop (Linkof 2012: para 6). *Just What Is It* shared many of the same perspectives and, for this reason, should be understood as standing in a line of development from earlier visual culture and as a queer statement in its own right.

Notes

1 Danziger, *Beaton*, reprints an impressive selection of these materials but the plates section of this volume is largely unpaginated and references to specific scrapbooks are not given. The originals are held at the Sotheby's Picture Archive in London but, owing to their fragile nature, were not open for public consultation at the time of writing (personal communication with Katherine Marshall, Sotheby's).

2 See also letter of Peter Watson to Beaton, 12 December 1939, quoted in Vickers, *Cecil Beaton*, 231.

3 Also email communications with Hannah Dewar, Tate Gallery, London, 8 May 2014 and Teresa Millet, Institut Valencià d'Art Modern, 24 February 2015.

References

Albrecht, D. (2011), *Cecil Beaton: The New York Years*, New York: Skira Rizzoli.

Alloway, L. (1962), '"Pop Art" since 1949', *Listener*, 27 December 1962, 1085–7.

Alloway, L. (1966), 'The Development of British Pop', in *Pop Art*, Lucy R. Lippard (ed.), 27–68, London: Thames & Hudson.

Alloway, L. (1990), 'The Independent Group and the Aesthetics of Plenty', in Robbins, *The Independent Group*, 49–54.

Banash, D. (2014), 'From Advertising to the Avant-Garde: Rethinking the Invention of Collage', *Postmodern Culture* 14 (2). Available online: http://muse.jhu.edu.ezproxy.lib.bbk.ac.uk/journals/postmodern_culture/v014/14.2banash.htm (accessed 4 September 2013).

Beaton, C. (1937), *Cecil Beaton's Scrapbook*, London: Batsford.

Beaton, C. (1948), *Cecil Beaton's New York*, London: Batsford, 1938; 2nd ed. London: Batsford.

Beaton, C. (1960), *My Royal Past*, 1st ed. London: Batsford, 1939; 2nd ed. London: Weidenfeld and Nicolson.

Bengry, J. (2009), 'Courting the Pink Pound: *Men Only* and the Queer Consumer, 1935–39', *History Workshop Journal*, 68 (autumn): 122–48.

Bradley, P. (1998), 'John Wanamaker's "Temple of Patriotism" Defines Early 20th Century Advertising and Brochures', *American Journalism*, 15 (2): 15–35.

Brady, J. (2014), 'Ambiguous Exposures: Gender-Bending Muscles of the 1930s Physique Photographs of Tony Sansone and Sports Photographs of Babe Didrikson', in *Sensational Pleasures in Cinema, Literature and Visual Culture: The Phallic Eye*, G. Padva and N. Buchweitz (eds), 180–94, Basingstoke: Palgrave.
Branchik, B. J. (2007), 'Pansies to Parents: Gay Male Images in American Print Advertising', *Journal of Macromarketing*, 27 (1): 38–50.

Bronski, M. (2011), *A Queer History of the United States*, Boston: Beacon.

Brown, E. H. (2009), 'De Meyer at *Vogue*: Commercializing Queer Affect in First World War-Era Fashion', *Photography and Culture*, 2 (3): 253–74.

Butt, G. (2004), 'How New York Queered the Idea of Modern Art', in *Varieties of Modernism*, P. Wood (ed.), 317–37, New Haven: Yale University Press.

Butt, G. (2005), *Between You and Me: Queer Disclosures in the New York Art World, 1948–1963*. Durham, NC: Duke University Press.

Butt, G. (2006), '"America" and its Discontents: Art and Politics 1945–60', in *A Companion to Contemporary Art Since 1945*, A. Jones (ed.), 19–37, Oxford: Blackwell.

Campbell, J. W. (1947), 'In Times to Come', *Astounding Science Fiction*, August: 138.

Chauncey, G. (1994), *Gay New York: Gender, Urban Culture and the Makings of the Gay Male World, 1890–1940*, New York: Basic Books.

Clark, A. and Dronfield, J. (2015), *Queer Saint: The Cultured Life of Peter Watson, Who Shook Twentieth-Century Art and Shocked High Society*, London: Metro.

Cohen, L. (1999), '"Frock Consciousness": Virginia Woolf, the Open Secret, and the Language of Fashion', Fashion Theory, 3 (2): 149–74.

Cole, S. (2010), *The Story of Men's Underwear*, Parkstone: New York.

Cowling, E. (with Calvocoressi, R., Elliott, P. and Simpson, A.) (1997), *Surrealism and After: The Gabrielle Keiller Collection*. Edinburgh: Scottish National Gallery of Modern Art.

Crisp, Q. (1997), *The Naked Civil Servant*, London: Penguin.

Curcio, V. (2000), *Chrysler: The Life and Times of an Automotive Genius*. Oxford: Oxford University Press.

Curtis, B. (2013), 'Tomorrow', *Journal of Visual Culture*, 12 (2): 279–91.

Cutler, L. S. and Cutler, J.G. (2008), *J.C. Leyendecker: American Imagist*, New York: Abrams.

Danziger, J. (2010), *Beaton: The Art of the Scrapbook*, New York: Assouline.

Dennis, P. (ed.) (1992), *Daring Hearts: Lesbian and Gay Lives of 50s and 60s Brighton*, Brighton: QueenSpark.

Doris, S. (2007), *Pop Art and the Contest over American Culture*, Cambridge: Cambridge University Press.

Dorsey, T. (undated), 'I Met My Baby in Macy's', *Lyricsplayground*, undated. Available online: http://lyricsplayground. com/alpha/songs/i/imetmybabyinmacys. shtml (accessed 1 September 2013).

Doyle, J. Flatley, J. and Muñoz, J.E., (eds) (1996), *Pop Out: Queer Warhol*, Durham, NC: Duke University Press.

Dyer, R. (1987), *Heavenly Bodies: Film Stars and Society*, Basingstoke: Macmillan.

Ellenzweig, A. (1997), 'Picturing the Homoerotic', in *Queer Representations: Reading Lives, Reading Cultures*, M. Duberman (ed.), 57–68, New York: New York University Press.

Farmer, B. (2005), 'The Fabulous Sublimity of Gay Diva Worship', *Camera Obscura*, 20.2 (59): 165–95.

Foster, H. (2003), 'Notes on the First Pop Age', in *Richard Hamilton*, H.Foster and A. Bacon (eds) 45–64. Cambridge, MA: MIT Press, 2010.

Francis, M. (2006), 'Cecil Beaton's Romantic Toryism and the Symbolic Economy of Wartime Britain', *Journal of British Studies*, 45 (1): 90–117.

Franklin, P.B. (2000), 'Object Choice: Marcel Duchamp's *Fountain* and the Art of Queer Art History', *Oxford Art Journal*, 23 (1): 23–50.

Gibson, R. (2003), 'Schiaparelli, Surrealism and the Desk Suit', *Dress* 30 (1): 48–58.

Gilbert, J.B. (2005), *Men in the Middle: Searching for Masculinity in the 1950s*. Chicago: University of Chicago Press.

Glick, E. (2009), *Materializing Queer Desire: Oscar Wilde to Andy Warhol*. Albany: State University of New York Press.

Hamilton, R. (1990), 'Retrospective Statement', in Robbins, *The Independent Group*, 188.

Hamilton, R. (2006), *Painting by Numbers*, London: Edition Hansjörg Mayer.

Hammer, M. (2014), 'The Independent Group Take on Francis Bacon', *Visual Culture in Britain*, 15 (1): 69–89.

Harvey, R. (2006), 'Where's Duchamp: Out Queering the Field', *Yale French Studies*, 109: 82–97.

Hearn, J. and Melechi, A. (1992), 'The Transatlantic Gaze: Masculinities, Youth, and the American Hegemony', in *Men, Masculinity, and the Media*, S. Craig (ed.), 215–32, Newbury Park, CA: Sage.

Hebdige, D. (1995), 'Fabulous Confusion! Pop before Pop?' in *Visual culture*, C. Jenks (ed.), 96–122, London: Routledge.

Hornsey, R. (2010), *The Spiv and the Architect: Unruly Life in Post-war London*, Minneapolis: University of Minnesota Press.

Howard, A. (2011), 'The Life and Times of Charles Henri Ford, *Blues*, and the Belated Renovation of Modernism', PhD dissertation, University of Sussex.

Hunter, S. (1952), 'Francis Bacon: The Anatomy of Horror', *Magazine of Art*, 45 (1): 11–15.

Janes, D. (2015), 'Cecil Beaton, Richard Hamilton and the Queer, Transatlantic Origins of Pop Art', *Visual Culture in Britain*, (16) 3: 308–30.

Jarman, D. (1991), *Dancing Ledge*, London: Quartet.

Jobling, P. (2005), *Man Appeal: Advertising, Modernism and Menswear*, Berg: Oxford.

Joffe, B.H. (2007), *A Hint of Homosexuality? 'Gay' and Homoerotic Imagery in American Print Advertising*, Bloomington: Xlibris.

Johnson, M.M. (2006), 'Souvenirs of Amerika: Hannah Höch's Weimar-era Mass-Media Scrapbook', in *The Scrapbook in American Life*, S. Tucker, K. Ott and P. P. Buckler (eds), 135–52. Philadelphia: Temple University Press.

Katz, J.D. (2012), 'Dada's Mama: Richard Hamilton's Queer Pop', *Art History*, 35 (2): 139–55.

Lahti, M. (1998), 'Dressing up in Power: Tom of Finland and Gay Male Body Politics', *Journal of Homosexuality*, 35 (3–4): 185–205.

Lears, J. (1994), *Fables of Abundance: A Cultural History of Advertising in America*, New York: Basic.

Le Corbusier, (1987), *The Decorative Art of Today*, trans. James Dunnett, London: Architectural Press.

Leffingwell, E. (1988), 'Introduction', in *Modern Dreams: The Rise and Fall and Rise of Pop*, 6–7. Cambridge, MA: MIT Press.

Linkof, R. (2012), 'Shooting Charles Henri Ford: Cecil Beaton and the Erotics of the "Low" in the New York Tabloids', *Études Photographiques* 29. Available online: http://etudesphotographiques.revues.org/3478 (accessed 8 July 2015).

Loftin, C.M. (2007), 'Unacceptable Mannerisms: Gender Anxieties, Homosexual Activism, and Swish in the United States, 1945–1965', *Journal of Social History*, 40 (3): 577–96.

Lord, C. and Meyer, R. (2013), *Art and Queer Culture*, London: Phaidon.

Luciano, L. (2007), 'Muscularity and Masculinity in the United States: A Historical Overview', in *The Muscular Ideal: Psychological, Social and Medical Perspectives*, J. K. Thompson and G. Cafri (eds), 41–66. Washington, D.C.: American Psychological Association.

Maharaj, S. (1992a), '"A Liquid Elemental Scattering": Marcel Duchamp and Richard Hamilton', in *Richard Hamilton*, 40–48, London: Tate.

Maharaj, S. (1992b), 'Pop Art's Pharmacies: Kitsch, Consumerist Objects and Signs, the "Unmentionable"', *Art History*, 15 (3): 334–50.

Manchester, E. (2007), 'Richard Hamilton, *Just What Was it that Made Yesterday's Homes So Different, So Appealing, Upgrade*, 2004, Summary', Tate Gallery: London, 2007. Available online: http://www.tate.org.uk/art/artworks/hamilton-just-what-was-it-that-made-yesterdays-homes-so-different-so-appealing-upgrade-p20271/text-summary (accessed 7 July 2015).

Martin, R. (1996), 'J. C. Leyendecker and the Homoerotic Invention of Men's Fashion Icons, 1910–1930', *Prospects*, 21 (October): 453–70.

Massengil, R. (2010), *Quaintance*, Cologne: Taschen.

Massey, A. (2013), *Out of the Ivory Tower: The Independent Group and Popular Culture*, Manchester: Manchester University Press.

Morphet, R. (1970), 'Introduction', in *Richard Hamilton*, 7–15, London: Tate.

Myers, J. (2000), 'The Future as Fetish', *October*, 94 (Fall): 63–88.

Ofield, S. (2001), 'Wrestling with Francis Bacon', *Oxford Art Journal*, 24 (1): 113–30.

Pepper, T. (2004), *Beaton Portraits*, New Haven: Yale University Press.

Philo, S. and Campbell, N. (2004), 'Biff! Bang! Pow! The Transatlantic Pop Aesthetic, 1956–66', in *Issues in Americanisation and Culture*, N. Campbell, J. Davies and G. McKay (eds), 278–94. Edinburgh: Edinburgh University Press.

Reay, B. (2010), *New York Hustlers: Masculinity and Sex in Modern America*, Manchester: Manchester University Press.

Reed, C. (2006a), 'A *Vogue* that Dare not Speak Its Name: Sexual Subculture during the Editorship of Dorothy Todd, 1922–26', *Fashion Theory*, 10 (1–2): 39–72.

Reed, C. (2006b), 'Design for (Queer) Living: Sexual Identity, Performance, and Décor in British *Vogue*, 1922–1926', *GLQ*, 12 (3): 377–403.

Reed, C. (2011), *Art and Homosexuality: A History of Ideas*, Oxford: Oxford University Press.

Richardson, J.A. (1966), 'Dada, Camp and the Mode called Pop', *Journal of Aesthetics and Art Criticism* 24 (4): 549–58.

Richlin, A. (2005), 'Eros Underground: Greece and Rome in Gay Print Culture, 1953–65', in *Same-Sex Desire and Love in Greco-Roman Antiquity and in the Classical Tradition of the West*, B. C. Verstraete and V. Provencal (eds), 421–61, Bloomington: Harrington.

Robbins, D. (ed.) (1990), *The Independent Group: Post-war Britain and the Aesthetics of Plenty*, Cambridge, MA.: MIT Press.

Schimmel, P. (2014), 'Introduction', in *Richard Hamilton*, M. Godfrey, P. Schimmel and V. Todoli (eds), 15–17. London: Tate.

Sherman, F.F. (1940), 'Alexander de Canedo', *Art in America*, 28 (3): 132–3.

Smith, G. (1990), 'Richard Hamilton's *Just What Is It That Makes Today's Homes So Different, So Appealing?' Source: Notes in the History of Art*, 9 (4): 31–4.

Snaith, G. (2003), 'Tom's Men: The Masculinization of Homosexuality and the Homosexualization of Masculinity at the End of the Twentieth Century', *Paragraph*, 26 (1–2): 77–89.

Sontag, S. (1964), 'Notes on camp', Available online: http://faculty.georgetown.edu/irvinem/theory/Sontag-NotesOnCamp-1964.html (accessed 27 January 2017).

Spencer, R. (ed.) (2000), *Eduardo Paolozzi: Writings and Interviews*, Oxford: Oxford University Press.

Stonard, J.P. (2007), 'Pop in the Age of Boom: Richard Hamilton's *Just What Is It That Makes Today's Homes So Different, So Appealing?*, *Burlington Magazine*, 149: 607–20.

Stonard, J.P. (2008), 'The "Bunk" Collages of Eduardo Paolozzi', *Burlington Magazine*, 150: 238–49.

Stonard, J.P. (2011), 'Eduardo Paolozzi's *Psychological Atlas*', *October*, 136: 51–62.

Tamagne, F. (2006), *A History of Homosexuality in Europe: Berlin, London, Paris, 1919–1939*, New York: Algora.

Thomas, J. A. (1999), 'Pop Art and the Forgotten Codes of Camp', in *Memory and Oblivion*, W. Reinink and J. Stumpel, 989–95. Dordrecht: Klewer.

Turbin, C. (2002), 'Fashioning the American Man: The Arrow Collar Man, 1907–1931', *Gender and History*, 14 (3): 470–91.

Vickers, H. (1985), *Cecil Beaton: The Authorised Biography*, London: Weidenfeld and Nicolson.

Walker, I. (2007), *So Exotic, so Homemade: Surrealism, Englishness and Documentary Photography*, Manchester: Manchester University Press.

Watney, S. (1996), 'Queer Andy', in Doyle, Flatley and Muñoz, *Pop Out*, 20–30.

Whitham, G. (1990), 'Science Fiction', in Robbins, *The Independent Group*, 61–2.

Wyke, M. (1999), 'Herculean Muscle! The Classicizing Rhetoric of Bodybuilding', in *Constructions of the Classical Body*, J.I. Porter (ed.), 355–79. Ann Arbor: University of Michigan Press, 1999.

Althea McNish and the British-African Diaspora

Christine Checinska

3

Artist Althea McNish's contribution to the field of British textile design, and to British culture more widely, cannot be overstated. One of the first designers of African-Caribbean descent to achieve international recognition, McNish injected much-needed colour and life into the post-war fashion and textile industry from the 1950s onwards. As her partner and husband John Weiss writes, 'She brought to London a tropical framework of reference' (Weiss in Harris and White, 2009: 91).

McNish was born in Port of Spain, Trinidad and moved to London in the early 1950s. Although she had been painting from a very early age and planned to study architecture at the Architectural Association, she enrolled instead at the London School of Printing. McNish then went on to the Royal College of Art, (RCA), London where, during her final year, she was encouraged by the artist Eduardo Paolozzi to specialize in textile design.

Graduating in 1957, McNish's remarkable talent caught the attention of the prestigious London department store Liberty. It was through this association that she subsequently met Zika Ascher, who commissioned her to create a range of exclusive designs for the Parisian couture house Dior. Her unique eye for colour and energetic brush strokes lent themselves to interior applications as well as international fashion collections. The pattern *Golden Harvest* (1959), originally produced by Hull Traders, is one of her most important and well-known furnishing designs.

CC: John, you and Althea McNish were at art school in Britain during the late 1950s with Pop artists such as Eduardo Paolozzi, who were known for ignoring the boundaries between art and design. How did the blurring of the boundaries between art, fashion and textiles begin for Althea?

JW: Althea was at art school at a later time than Paolozzi, who had finished his studies in 1947, afterwards working in Paris until 1949 and then in London. His experimental work in screen-printed textiles led to his setting up Hammer Prints and to being invited to run courses in the subject at the Central School of Arts and Crafts. It was while studying graphic design at the London School of Printing and Graphic Arts (now part of the University of the Arts London, UAL) that Althea became aware of the work of students on Paolozzi's course at the Central. She attended his evening class there, developing in his view a talent for printed textiles that led him to persuade her that on taking up her scholarship at the Royal College of Art she should study Printed Textiles in place of Fine Art as she had planned. During her time at the London School of Printing she had pursued graphic design while at the same time taking up screen-printing as a way of producing her fine art in multiple editions, so she was already working as an artist and a designer side by side; on going to the RCA her design field became printed textiles in place of graphic design. Her work as an artist and as a textile designer was

3.1 (opposite)

Althea McNish, *Golden Harvest*, Hull Traders. Photograph by John Weiss.

3.2 (above)

Althea McNish, *Bézique*, Liberty. Image of headboard showing four colourways. Photograph by John Weiss.

unique, the textile design coming out of her awareness and tendencies as a painter and in her final year she was approached by architects to produce for their buildings both unique murals and textile designs, produced in quantity by industrial methods. She does not seem to have been interested in other people's perceptions of boundaries between fine art and manufactured textiles and simply continued working as a painter and textile designer side by side. She was not involved in fashion during this period.

These young Pop artists actively rebelled against what was being taught in the art schools since it did not relate to their own lives. How did Althea come to be at the Royal College of Art (RCA)?

Althea had always done her own thing since starting to paint in her childhood, she took little notice of surrounding influences and appears to have seen nothing to rebel against; she accepted as beneficial the conversation with older artists, which included as tutors people such as Humphrey Spender, John Drummond and Louis le Brocquy, without either being influenced by them or reacting against their teaching. As for the RCA, it was the natural place for further study after completing the course at the London School of Printing and having come to London with official approval for the extended studies required for architecture there was no problem in continuing her design studies with a post-qualification course at the RCA as senior institution. Paolozzi's advice was for the choice of study; Althea was already committed to her studies at the RCA.

How did Althea relate to the tutors and what was being taught there?

At both the London School of Printing and the RCA it seems that Althea had a good relationship with her tutors, learning what they could offer on the technical side and apparently interesting them with her independent attitudes, which they seem to have accepted with enthusiasm. Photographs of the time show her as looking intensely serious. At both schools the technical staff provided her with resources to do her own thing, especially as her facility in screen-printing included devising new methods of preparing the screens, including making up solutions for blocking out (in effect, liquid stencil-making), which she attributes to her early experience of making up mixtures in her father's pharmacy when he ran a drug store in Trinidad.

What was Althea's experience of studying art in Trinidad before coming to London?

Althea's activity as a painter in Trinidad was self-taught, though with guidance from established painters, such as Sybil Atteck, Pierre Lelong and M.P. Alladin, and in the company of Geoffrey and Boscoe Holder, Carlyle Chan, the sculptor Hettie de Gannes and others. Her studies in London had no parallel in her previous experience in Trinidad – there were no art courses there at that time, other than in the schools, and Althea seems to have enjoyed herself in her school art classes and made her teachers happy.

In previous conversations Althea has spoken about working with the technicians, well teaching them actually! Share some of your memories ...

This applied to screen-printing in particular, at the London School of Printing with the intention of reproducing her artworks and then at the RCA and throughout her later career in the printing of textiles. Technicians during her studies were interested in what she was doing and helped her achieve what she wanted and, later, technicians in the textile firms were sympathetic to her design intentions once they appreciated how well she understood the technical side of the business.

When was the moment that Althea found her language, her aesthetic, for example her unique sense of colour?

It seems to have been in childhood when she first picked up a brush. As regards the earlier generation of modern artists, Althea told me that in her student days she had gone to visit Matisse at his studio in Venice and that she admired his work and that of Picasso, Braque, Van Gogh and Gauguin. Early in her studies she had met, through a fellow student, the artist and collector William Ohly, who had been a sculptor earlier in the century and who now owned two London galleries; the Abbey Arts Centre, with ethnologist Cottie Burland as curator and the Berkeley Gallery, where he showed African art among other things. Amongst the Abbey community she met many new artists, including the sculptor Phillip King and the Scottish painter Alan Davie and at the British Museum was taken by Burland, one of the ethnographic specialists there, into storerooms where she studied African textiles and other artefacts.

Many Pop Art artists and designers attribute their use of bright colours to the influence of popular culture and the inspiration of commercial advertising. Is this why Althea parted company with them? Was her fearless use of colour rooted in her Caribbean heritage?

As with other things, there seem to have been no influences such as described for Pop Art artists, but rather it was nature and its forms and colours. Thinking about the overall spectrum of both her painting and textile design, I think that although exposed to a great range of artistic work she really did go her own way; I can see little influence from outside as regards artists, and her study of African artefacts was one particular stimulus within the general spectrum of her textile designs.

Althea started painting when she was a child. How did she start and who were her early artistic influences?

No artistic influences, but much encouragement from parents during childhood.

In spite of the freedom and creative energy that characterizes both Althea's painting and textile designs, I understand that she initially studied architecture and spent some years working as a cartographer. Tell us more ...

In Trinidad, on leaving school, Althea was briefly apprenticed to a private architect and worked for a short period as a civil servant, cartographer and entomological illustrator, a job previously held by artist Sybil Atteck; but she left government employment to take up her studies in London.

Getting back to textiles, when Althea graduated from the RCA in 1957, Arthur Stuart-Liberty famously commissioned her to create new and exclusive designs for Liberty, the famous London department store. Tell us about this moment and the designs that you sold to him.

JW: He saw her work in the graduation show at the RCA, among many other viewers, and was evidently attracted by her colours and free brushwork. He asked her to bring her work to his office and once there he called in the buyers of all the departments to show them what he wanted them to use and then asked her to go away to develop a collection.

Were the designs being used for fashion or furnishing fabrics at this stage?

Liberty commissioned Althea to design fabrics both for fashion (including scarves as well as piece goods) and for furnishing; the timescale for fashion fabrics being shorter than for furnishings, the fashion fabrics appeared first and the furnishing fabrics later.

What was it that Arthur Stuart-Liberty saw in Althea's work?

We heard recently that he was looking for something new and his response in an interview a few years before he died was that he thought the British public was ready for what Althea had to offer, especially for the shock of new colours.

And from there she designed for Ascher? Once the designs were produced, who would have bought them?

It was Arthur Stuart-Liberty who introduced Althea to Ascher, sending her in a taxi at the conclusion of her first meeting with his staff. Zika Ascher was used to producing textiles that took the fashion world by storm, both in constructed textiles and in printed textiles. He appears to have taken to Althea and the work she showed him immediately and displayed – in an interview I had with him many years later – an excited enthusiasm for the work they did together. He would take Althea's designs on paper to his Paris designer clients whose customers wanted something unique; but his fabrics, including Althea's designs, were also chosen by many fashion designers for their catwalk collections.

In Britain, would we have seen Althea's designs in the boutiques that were becoming a feature of 1960s London, for example Mary Quant's Bazaar and Barbara Hulanicki's Biba?

Both used Althea's designs, which they would have bought through design agents.

During the 1960s Heals, Hull Traders and Conran Fabrics notoriously bought designs from young textile graduates whose work reflected the growing sense of post-war prosperity. Hull Traders produced some of Althea's most recognizable designs such as Golden Harvest. Tell us about this collaboration and how the design Golden Harvest was born.

The text from the RCA Black exhibition sums it up well:

> *Golden Harvest Printed textile c1958: early print by Tofos Prints, later produced by Hull Traders in their Time Present collection.*

In the catalogue notes for the recent celebratory exhibition of the firm of Hull Traders, whose collection included eight of Althea McNish's designs, Lesley Jackson, curator of the exhibition and eminent historian of modern textile design, noted Golden Harvest as Hull Traders' bestselling design ever and Althea as 'Britain's first and most distinguished black textile designer'.

The origins of Golden Harvest go back to Althea's final year of study at the RCA, when tutors Edward and Charlotte Bawden invited her to stay with them in Chipping Camden, the artists' community in Essex. On an early morning walk in the nearby fields the sight of the sun shining through the ears of golden wheat inspired the creation of a colourful design that was a tropicalization of the Essex wheatfields. As a result of tutors inviting into the College potential clients for their students' work, a firm of architects commissioned Althea to produce Golden Harvest for a school they were designing, and for its production Althea turned to the textile printers then established in Jays Mews, Tofos Prints, set up a few years earlier by John Drummond and Anne Loosely, with Ivo Tonder involved in the printing. At the end of the schools contract, when the architects indicated that Althea might take the design into commercial production for her own purposes if she wished, she put it into the hands of Tofos Prints to add to their collection. Shortly afterwards, Hull Traders, recently set up to deal in modern furnishings, decided to produce their own fabrics and incorporated the Tofos collection into their own new Time Present collection. The exhibited length of Golden Harvest is an early print under the Tofos name, but subsequent printings bore the selvedge indication of a Time Present fabric by Hull Traders. Golden Harvest was nominated at one point for a Design Council award but production problems of the time prevented completion of the submission. Produced by Hull Traders in four colourways, Golden Harvest is represented in the collections of the Victoria and Albert Museum and the Whitworth Museum. As well as being sold around the world as an example

of colourful British textiles, Golden Harvest has had Caribbean and Commonwealth connections: in 1959 in the furnishings of the West Indian Students centre, in 1973 in the Caribbean edition of the BBC's TV programme *Full House*, and in 1975 in the furnishings of the official residence of the Guyanese Sir Shridath Ramphal on his appointment as Secretary-General of the Commonwealth. More recently, in 2007, it was used as a symbol of the African-Caribbean component of British history and cultural life, forming a centrepiece in the exhibition *Remembering Slavery* at the Whitworth Art Gallery in Manchester.

Were Althea's textile designs also bought by Heals and Conran Fabrics?

Heals yes, Conran no.

Althea also travelled to America during this period. Did she meet any influential art figures while she was there?

On a business trip to New York in the early 70s, Althea was introduced by friends to Andy Warhol, and she then visited him at his studio, finding him and his work fascinating and meeting many of his circle. Perhaps it is interesting that the experimental techniques for which he was noted – in screen-printing as a medium and blotted monotype images as part of his language, apparently new to the art world – were similar to those Althea had been using almost from the start of her student days at the beginning of the 50s. The Wikipedia article on Andy Warhol refers to his method of 'applying ink to paper and then blotting the ink while still wet' and notes that 'chance plays a role and mistakes and unintentional marks are tolerated', characteristics of Althea's work that show in her earliest produced design, *Golden Harvest* of 1959. Their meeting appears to have been one of like minds, though with Althea having become known for her involvement in the transformation of textile design as distinct from Warhol's very public instigation of the Pop Art movement.

When and how did she start working with Tootal Fabrics/ICI? Why was the development of man-made fibres significant?

ICI had developed a new fibre, which they named Terylene Toile, which was the first man-made fibre to take strong colour, and Althea was seen as a designer whose understanding of colour could make good use of the possibilities. Tootal Fabrics were the primary textile producers responsible for the making of the cloth and a number of fashion houses were appointed to produce collections featuring the fabrics.

Althea also had some exciting commissions for wall hangings and murals. When and how did you start working for the Royal Caribbean Line cruise ships and the British Railway Boards offices? Tell us about the inspiration for these designs and the reaction of the public to them.

First *Oriana*, originally for the Orient Line, acquired by P&O and launched c. 1960 under their name; architects originally wanted textiles and then the commission turned into laminate plastics, a technique that Althea developed with Warerite Plastics and was later followed up by Perstorp, the Swedish firm on the Nordic Empress and Empress of the Seas.

The Pop Art era in Britain saw fashion and textile designers increasingly moving in the same circles as visual artists. As we have seen, Althea's work straddled these disciplines. But can you tell us about her connection to the Caribbean Artists Movement, specifically to artists such as Aubrey Williams, Ronald Moody and Jerry Craig?

JW: As a painter Althea was involved with CAM from its beginnings; the works she contributed to exhibitions were very much her own thing and she appears not to have been influenced by others.

The fashion journalist Colin McDowell wrote:

> **It was the black approach to colour and pattern that had the most wide effect. In fact it is time to say that the dress of the hippies and the flower children would not have been so gloriously uninhibited had it not been for the African Caribbean inspiration which broke down many of the sterile rules of taste besetting the white fashion world. (Colin McDowell, 1997, p. 31)**

Does this statement resonate with you? How might you sum up the impact of Althea's work on British textiles?

Althea broke the ice and led the way, but British designers were ready to work in colour; Althea may have influenced fellow students at the RCA and those who were coming up at the time; once the manufacturers started utilizing her textures and bright colours, other designers followed.

References

Harris, R. and White, S. (eds) (2009), Althea McNish in conversation with John Weiss (22.02.1999) with John La Rose in the chair in *Building Britannia: Life Experience with Britain*, London: New Beacon Books, 47–92.

Programming Pop Art and Design

Anne Massey

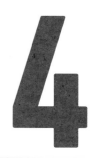

The Institute of Contemporary Arts (ICA) in London provided a transdisciplinary space that was to prove an important catalyst in the development of Pop Art and Design. The newly formed organization not only offered an important meeting point for the discussion and exhibition of both art and design but also provided a broader intellectual framework and network of contacts for its members. It acted as a magnet for practitioners to meet and discuss the latest cultural developments in their fields and related areas of activity. Artworks and ideas were sourced internationally by the ICA for the benefit of its audience; this included the work of the Independent Group, the first institutional exhibition of Francis Bacon (Hammer 2014) and the first London showing of Jann Haworth, Archigram and American Pop Art. It was the heterogeneity and tolerance of the ICA project which made it such an important space for the creation of Pop Art and Design. Indeed, it would be difficult to see how early Pop Art and Design would have developed in the way it did without the supporting linchpin of the ICA. This chapter draws on approaches from the emerging field of exhibition histories, which attend to methods and meanings surrounding the institutional display of art and design, rather than the individual works of artists and designers (Altshuler 2008). I argue that it was the programming of art, design and popular culture at the ICA which facilitated the interdisciplinary interaction that contributed to the development of a Pop sensibility.

A Place to Meet

At a basic level, the ICA acted as a physical meeting place to enable creative networking. It brought together audiences, architects, artists, designers, musicians, theorists and writers into a physical space for the consideration of contemporary culture. It got people together. It brought ideas together. The ICA founders, led by Roland Penrose and Herbert Read, wanted to provide a playground for the creative practitioner to experiment. This philanthropic desire was fuelled by their shared belief in the avant-garde as a source of social reform and political enlightenment. This drew on their common enthusiasm for surrealism and for Modernism in general. It was also inspired by Penrose's Quaker background, the legacy of which was a tolerance of difference, individuality guided by an inner light, non-

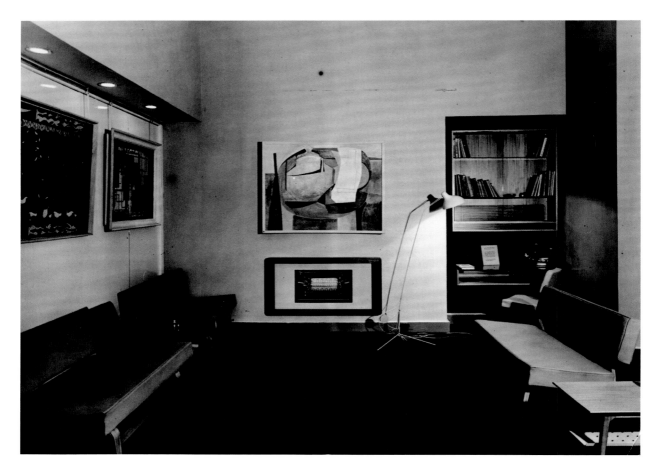

4.1

The interior of the members' room at the new ICA premises, December 1950. Collection of author, courtesy of the ICA.

conformity, a certain asceticism, non-hierarchical views including equality across gender and sexuality, and a lingering sense of persecution (King 2016). From its beginnings the ICA conceived of itself as a facilitator for creative experiment and for riding the crest of the avant-garde wave. It was the self-styled 'Home of the Avant-Garde' (Massey and Muir 2014: 37). The ICA was based at 17/18 Dover Street in London's West End, near the Ritz Hotel, Royal Academy and Piccadilly Circus, from 1950 until 1967. Situated on the upper floors of a Georgian townhouse, the space was restrictive but the intense enthusiasm surrounding the unique ICA project meant that it succeeded in enhancing avant-garde theory and practice. This is best evidenced through the imaginative programming of the institution from its earliest days, a virtual collage of aural, intellectual and visual stimulation which attracted a keen and ambitious coterie of artists, designers and writers.

Looking at the programme of events staged by the ICA during the 1950s and 1960s the sheer quantity is staggering (Massey and Muir 2014: 165–200). There were 10 to 12 exhibitions organized annually, mainly by the ICA. In contrast to the situation today, where cultural institutions privilege public engagement, the ICA was the exception during the 1950s in providing a quasi-adult education resource combined with a private club for the modernist-minded. There was something happening nearly every evening

at the small-scale Dover Street premises, with high-level discussions and lectures taking place in the exhibition space. The membership of the ICA also enjoyed a club room with bar and contemporary furniture and décor. This provided a convivial gathering place. In terms of Pop Art and Design, popular culture and design was discussed alongside fine art with intellectual integrity from the very beginning. In early 1950 the ICA staged a forum on *A Comparison Between Television and Film*, chaired by Donald McCullough the witty chair of the BBC radio programme *The Brains Trust*. This was followed by a discussion on *The Industrial Designer and Public Taste* chaired by industrial designer, Misha Black. The ICA also ran a *Course in*

James Joyce: His Life and Work, exhibition catalogue, ICA 1950. Courtesy of ICA.

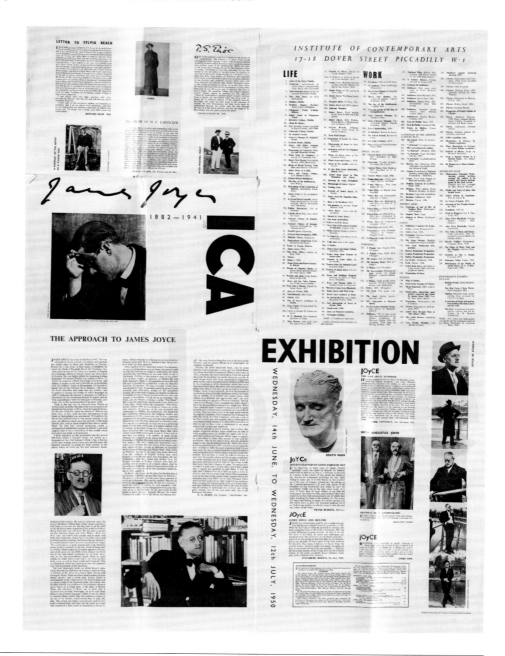

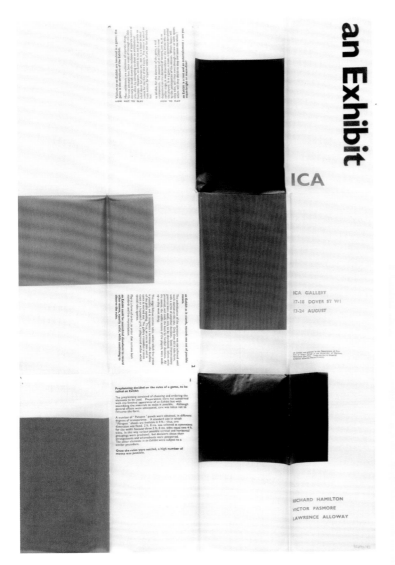

4.3 (above)

Exhibition catalogue, an Exhibit.
Courtesy of the ICA.

4.4 (right)

Private View Card, *Theo Crosby, Sculpture, Peter Blake, Objects, John Latham, Libraries*, 1960. Courtesy of the ICA.

THEO
CROSBY
sculpture
PETER
BLAKE
objects
JOHN
LATHAM
libraries

private view
Wednesday 6th January at 6 p.m.

open to the public
7th January—30th January

ICA 17-18 DOVER STREET
LONDON W.1.

Contemporary Art with lectures on the scientific and philosophical basis of Modernism. It was into this vibrant context that one of the most important facets of Pop Art and Design flourished, the Independent Group.

Future members of the Independent Group gathered at the ICA as they were attracted by the lively programme of events and the chance to further individual careers. The ICA was an excellent place for networking. Richard Hamilton and Nigel Henderson had met at the Slade, and Henderson introduced Hamilton to the ICA by means of his pre-war contacts. Eduardo Paolozzi exhibited in the ICA's first exhibition, *Forty Years of Modern Art* in 1948 and spent time with William Turnbull in Paris. Paolozzi worked with the architect Jane Drew in the redesign of the ICA's Dover Street premises, and decorated it for the New Year's Eve party to see in 1951 along with Pop theorist, Toni del Renzio. Del Renzio had been involved with the British surrealists before the Second World War, and was a close acquaintance of ICA Management Committee member, Peter Watson.

This coterie of ambitious, and often troublesome, artists and theorists populated the ICA throughout 1951 and into 1952 when they began to become impatient with what they regarded as the narrow focus of the programme. What they demanded was a more contemporary series of discussions, which acknowledged the changing cultural landscape of the post-war world. The increasing importance of technology and of mass culture was central to their concerns. The ICA's first meeting of its subcommittee on visiting lecture policy agreed that the 'Young Independent Group' could run lectures and discussions for themselves (Massey 1995: 46). The first three sessions were convened by gallery assistant and photographer, Richard Lannoy. The first of these was the session by Paolozzi entitled *Bunk!* where he fed images collected in his scrapbooks taken from American advertising imagery into an epidiascope to a small and select audience. This included Richard and Terry Hamilton, Mary and Peter Reyner Banham, Toni del Renzio, Colin St John Wilson, William Turnbull and Richard Lannoy. It is tempting to regard these images from the perspective of the twenty-first century as some kind of vintage kitsch, with glamorous models enjoying retro kitchen equipment and gaudy, processed food. However, from the point of view of the Independent Group in 1952 these were examples of expertly produced images, proclaiming the dawn of an age of plenty. It was a message of hope from across the Atlantic and the Independent Group wanted a piece of the action.

In the development of Pop Art and Design it is important to acknowledge the positive reception which the Independent Group afforded to popular culture. This was not, as the group saw it, the dismissive and dated analysis characteristic of British cultural studies, but a genuine admiration (Massey 2013b: 1–36). The crucible of the ICA continued to provide an important meeting place for proto-Pop during the 1950s. With the valuable support of the Director, Dorothy Morland, the Independent Group continued to flourish (Massey, 2013a). Dorothy Morland also had a Quaker connection, married to the doctor Andrew Morland who came from

a Quaker family, there was the same non-conformist, accepting world view as of Roland Penrose and he and Dorothy shared a close working relationship (Boothby and Morland 2015: 79–94).

The first full session of the Independent Group took place during late 1952 to early 1953 and was convened by Reyner Banham, then a PhD student at the Courtauld Institute of Art. The theme was art, science and technology, which problematized the accepted history of the modern movement in architecture and started to map out a history of design. During sessions such as 'The Helicopter as an Example of Technical Development' the Independent Group formulated an innovative approach to design, which took into account technical innovation. The Group shared an expert knowledge in the technical aspects of engineering design, and quite rightly noticed that the Modern Movement theorists did not take this into account. Architects, in particular Le Corbusier, celebrated the timeless beauty of classical forms, rather than the latest technological breakthroughs. This was an important aspect of the Independent Group's aesthetic, which fed into the development of Pop at the ICA.

The Group's ideas were further developed later in 1953 when it ran a nine-week public programme on *The Aesthetic Problems of Contemporary Art*. In the first session, Reyner Banham spoke about 'The Impact of Technology' and concentrated on the impact of techniques of mass production in relation to the work of art and Richard Hamilton followed on in the next session with 'New Sources of Form'. Hamilton discussed new extensions to the visual landscape through the use of micro-photography and long-range astronomy, themes he had begun to explore in the ICA exhibition, *Growth and Form*, in 1951.

It was in the second session of the private meetings of the Independent Group that a sophisticated approach to contemporary, popular culture was articulated. This second series ran during 1955 and was convened by John McHale and Lawrence Alloway; the theme was American popular culture. This was controversial at the time, and surprisingly, remains controversial today. Critical commentators continue to take it for granted that popular culture is the seductive face of capitalism. This has been questioned by Hal Foster in *The First Pop Age*, which considers 'Painting and Subjectivity' in the work of Hamilton, Lichtenstein, Warhol, Richter and Ruscha. He concludes:

> From the start, many critics have viewed practitioners of Pop as dupes of the media, its zombies in awe; in my view, on the contrary, the artists in question are not only its canny experts but also its dialectical theorists. Each, I have argued, produced a distinctive version of the artistic image as a mimetic probe into a given matrix of cultural languages, both high and low – a probe that, far from facile, is complex in its making and viewing alike.
> (Foster 2012: 251)

For the development of early Pop Art and Design, it is crucial to drop this critical 'groupthink', as Foster argues. Moreover, it is also important to consider the Independent Group within its historical context, which is the situation in 1950s Britain. This was the height of the Cold War, when the Iron Curtain had just come down. Many of the Independent Group had seen active service during the Second World War, including Nigel Henderson, William Turnbull and Frank Cordell. This was the shiny new world they had risked their lives to defend and were not about to dismiss it out of hand. As David Lodge noted when discussing the biography of writer Kingsley Amis, who came from the same generation as the Independent Group, and shared a similar lower middle class background:

> He certainly soon tired of earnest discussions of dialectical materialism, and the effect of his military experience was to turn him away from dogmatic Marxism to a democratic socialism which would allow plenty of individual freedom. The young soldier corresponding to Amis in 'Who Else Is Rank?' dreams of a post-war England 'full of girls and drink and jazz and books and decent houses and decent jobs and being your own boss.' (Lodge 2015: 31)

The visual imagery carried in colourful magazines and Hollywood films, the cool jazz of the West Coast of America and the sophisticated advertising of a whole new consumer way of life was lapped up by the Independent Group during its meetings.

American popular culture dominated the imagination in the Western world throughout the 1950s. And it dominated because it was the most alluring, complete with a promise of a brighter new tomorrow, with decent jobs and houses. For example, this consumer culture dominated approaches to art and design in Italy. Gillo Dorfles, the leading design critic and expert semiologist, spoke to the Independent Group at one of their meetings in June 1955. He investigated the 'Aesthetics of Product Design', which drew upon his work at the 1954 Milan Triennale that had featured contemporary design objects juxtaposed with photographic images, bridging the gap between fine art and design. Of the nine sessions of the last Independent Group series of private meetings, only one session was exclusively about fine art. This was the first, which concentrated on Richard Hamilton's paintings, most probably the *Trainsition* series in relation to photography. The remainder were about American car design; advertising; fashion and fashion magazines; information theory and popular music.

The approach taken in all the sessions was to examine the process of creation and the relationship between consumers and producers. Whilst the developing field of cultural studies might enquire about the why of cultural production, the Independent Group wanted to know about the how. This was a pragmatic approach, which accepted the place of America in the Cold War world of the 1950s. It was the stuffy London art world which the Independent

Group wanted to disrupt with its disreputable love of contemporary, American popular culture. This challenge was co-created in the private meetings of the Group, but soon infiltrated the public programme of the ICA. Crucially, it inspired the next generation of Pop artists and designers at the RCA.

Members of the Independent Group voiced their reservations about the mainstream ICA programme as early as 1954 at the Members' Annual General Meeting:

Mr Richard Hamilton suggested that discussions should be held about the films released to the local cinemas, as these had an enormous influence, and were amongst the most significant things in film today. Mrs Morland said she did not think people would visit the cinema independently and then come to a discussion at the ICA on the film. Mrs Richard Hamilton asked whether a policy decision had been taken in the film section: were the ICA to stick to 'Caligari and all that' (Film Society fare), or would discussions be arranged on the commercial cinema. Mr Penrose said there were great difficulties: the film section were continually considering how to do something at the ICA which was not covered elsewhere, and which would attract an audience … Mr Hamilton said the question was, should we look for new films, or should we discuss the film everyone was seeing.

Mrs Cordell asked why the very interesting talk on the Western film had not been advertised in the usual way. Mrs Morland said the advertisement had been sent to the 'New Statesman', but they had omitted to put it in.

Mr Donald Holmes suggested a discussion about TV. Mrs Morland said the majority of programmes were so poor she questioned whether they were worth serious discussion.

Mr Frank Cordell complained that the Music Section were unadventurous, and wished that professional musicians were represented on the Music Committee. Mrs Morland said they were very busy people: musicians did not even come to the ICA concerts which they organised themselves. (ICA 24th July 1954: 3–4)

The Independent Group began to infiltrate the public programme through gaining more representation on the ICA committees. Lawrence Alloway joined the Exhibitions Sub-Committee in October 1953 and was appointed Assistant Director in July 1955. Reyner Banham joined the Management Committee in 1953 to replace Herbert Read, who had embarked on a lengthy lecture tour of America. Alloway contributed to the public programme with talks based on his enthusiasm for American popular culture, including 'Science Fiction' in January 1954, chaired by the science fiction writer, Arthur C Clarke and 'Ambush at the Frontier', a dialogue on the contemporary Western with Toni del Renzio. Alloway and del Renzio

joined forces again in October 1955 to discuss 'Mass Communications 1: Fashion and Fashion Magazines', del Renzio was living the dream during the 1950s and worked as an Art Director for *Harper's Bazaar*. He brought a sophisticated analysis of women's fashion to the ICA's public programme, which was subsequently published by the ICA in a pamphlet entitled: *after a fashion...* in 1956. In it he described the fashion system in which the knowing consumer plays a key role:

> The skill is exactly the gauging of the force of the tendency to be typical, the defining of trends, the capturing of the next step, the double game of procuring and answering unvoiced wants, the confidence trick of significance, the acceptable and meaningful coding. It is a conspiracy between fashion editor, manufacturer and couturier, but a conspiracy whose victims are willing and sub-equal partners in a double-deal from which everyone profits. (Del Renzio 1956: 2)

Del Renzio developed these ideas further in an article for the RCA student magazine *ARK* in the following year. This magazine provides an important link between the Independent Group, the ICA and the RCA; stimulating and preserving conversations between the 'Avant Garde HQ' and London's leading school for postgraduate art and design. As Alex Seago has argued:

> Under Roger Coleman's editorship between the autumn of 1956 and the summer of 1957 *ARK* blossomed into an attractive, lively, and sophisticated magazine. Several commentators have mentioned that Coleman's friendship with Lawrence Alloway and involvement in the ICA led to *ARK* becoming a mouthpiece for the idea of the Independent Group....These claims have to be examined carefully, however, for the cultural politics of the period were more complex than most critics allow. (Seago 1995: 156)

The first contribution to *ARK* magazine from the Independent Group was by Reyner Banham, who contributed an article on British and Italian motorcycle design, entitled 'New Look in Cruiserweights' to Issue 16 in Spring 1956, before Coleman took over as editor. Reyner Banham had come into contact with the RCA through the College Librarian, art historian and broadcaster, Basil Taylor (Seago 1995: 158). Taylor had broadcast three programmes on the Third Programme during November 1953, taking Nikolaus Pevsner to task for his support of the picturesque. 'English Art and the Picturesque' was the title of the series, and Taylor's anti-picturesque argument would certainly have struck a chord with Banham and his Independent Group allies. Taylor was sympathetic to the Independent Group's affiliation with the brave new world of American popular culture and he contributed to the BBC Third Programme series on *Art-Anti-Art* during 1959 to 1960, including 'Artists as

Consumers: the Splendid Bargain' on 11 March 1960. Leonie Cohn produced the series for the BBC, and also served on the ICA Managing Committee from October 1954, right through the 1950s, providing an essential link.

The painter, Richard Smith, provided another invaluable link between the RCA and the ICA. He was a fine art student at the college from 1954 to 1957 and first visited the ICA in July 1955 for the opening of the library exhibition of Magda Cordell's work, *Monotypes and Collages*. He then joined fellow student, the graphic designer and writer, Roger Coleman, for an evening discussion on 'Man About Mid-Century' in February 1957. The two dapper art students discussed contemporary trends in men's fashion:

> The increase in mass media communication, particularly the movies, and the general levelling out of social gradings have provided the men's wear designer, and the clothes conscious male himself, with new sources and new influences. Mr. Coleman and Mr. Smith present a personal view of these new influences and trends in the Fifties. (ICA 1957: 8)

Coleman became a member of the ICA Exhibitions Sub-Committee during the following month joining his friend, Lawrence Alloway plus Theo Crosby, Robert Melville, Roland Penrose and Toni del Renzio. By this stage he was also editor of *ARK* magazine, and welcomed articles by the Independent Group, inspired by its clandestine ICA meetings. This included Alloway's 'Technology and Sex in Science Fiction: A Note of Cover Art' in Number 17, Summer 1956; Alison and Peter Smithsons' 'But Today We Collect Ads' in Number 18; John McHale's 'Gold Pan Alley' in Number 19 along with John McHale's 'Technology and the Home', and Lawrence Alloway's 'Personal Statement' to produce a virtual Independent Group special issue for Spring 1957. Toni del Renzio's 'Shoes, Hair and Coffee' was included in Issue 20 alongside Alloway's 'Communication Comedy and the Small World'. Another feature of the close links between *ARK* and the ICA is the full-page advert for the magazine which ran in the ICA Bulletin from July/August 1957 until March 1958. The ICA programme continued to attract the RCA students and in April 1957 Roger Coleman contributed to a discussion about the painter, Karel Appel with situationist Ralph Rumney.

The ICA's programme during the 1950s succeeded in providing the intellectual base on which the Independent Group built. The Group created a theoretical framework which was inclusive of all aspects of the cultural landscape; took the notion of the ephemeral into account and brought an in-depth analysis of technology to discussions of modern architecture and design. This provided a crucial interdisciplinary basis for the intellectual development of Pop Art and Design. The exhibition programme at the ICA was also vital in making manifest this intellectual enquiry, which investigated the gaps and connections between art and design during the 1950s and 60s.

A Place to Exhibit

One of the key exponents of Pop Art and Design was Richard Hamilton. He was introduced to the ICA by the photographer, Nigel Henderson, who knew Roland Penrose through his mother, Wyn Henderson (Massey 1995: 38). Hamilton installed the first exhibition at the new ICA's premises at Dover Street, *James Joyce: His Life and Work* and designed the exhibition catalogue, which doubled as a foldout, A0 poster. From the beginning Hamilton, with his background in design as well as fine art, was inspired by the transdisciplinary nature of the ICA. Here, he could not only exhibit his artwork, as he did in the official opening exhibition, *1950: Aspects of British Art*, where he showed *Microcosmos (Plant Life)* (1950) but also formulate ambitious exhibition design. His second exhibition installation at the ICA was *Growth and Form*, held at the ICA in July to August 1951, and based on the biological treatise by D'Arcy Wentworth Thompson. Encouraged and supported by Roland Penrose with the backing of an exhibition committee, Hamilton was able to explore the creative practice of exhibition installation to explore a scientific theme. The initial impetus behind the show was to inform design. As the ICA's *Bulletin of Information* declared on 28 December 1948:

4.5

Cover of exhibition catalogue, *The Popular Image*, 1963. Courtesy of the ICA.

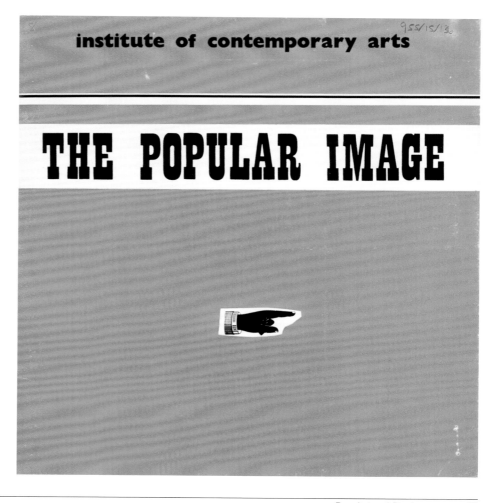

Modern science has made available a rich world of new forms and opened up a new source of inspiration to artists and industrial designers. Owing to the cleavage between science and art, this material, potentially revolutionary in its significance for modern design, has not yet been sufficiently noticed. By making available material hitherto difficult to access, such an exhibition may have a profound influence on the trend in design.
(ICA 1948: 3–4)

Hamilton continued to explore design through innovative exhibition installations with the 1955 show, *Man, Machine and Motion*. This was conceived of as a display of adaptive appliances and foregrounds the enthusiasm of Hamilton and his Independent Group colleagues in the burgeoning fantasy world of transport design and advertising imagery. The system of metal frames in which photographs and technical drawings were clipped created an all-embracing environment for the contemplation of the visual culture of movement. Reyner Banham wrote the extensive catalogue, which was designed by typographic pioneer, Anthony Froshaug. It first opened at the Hatton Gallery at King's College in Newcastle, then part of Durham University before installation at the ICA in London. This challenges the London-centric tendency of much writing on British Pop Art, which privileges the capital and the London-based galleries and art colleges over the rest of the UK. This is often based on the *Time* article, 'London: The Swinging City' of 15 April 1966 (Mellor 1993) but Newcastle, through the link with Hamilton, provided an important exhibition venue for Pop Art and Design.

The second touring exhibition organized by Richard Hamilton, Lawrence Alloway, Victor Pasmore, the ICA and the Hatton Gallery was *an Exhibit* in 1957. In the spirit of the Independent Group, this was a portable and flexible environment. Constructed from Perspex sheets hung from the ceiling, the exhibition provided a maze-like environment, ultimately disposable and rearrangeable. This countered the fine-art bias of many gallery spaces at the time, and reconceptualized the gallery as an exhibition space in its totality. This was the brave new world of the avant-garde, with the nineteenth-century plasterwork backdrops of the two venues partly obscured by this new, synthetic material. In the same spirit, the familiar format of the exhibition catalogue was abandoned in favour of a foldout, A0 sheet in the form of a quasi-map. Roger Coleman, now graduated from the RCA, positively reviewed the exhibition and its catalogue for *Art News & Review*, highlighting *an Exhibit*'s success in that it: '...repudiates any purely aesthetic interpretation and steers the whole thing off in another direction entirely; namely towards spectator participation, the corridors of Behaviourism, and the Theory of Games, etc. Which should present no difficulties to regular attenders at the ICA.' (Coleman 1957). This reinforces the argument that Roger Coleman, and his RCA colleagues, were familiar with the programme of events at the institute.

Richard Smith, who had now graduated from the RCA, took part in an exhibition at the ICA in January 1958 which offered younger artists the opportunity to show at this important avant-garde centre. *Five Young Painters* also included work by John Barnicoat, Peter Blake, Peter Coviello and William Green. Roger Coleman wrote the catalogue introduction, where he echoed Independent Group preoccupations when he explained that these artists: '...regard "Astounding Science Fiction" as more essential reading than, say, Roger Fry' (Coleman 1958: 1). Smith exhibited again at the ICA with Robyn Denny and Ralph Rumney in an exhibition entitled *Place* in September 1959. Roger Coleman wrote the catalogue introduction once more which drew on Independent Group themes. He argued: 'The mass media for Denny, Rumney and Smith is not a source of imagery, but a source of ideas that act as stimuli and an orientation in a cultural continuum' (Coleman 1959: 1). Building on the approach of *an Exhibit*, *Place* created an overall installation with the large canvasses placed directly on the gallery floor to create a maze for the ICA visitor to enter. But this time, the installation obliterated the gallery setting with the canvasses almost reaching the ceiling of the ICA gallery and virtually blocking out the light from the west-facing windows. Coleman referred to the work of the Independent Group and also Peter Blake in the *Place* exhibition catalogue in terms of the influence of the mass media: 'This can be seen ... in the allusions to Science Fiction and monster lore in the sculpture of Paolozzi, in McHale's ikons on consumption and in Blake's collages of pop heroes' (Coleman 1959: 1).

In the following year, 1960, Blake was to exhibit his artworks inspired by popular culture in the ICA exhibition, *Theo Crosby, Sculpture, Peter Blake, Objects, John Latham, Libraries*. Blake exhibited artworks made on remnants of the interior: *Girlie Door* (1959), *Everly Wall* (1959) and *Kim Novak Wall* (1959). As Alloway rightly observed in the exhibition catalogue: 'Blake works as a fan' (Alloway 1960: 1). This is a subtly different approach to the Independent Group, and indeed Roger Coleman, Denny and Smith, who wanted to unpack the processes of popular culture and design. Peter Blake is a painter who is inspired by popular culture, and uses it to inform the content of his work. In 1963 Blake was to marry the American Pop artist, Jann Haworth. She too exhibited her work at the ICA when her sculptures were rejected for the 1963 Young Contemporaries; the ICA included her tableau of two life-size figures with flowers, a hound and doughnuts in its *Four Young Artists* show in September 1963, her first London showing.

The nature of the transatlantic relationship between the British architects, artists, curators and theorists had begun to materially alter by the early 1960s. Peter Blake paints as a fan of Kim Novak and the Everly Brothers, but the Independent Group members were starting to make the journey to the utopia of the USA, and many eventually settled there. William Turnbull first visited New York in 1957; Peter Smithson first visited the East Coast of the USA in the same year. Magda Cordell and John McHale left London in 1962 to join futurist designer, Buckminster Fuller at Southern

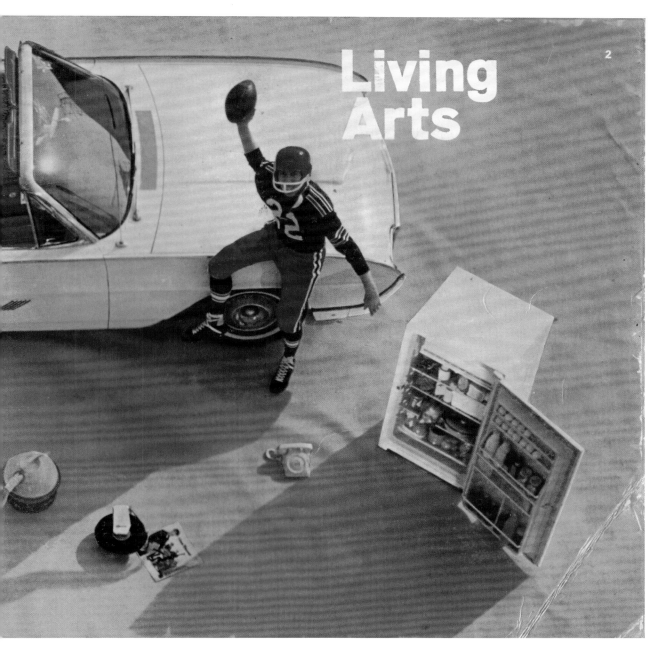

Living Arts

4.6

Cover of *Living Arts* No 2, 1963, published by the ICA. Cover photograph by Robert Freeman, arranged by Richard Hamilton in connection with his 'Urbane Image' article in the magazine. Courtesy of the ICA.

Illinois University. They were to remain in the USA for the rest of their lives. Alloway departed in the autumn of 1961 to teach at Bennington College in Vermont with his life partner, the painter Sylvia Sleigh. He was appointed Curator of the Solomon R. Guggenheim Museum in 1962 and organized many important exhibitions there, including *Six Painters and the Object* which featured American Pop artists Jim Dine, Jasper Johns, Roy Lichtenstein, Robert Rauschenberg, James Rosenquist and Andy Warhol. This was just at the moment when American Pop Art was emerging as an avant-garde movement in the wake of abstract expressionism. And it was at the ICA that the first institutional showing of this exciting new movement in painting and sculpture was exhibited.

The Popular Image USA in October and November of 1963 at the ICA brought the work of Rauschenberg, Johns, Dine, Tom Wesselmann, Lichtenstein, Warhol, Claes Oldenburg and Rosenquist to London for the first time. This was organized with the Ileana Sonnabend Gallery in Paris. Ileana Sonnabend had moved to Paris from New York in 1961 with her husband Michael to open the gallery in November 1962 (Temkin and Lehmann 2013: 19). She was on a mission to promote the new American Pop Art in Europe, and the ICA provided the ideal venue. The critical reception was not positive, with the majority of the British press ridiculing Warhol's multiple portraits of Marilyn Monroe and Wesselmann's giant ice-cream cone. *The Evening News* protested:

> An ice-cream cone three feet long and 49 portraits of Marilyn Monroe, all of them the same, are the highlights of an exhibition of American 'pop' art at the highbrow Institute of Contemporary Arts in Mayfair.
>
> The ice-cream cone made of plaster, is the contribution of 34-year-old Claes Oldenburg, whose 10ft-diameter hamburger caused a frenzy of excitement among New York intellectuals when it was shown at the Museum of Modern Art recently.
>
> The ice-cream cone you will be disappointed to hear, is not for sale. Nor are the Monroe portraits which are by 23-year-old Andy Warhol, a New York commercial artist. (*Evening News* 1963)

Reyner Banham also reviewed the exhibition for *New Statesman*, and complained that American Pop Art did not inspire British Pop Art; it was the other way round:

> Richard Hamilton, for instance, was painting pictures comparable (in content and style) with Rosenquist's man/equipment mural five years or so ago, long before any Rosenquists had been seen over here, while the link up between the ICA's Independent Group and the Royal College dissidents, which was one of the points of departure for Royal College

Pop painting dates from slightly earlier, from the period of the earliest Pop pictures by Peter Blake (the famous *Drum Majorette*) and the earliest just-off-Pop-action-painting by Richard Smith. (Banham 1963)

A Place to Publish

From its very first exhibition, the ICA had taken the time and trouble to produce informative exhibition catalogues, often with the support of one of the key founders, Peter Gregory, chairman of Lund Humphries. The experimental nature of the ICA's catalogues in terms of design and layout is evidenced through the work of Richard Hamilton and Anthony Froshaug. By 1963 the ICA had launched its own version of *ARK*. *Living Arts* was launched in 1962 to commit to print the ongoing debates and exhibitions held at the ICA and edited by Theo Crosby and John Bodley. As the editorial to the first issue observed:

> The fifties have passed, and we remember the ferment of intellectual exchange and experiment that took place in and around the ICA; yet how little except fugitive pieces survives to fix the activity of those years in print; a generation engrossed in the processes of communication will be found in retrospect to have committed only a fraction of its aims, arguments, basic ideas and sources to the record. The effort to start *Living Arts* will have been justified if something of the live art, the raw thinking and the studio talk of the following period, however tangential, survives in its pages. There will be three issues of the magazine in the first year. (1962: 1)

4.7

Cover of *Living Arts* No 3, 1964, published by the ICA. Cover photograph by Geoffrey Gale. Courtesy of the ICA.

The link with the RCA and *ARK* is exemplified by the cover of the first issue which featured a colour photograph of a Richard Smith work, taken in his studio by Robert Freeman. The cover of Issue 2 was a striking image of a 1963 Ford Thunderbird and American product design against a lipstick pink background, featuring Richard Hamilton in an American football strip, also taken by Robert Freeman. This illustrated Hamilton's article on 'Urbane Image' in which he reproduced his most recent Pop Art works, including *Homage a Chrysler Corp* (1957), *Hers is a Lush Situation* (1958), *Pin-up* (1961), *AAH!* (1962) and associated preparatory work. The text is full of knowing analysis of contemporary consumer culture and design.

The issue also included no less than 49 pages devoted to the Archigram *Living City* exhibition, held at the ICA from 19 June to 2 August in place of an exhibition catalogue.

Issue 3 was the last issue to be produced before the publication ran into financial problems. It included an interview of American colour field painter, Paul Feeley, who had established the art department at Bennington College, Vermont where Alloway worked during the early 1960s. The Italian design critic, Gillo Dorfles, contributed an important article on 'Communication and Symbolic Value', where he proposed: '… an analysis of some fields of contemporary creativity based on symbology and the theory of communications, and extend to take in architecture, industrial design and advertising. The three latter fields increasingly condition our lives and affect many of our creative ideas, but until fairly recently they have been regarded as less important than the fine arts' (Dorfles 1964: 79).

An article in the same issue by Reyner Banham echoed Dorfles's augments. 'The Atavism of the Short-Distance Mini-cyclist' was a transcription of Banham's Terry Hamilton Memorial Lecture delivered at the ICA the previous year to mark Terry Hamilton's tragic death in a car accident. Banham argued from the point of view of a working-class, knowing consumer who grew up with American popular culture. For Banham: 'Pop … has become the common language musical, visual and (increasingly) literary, by which members of the mechanised urban culture of the Westernised countries can communicate with one another in the most direct, lively and meaningful manner' (Banham 1964: 97).

The ICA provided the intellectual incubator for the development of Pop Art and Design. Through the premises it provided, the programme of events staged, the exhibitions organized and the publications printed it was the linchpin of the development of Pop Art and Design.

References

Alloway, L. (1960), 'Introduction', *Theo Crosby, Sculpture, Peter Blake, Objects, John Latham, Libraries*, London, ICA.

Altshuler, B. (2008), *Salon to Biennial – Exhibitions That Made Art History, Vol 1: 1863–1959*, London: Phaidon.

Banham, R. (1963), 'No Dave', *New Statesman*, 15 November. ICA Press cuttings book.

Banham, R. (1964), 'The Atavism of the Short-distance Mini-cyclist', *Living Arts*, London, ICA, 91–7.

Boothby, J. and Morland F. (2015), *The Art of Smuggling*, Milo Books Ltd.

Coleman, R. (1957), 'Mice and Men', *Art News and Review*, 17 August 1957.

Coleman, R. (1958), Introduction, *Five Young Painters*, exhibition catalogue, London: ICA.

Coleman, R. (1959), Introduction, *Guide to Place*, exhibition catalogue, London: ICA.

del Renzio, T. (1956), 'After a Fashion ...', ICA Publications 2, London: ICA.

Dorfles, G. (1964), 'Communications and Symbolic Value', *Living Arts*, London, ICA, 79–97.

Evening News (1963), 'Big Ice', 25 October. ICA Press cuttings book.

Foster, H. (2012), *The First Pop Age: Painting and Subjectivity in the Art of Hamilton, Lichtenstein, Warhol, Richter, and Ruscha*, Princeton and Oxford: Princeton University Press.

Hammer, M. (2014), 'Respect: the IG Take on Francis Bacon', *Journal of British Visual Culture*, 15 (1): 69–89.

ICA Bulletin (1949), 28th December, 3–4, London: ICA.

ICA Bulletin (1957), No 73, February.

King, J. (2016), *Roland Penrose: The Life of a Surrealist*, Edinburgh University Press.

Living Arts (1962–4), Issue 1 1962; Issue 2 1963; Issue 3 1964, Bolton: ICA.

Lodge, D. (2015), *Lives in Writing*, London: Vintage Books. First published 2014.

Massey, A. (1995), *The Independent Group: Modernism and Mass Culture in Britain, 1945-59*, Manchester, Manchester University Press.

Massey, A. (2013a), 'The Mother of Pop?: Dorothy Morland and the Independent Group', *Journal of Visual Culture*, 12 (2): 262–78.

Massey, A. (2013b), *Out of the Ivory Tower: The Independent Group and Popular Culture*, Manchester: Manchester University Press.

Massey, A. and Muir, G. (2014), *ICA: 1946–68*, London: ICA.

Mellor, D. (1993), *The Sixties Art Scene in London*, London: Phaidon.

Seago, A. (1995), *Burning the Box of Beautiful Things: The Development of a Postmodern Sensibility*, Oxford: Oxford University Press.

Temkin, A. and Lehmann, C. (2013), *Ileana Sonnabend: Ambassador for the New*, New York: The Museum of Modern Art.

ARK Magazine: The Royal College of Art and Early British Art School Pop

Alex Seago

Pop was a resistance movement: a classless commando which was directed against the Establishment in general and the art-Establishment in particular ... Pop was meant as a cultural break, signifying the firing-squad, without mercy or reprieve, for the kind of people who believed in Loeb classics, holidays in Tuscany, drawings by Augustus John, signed pieces of French furniture, leading articles in *The Daily Telegraph* and very good clothes that lasted for ever (Russell and Gablik 1969: xi).

Between the mid-1950s and early 1960s British culture was propelled into a new era by young visual revolutionaries who transformed the face of British art, fashion, film, television, advertising, newspapers and magazines. Responsible for setting the pendulum of the image-obsessed 'Swinging Sixties' in motion, many such 'neophiliacs' (Booker 1969) were alumni of London's Royal College of Art. Within the RCA the epicentre of this movement was the School of Graphic Design, whose magazine *ARK* provides a fascinating insight into the development of peculiarly English Pop sensibility – an attitude and outlook that requires historical and cultural contextualization.

ARK, The Journal of the Royal College of Art was established in 1950 on the initiative of Jack Stafford, a student in the RCA's School of Woods, Metals and Plastics. In his editorial for the first issue he stated that the purpose of the magazine would be to 'explore the elusive but necessary relationships between the arts and the social context', an object of enquiry which remained relatively consistent throughout the magazine's twenty-five-year history and which makes it such a valuable archive for anyone interested in disentangling the complex 'little narratives' of British design history during the 1950s and early to mid-1960s.

ARK was initially produced in the style of contemporary 'little magazines' such as John Lehmann's *Penguin New Writing*. It assumed a literary tone characteristic of a pre-television era when rationing, paper shortages and restrictions on inessential imports ensured that visual material was in short supply and reading was one of the few forms

of entertainment. Appearing three times a year, with a full-time editor responsible for an annual edition and a separate team of student graphic designers responsible for every issue, the initial print run was 2,000, peaking at 3,000 in 1963 – by which time *ARK* could boast a global list of subscribers. While the high turnover of editors and art editors resulted in an almost total lack of stylistic unity or thematic continuity, *ARK* was far more professionally produced than almost any other student publication of the period – perhaps only surpassed by Cambridge University's *Granta*. Although it seldom managed to break-even, the magazine aimed to be self-financing and was available by subscription or over the counter at art booksellers such as London's Zwemmer's or Better Books. The magazine also relied heavily on advertising revenue charitably supplied by companies with strong links to the RCA via their directors' membership of College Council, including Schweppes, Gilbey's Gin, the Orient Line, Murphy's Radios, and from the late 1950s onwards by advertising agencies such as Colman, Prentis & Varley who were eager to attract talented recruits. These companies often encouraged students to design their advertisements. With its quirky contents and ever-changing layouts *ARK* provides a unique insight into the changing enthusiasms of post-war generations of British art and design students.

Established in 1948 as part of the incoming Rector Robin Darwin's radical reorganization of the Royal College of Art, the School of Graphic Design developed a distinctive character which set it apart from its contemporary rivals, the most notable of which was Jesse Collins' Department of Graphic Design at London's Central School of Arts and Crafts. Collins' department was influenced by the continental model of graphic design training and was staffed by progressive, avant-gardist/ modernist designer-teachers such as Herbert Spencer, Anthony Froshaug and Edward Wright. By contrast the RCA's approach, strongly favoured by Robin Darwin and the School of Graphic Design's Professor Richard Guyatt, was far more conservative and was characterized by the presence of a more traditional type of English 'gentleman graphic artist/illustrator' – including Edward Bawden, John Lewis, John Brinkley, Edwin La Dell, Reynolds Stone and also by the charismatic influence of John Minton, the famous young neo-romantic artist/illustrator attached to the RCA's School of Painting. While the Central School embraced European avant-garde experimentation, throughout the late 1940s and early 1950s the RCA virtually ignored foreign Modernism – preferring to emphasize genteel book illustration, steel and woodblock *gravure*, fine typography and the luxurious and exclusive bookbinding distinguishing the limited editions published by the RCA's The Lion and the Unicorn Press.

In his 1950 inaugural lecture entitled 'Head, Heart and Hand' the RCA's newly appointed Professor of Graphic Design outlined the aims of his department and the philosophy upon which its teaching would be based. For Guyatt an RCA design training implied the development above all of a refined aesthetic sensibility and 'good taste':

If the idea behind a poster or press advertisement is cheap
or silly, then the expression of it in pictorial form is bound to
be cheap and silly ... Obviously one cannot teach design at
the debased level. To learn about design one must first of all
understand what is 'good' in good design. This means developing
one's taste ... Ability in a young designer grows by this
assimilation of good taste coupled with the effort of creating it
in new and personal forms – in understanding and then trying to
create good designs. (Guyatt 1951: 38)

These sentiments were closely linked to Robin Darwin's insistence that
the new breed of RCA designer during the era of his leadership (the 'Era
of the Phoenix' as he liked to refer to it) needed not only applied skills of
production processes and business know-how, but also 'the amused and
well-tempered mind' of a gentleman which would enable him (and it was
typically 'him') to feel at home in the company of the cultivated elite:

You won't get good designs from the sort of person who is
content to occupy a small back room: a man who won't mix
because his interests are too narrow to allow him to, a man who
is prepared and, by the same token, only desires to eat, as it were,
in the servants' hall. (Frayling and Catterall 1987: 131)

The largest Department in the RCA, the School of Graphic Design (the
title was changed from 'Publicity Design' after an article in *The Times*
expressed its abhorrence at the vulgarity of the term) played a vital role in
fulfilling Darwin's intention of re-establishing the College at the pinnacle
of British art and design education. One key to the RCA's new identity was
'Englishness', an image epitomized by the Rector himself as an Old Etonian
and descendant of Sir Charles Darwin. This sense of 'Englishness' was
reinforced by the physical and psychological remodelling of the RCA in the
mould of a Cambridge University college, complete with a Senior Common
Room with a 'High' (or 'Painters') table, a wealthy and influential College
Council and a spate of recently invented 'traditions' and ceremonies –
including an elaborate graduation ceremony featuring a procession led by
the liveried College Beadle during which busby-wearing members of the
Brigade of Guards provided bugle fanfares at propitious moments.

Although Darwin's gentrification programme seemed absurd to some
of his more cynical contemporaries, a steely logic underlay his reforms. The
RCA had been an object of some derision amongst the tiny pre-war British
design community thanks to its perceived tendency to produce teachers
rather than practitioners. Darwin insisted that all his professors should be
practicing artists and designers and his reforms were intended to establish
the RCA as a 'switchboard institution' – a place where the captains of
British industry would feel comfortable and welcome, make connections

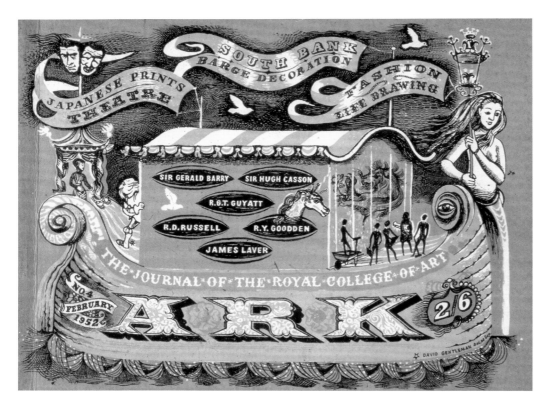

Chapter 5: *ARK* Magazine: The Royal College of Art and Early British Art School Pop | Alex Seago

with staff and be introduced to budding RCA student design talent. Moreover, the image of the College as a conservative, traditional institution was perfectly in keeping with the general mood of a population wearied by war and austerity, deeply suspicious of alien continental ideologies and longing for reassuring images of the national identity and culture so many had so many had fought for and died to defend.

A direct reflection of this peculiarly English *zeitgeist* much in evidence throughout the early issues of *ARK* was an enthusiasm for Victoriana. This nostalgic movement was intimately linked to the 1951 Festival of Britain and in particular to the collaboration between RCA staff and students in the design of the festival's Lion and the Unicorn Pavilion, within which the interior design and displays were intended to capture the essence of Englishness by emphasizing 'the leonine tradition and the whimsy of the Unicorn' (Seago 1995a: 52). This quest for Englishness was represented via the liberal use of archaic Victorian typefaces such as Egyptian Expanded, Doric Italic, Bold Latin, Thorowgood Italic and Thorne and Figgins Shaded, which had been enthused about by nostalgic typographic revivalists since the 1930s. Agreeing with Charles Hasler, Chairman of the Festival of Britain's Typographic Panel, that 'nothing could be more British in feeling than the display types created by the early nineteenth century typefounders' (Banham and Hillier 1976: 114), the RCA team developed a neo-Victorian display emphasizing the conservative traditionalism and inherent eccentricity of British culture. Replete with a host of reassuring images of country life, tweed jackets, briar pipes, salmon fishing rods and handmade brogues, the display could have easily convinced any foreign visitor that British design remained untouched by alien Modernism.

The cover of *ARK* 4 (Spring 1952) designed by the RCA-trained graphic artist and tutor David Gentleman, perfectly captures the spirit of the time, and for the next three years the magazine was characterized by nineteenth-century ecclesiastical typefaces, articles on nostalgic popular cultural themes such as the decoration of a Thames sailing barge ('its cabin finished in bird's eye maple, mahogany and gleaming brass … its rich and pleasant smell mingling sweetly with the tang of bitumen … and of the servings and ratlines soaked in Stockholm tar'), tattooing, sea shanties, Victorian china dolls and puppet theatres.

ARK was eventually dragged away from its nostalgic obsessions by two unconventional and assertive art editors, Len Deighton and Raymond Hawkey. Arriving at the RCA in 1952 from St Martin's College of Art, with experience in the RAF's film unit and a background in commercial photography, Deighton was appalled by the archaic attitudes and snobbish anti-commercialism of the RCA:

> At the RCA the role of the art director was not acknowledged,
> neither was the existence of photography … While studying
> I managed to spend some of my vacation time working as an

5.1 (opposite, top)

David Gentleman. Cover of *ARK* 4. Winter 1952. © Royal College of Art Archive.

5.2 (opposite, bottom)

Jim Lovegrove illustration for his article on 'The Spiritsail Sailing Barge'. *ARK* 4. Winter 1952. © Royal College of Art Archive.

unpaid supernumerary in various London advertising agencies where I found a rebellion – against such things as Victorian typefaces – that somewhat mirrored my own feelings. American advertising agencies were coming to London and preaching the disturbing idea that advertising should sell things. For their English competitors this was a most unpopular innovation, and at the RCA it was enough to confirm their darkest suspicions about American insensitivity. I could find no one on the staff of the RCA who wanted to know anything about the world into which students ... would one day have to fit. Hearing me call camera-ready material 'art work' one tutor confided that he found the expression horrible. Students ... did not dare to be seen to be producing 'slick' work (which meant anything publishers would buy). (Seago 1995a: viii)

Unwilling to undertake the required studio exercises in illustrating the classic works of literature in styles that had been popular fifty years earlier, Deighton developed a personal idiom heavily influenced by commercially successful contemporary American illustrators David Stone Martin and Bob Peak. Along with his RCA contemporary Joe Tilson (RCA 1952–5), Deighton was one of the first post-war RCA students to illustrate in *ARK* the first glimmerings of London's Pop 'scene' to be found in the jazz clubs and Italian restaurants of Soho before becoming the first of many RCA graduates to take the trip to New York City. Much to his tutors' chagrin *ARK* 10 (Summer 1954), art edited by Deighton, featured a photograph on the cover ('they called me "the photographer" and they didn't mean it as a compliment, either') and a US cowboy comic Hopalong Cassidy feature inside.

As the 1950s merged into the 1960s it became apparent that the interests of *ARK* contributors in Pop could be loosely divided into what Joe Tilson has termed 'uptown' and 'downtown' tendencies:

It's easy to get this period terribly wrong. There are two quite distinct things you have to trace. The first is interest in Americana and American culture generally. The second is when it's used, how it's used and who it's used by ... All Pop tends to get lumped together, but it's much more complex than that. I've always said there was an Uptown Pop and a Downtown Pop. (Seago 1995a: 139)

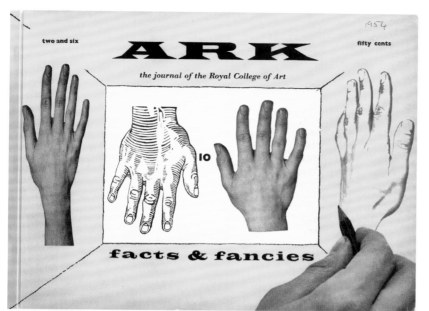

5.3 (left)

Len Deighton. Cover of *ARK* 10. Spring 1954. © Royal College of Art Archive.

5.4 (below)

Comic book insert in *ARK* 10. Spring 1954. © Royal College of Art Archive.

5.5 (bottom)

Len Deighton 'A Bowler Hat on Broadway' illustration for *ARK* 13. Winter 1955. © Royal College of Art Archive.

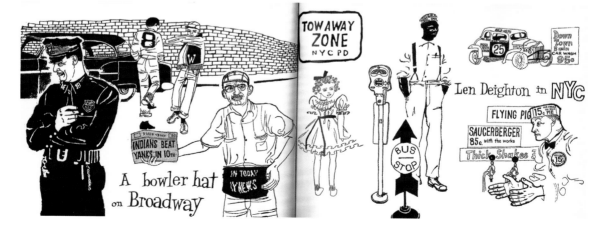

Len Deighton's friend Raymond Hawkey, art editor of *ARK* 5 (Summer 1952) was one of the earliest *ARK* contributors to celebrate this 'uptown' sensibility. Admitted to the RCA's School of Graphic Design on the basis of the excellence of his traditional skills as a graphic artist he quickly began to appreciate the limitations of his tutors' aesthetic preferences:

> I remember buying one of the first *Art Directors' Annual of Advertising and Editorial Art*, published by the Art Directors' Club of New York. It came as an absolute revelation. Even today you can see a lot of work in magazines that looks as if it could have come from those chic, elegant annuals. In America at that time they were already using very sophisticated modern photography whereas the emphasis in England was very much on drawing, producing illustrations which often had a fake wood block quality. (Seago 1995a: 142)

For talented students like Deighton and Hawkey what was so admirable about American graphic design was its sheer professionalism and self-confidence. For them it represented an escape from the future their tutors seemed to be mapping for them – the penury of part-time teaching, occasional work for contemporary journals like *Lilliput* and the *Radio Times* or perhaps, if you were lucky, the odd advertising commission for a patrician patron like Shell UK's Jack Beddington (see Hawkey 1952).

After winning a *Vogue* talent contest in 1953 Raymond Hawkey went to work for Condé Nast and was soon Art Director of British *Vogue*. It was here that the interest in American graphic design he had developed at the RCA stood him in good stead: 'because my interests reflected what their American art director Alexander Liberman had been doing for many years … the accent of my work was right (Seago 1995a: 143). By 1958 Hawkey had been headhunted by Lord Beaverbrook as a consultant and by 1959 he was Design Director of the *Daily Express*, collaborating with Michael Rand to transforming the image of the newspaper with the introduction of polished, sophisticated, modern magazine flavour. In 1964 Michael Rand left the *Express* to become Art Editor of the *Sunday Times Magazine* while Hawkey left the paper to join the *Observer* as Presentation Director, where he worked with another RCA graphic design graduate and *ARK* contributor, Romek Marber, to design the *Observer Colour Magazine*. Both publications epitomize British 'uptown Pop' of the 1960s and both were of the utmost importance in disseminating the new Pop sensibility during that decade.

Two years earlier, in 1962, former *ARK* contributors Deighton and Hawkey had collaborated once again, with Deighton as the author and Hawkey as the designer of one of the iconic British bestsellers of the decade, Len Deighton's *The Ipcress File*, which became a hugely successful film in 1965 starring Michael Caine as the anti-hero Harry Palmer. Both the novel's dust jacket – featuring a photograph of a revolver and an MoD coffee

Raymond Hawkey book jacket for
Len Deighton's *The Ipcress File*, 1962.
© Mary Ellen Hawkey.

cup with an extinguished Gauloise cigarette in the saucer, and the novel's
plot, highlighting the street-smart, sophisticated working class ex-con Harry
Palmer's lack of deference to his public-school accented superiors can be
interpreted as partly reflecting the experiences of the book's author and its
graphic designer whilst at the RCA.

Although Robin Darwin appeared to epitomize patrician upper-class
English 'good taste' his attitudes to design education were pragmatic
and far from being close-minded. As the 1950s progressed he became
increasingly impressed by the dynamism and professional focus of design
education in the USA. Richard Guyatt also visited Yale in 1955 and the
following year, Alan Fletcher, art editor of *ARK* 13 (Summer 1955) became
the first student in the School of Graphic Design to be awarded an FBI

5.7 (top)

Patricia Davey. Cover of *ARK* 12, Autumn 1954. © Royal College of Art Archive.

5.8 (bottom)

Alan Fletcher. Frontispiece for *ARK* 13, Winter 1954. © Royal College of Art Archive.

Travelling Scholarship as a Yale/RCA Exchange Scholar. Strongly influenced by the modernist curriculum of Jesse Collins' Graphic Design Department at the Central School, which he had attended before the RCA, Fletcher was responsible for featuring modernist typography in *ARK* and ensuring that the journal featured an article on 'Recent Developments in Typography' by Herbert Spencer, his ex-tutor at the Central School and editor of the influential journal *Typographica*. Like Len Deighton and Raymond Hawkey in the year before him, Alan Fletcher was chafing against the limitations of the RCA approach to graphic design and seized the opportunity to study in the USA with the greatest enthusiasm:

> I'd always wanted to go to America. It was all grey here but in the States was Doris Day, bright lights, big cars. It seemed like Mars to me when I got there, I couldn't believe it, it was great ... At Yale I was taught by amazing guys – Paul Rand, Leo Lionni, Saul Bass, Lou Dorfsman – really big cheeses. On the British side you had Henrion, Games, Lewis, Unger, Brinkley. It was a total generation gap not so much of age but of *attitude*. (Seago 1995a: 149)

In contrast to the RCA where the staff of the School of Graphic Design kept the sans serif type 'under lock and key'– considering it 'too modern' for everyday use – in the USA Fletcher's teachers were integral components in a fast-paced, high-powered, lucrative world of publicity design with integral links to Madison Avenue and Hollywood. Fletcher's breathless response to US 'uptown Pop' appeared in a 'Letter From America', mailed from New York and published in *ARK* 19 (Spring 1957) by the influential *ARK* editor Roger Coleman:

> At rush hour commuting New Yorkers drive out of Manhattan at sixty miles an hour ... By day the streets of New York are a kaleidoscope of colour. The dazzling hues of automobiles form constantly changing and dazzling patterns within the rigid design of the gridded streets and vertical buildings. The flat areas of pink, blue, chocolate and red are punctuated with the chequered squares of taxis ... the garish colours and tinsel ads lie haphazardly across the faces of buildings. By night the city is transformed. The skyscrapers blend into the night sky and glittering neons write across a drop of twinkling stars ... the moving lights of Coca-Cola reflect from a waterfall which cascades down to the brightly lit street. (Fletcher 1957)

As Anne Massey argues elsewhere in this volume, early Pop in Britain involved a complex combination of interests and enthusiasms for avant-garde Modernism and commercially oriented Americana. The layout of *ARK*s 18, 19 and 20 (Winter 1956–Summer 1957), edited by Roger Coleman

5.9 (below)

Gordon Moore. Cover of *ARK* 19. Spring 1957. © Royal College of Art Archive.

5.10 (opposite, top)

Alan Fletcher photocollage illustrating his 'Letter from America'. *ARK* 19. Spring 1957. © Royal College of Art Archive.

5.11 (opposite, bottom)

Alan Fletcher 'Letter from America'. *ARK* 19. Spring 1957. © Royal College of Art Archive.

(and famously, via Coleman's friendship with Lawrence Alloway, featuring articles written by Independent Group luminaries including Alloway, Peter and Alison Smithson, Reyner Banham, John McHale, Frank Cordell and Toni Del Renzio) combined Swiss modernist influences with Pop Americana including collages of photographs of contemporary magazine covers sent from New York by Alan Fletcher. While the theoretical elements of early British Pop these *ARK*s contain has been analysed extensively, most of the practitioners responsible for their design had a huge impact on the visual landscape of Britain during the 1960s – none more so than Alan Fletcher who, after gaining experience in the USA working on full-colour commissions for *Fortune* magazine, returned to London in 1958 as consultant Art Editor for *Time Life* before helping form the Fletcher, Forbes, Gill Partnership (later to become Pentagram) in 1962, the year which also saw the foundation of the British Designers and Art Directors' Association.

As in other areas of British culture, 1956 was a key year for *ARK* and graphic design at the RCA, marking the beginning of a rapid period of transition in which a generation of young designers, including June Fraser,

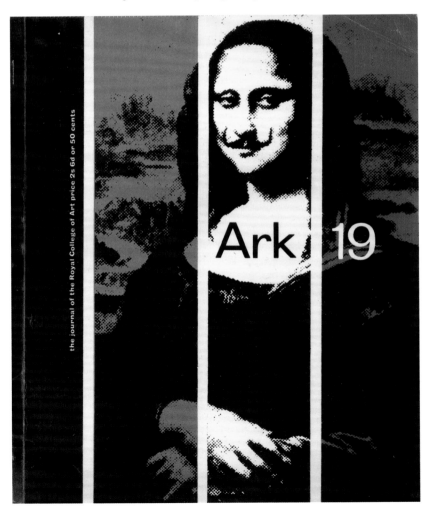

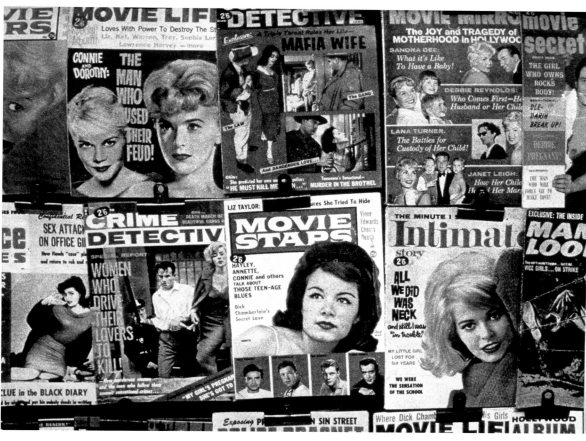

LETTER FROM AMERICA

First impressions of New York

Alan Fletcher

The impact of America on a visitor is partly tempered by his previous knowledge gained from the cinema, periodicals and hearsay. Of course I knew that American cars were big, but it never occurred to me that they were all big. Rapidly one has to readjust one's scale of values to the environment, and as an observer I find the most striking impressions are given by those things which require the readjustment most.

I am more aware of the potentialities of a brash aluminium diner (a static stratoculture) than of Corbusier's sophisticated United Nations building. The former has the advantage of surprise, an unreality equal to meeting a man from Mars, whereas Corbusier's building is international. I was already acquainted with its language before I even saw it.

My impressions then, centre around those aspects of everyday life accepted as normal by the Americans, but to me unusual, extreme, and in some cases stimulating. In fact – Americana.

They say that dogs in New York walk faster than anywhere else in the States. At rush hour commuting New Yorkers drive out of Manhattan six miles per hour, bumper to bumper, while the subway – reminiscent of the Paris Metro in appearance and smell – feeds harassed passengers out to Brooklyn and neighbouring suburbs. By day the streets of New York are a kaleidoscope of colour. The dazzling hues of automobiles form constantly changing and brilliant patterns within the rigid design of gridded streets and vertical buildings. The flat areas of pink, blue, chocolate, and red are punctuated with the chequered squares of taxis. Meccano-like neon structures rear against

the sky, and the garish colours and tinsel of advertisements lie haphazardly across the faces of buildings.

By night the city is transformed. The skyscrapers blend into the night sky and glittering neons write across a drop of millions of twinkling lights. Many of the signs, seemingly suspended in the blackness above the sidewalk's glare, give a feeling of disbelief as the interweaving shapes and lines grow and then fade away into nothingness. The moving lights of Coca-Cola reflect from a waterfall which cascades down to the bright lit street and then silently disappears just above the sidewalk without a splash or drop of water.

Dream-cars, those mobile wonders of mechanical comfort, assuredly six years ahead of design say the manufacturers producing their 1957 models, have reached such an unprecedented length that the proud owner can no longer close his garage doors. Dressed in brilliant colours and girdled with chromium they are the gay deceivers of credit and instalment plans. An unkind truism, voiced by an American, explained that everyone thought chrome was silver! The automobile is king of the jungle, and the pedestrian, if not exactly the prey, must conform to a lesser role or meet a nasty end. Life literally centres around the wheel.

Besides the motels (usually well designed), there are drive-in restaurants, drive-in cinemas (al fresco), drive-in tellers (banks), and projected port breezes.

On the latter turnpikes you can drive non-stop for miles, traversing cross-points by cloverleaf intersections, bridges and tunnels. Many have the paraphernalia of the English by-pass, cluttered signs, ramshackle Max Snax, and the looseknitted wires of rusted vehicle cemeteries. On the

36

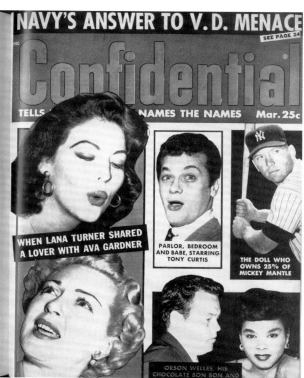

Douglas Merritt, Alan Bartram, David Collins and Gordon Moore used their art editorships of the magazine to develop an alternative graphic aesthetic. By late 1956, under Roger Coleman's editorship, *ARK* was transformed into a key document of early British Pop featuring articles (many of which, as Anne Massey explains, were transcriptions of ICA talks) on abstract expressionism, Hollywood film, the Pop music business, television design, fashion and the new teenage '*espresso* bar' culture. Abandoning the 'little magazine' format, the new breed of A4 format *ARK*s enabled a succession of art editors to experiment with typefaces, layouts, papers and overlays paving the way for the more extreme experimentations of the alternative 'underground' press of the mid to late 1960s.

Dadaist experimentation was another key element of the *ARK*s of the late 1950s and early 1960s. The British art school 'take' on this movement often involved performance-based satire. This movement was pioneered by the zany, surreal and often quite dark humour of BBC radio's *The Goon Show* which fused into the surreal 'trad' jazz performances of Bruce Lacey and The Alberts, The Temperance Seven, The Bonzo Dog Doo-Dah Band and the

5.12

A.J. Bisley, photography and David Collins, designer. Cover of *ARK* 20. Autumn 1957. © Royal College of Art Archive.

Shoes hair and coffee by Toni del Renzio

5.13 (left)

David Collins and Toni del Renzio. Design for Toni del Renzio's article 'Shoes, Hair and Coffee'. *ARK* 20. Autumn 1957. © Royal College of Art Archive.

Arcade fever by Michael Chalk

5.14 (above)

David Collins and Michael Chalk. Design for Michael Chalk's article 'Arcade Fever'. *ARK* 20. Autumn 1957. © Royal College of Art Archive.

5.15 (left)

A.J. Bisley photographer and Michael Collins designer. 'On the Mat in Lime Grove'. *ARK* 20. Autumn 1957. © Royal College of Art Archive.

Lucio Fontana (image) and Dennis Postle designer. Cover of *ARK* 24. Autumn 1959. © Royal College of Art Archive.

1960s Pop films of Richard Lester. A similar anarchic, anti-establishment spirit fuelled the post-Profumo affair satire boom including, for example, the 1961 launch of *Private Eye* magazine and the vitriolic 1962/1963 era satire of the TV show *That Was the Week That Was*. One of the main visual conduits of this spirit at the RCA was the graphic designer Edward Wright. Hired by Richard Guyatt in the late 1950s in a rather belated attempt to catch up with the new *zeitgeist*, the fizzing energy of Wright's typographic and sonic experimentation immediately influenced *ARK*. Sometimes his influence was direct, as in David Gillespie's cover for *ARK* 23 (Autumn 1958) but often it was subtler. For art editors like Denis Postle (*ARK* 24, 1959) and Terry Green (*ARK* 25, 1960), Wright's teaching and his own work with its emphasis on chance, randomness, anti-structure and intuition offered a graphic design-based equivalent to abstract expressionist *tachisme*-style painting that had recently been pioneered in the RCA Painting School by Richard Smith, Robyn Denny and William Green or by the sound of Ornette Coleman's free jazz. Postle's proto-punk cover for *ARK* 24, with its Lucio Fontana-inspired 'bad taste day-glo' cover and self-consciously ugly and sarcastic obligatory advertisement for the Orient Line ('The Orient Line Cruises The Med This Summer, Coming?') echoes the magazine's situationist-oriented contents. As Postle remembers, one of the main aims was to offend the Establishment:

> I learned the old-style book production at Sunderland College of Art and it provided a good basis to kick against ... the Lion and the Unicorn Press was regarded with hoots of derision by all of us as pointlessly and hopelessly anachronistic ... One of the famous jokes about the staff in the School of Graphic Design was that they had a box of ephemera labelled 'Beautiful Things'. We planned to find it and burn it in public ... *ARK* 24 was intentionally subversive in a kind of late teenage way ... but it was much more than that. It was technically innovative and original ... the day-glo cover was produced within twelve months of the first day-glo inks emerging. It's a bit faded now but when it came out it was really, really offensive. The opposite of 'Good Taste' in fact! (Seago 1995a: 131)

Terry Green and Mike Kidd's design for *ARK* 25 also drove the tutors to distraction with its portrayal of Brigitte Bardot (as Sue Tate explains in her chapter on Pauline Boty in this volume, the image of Bardot had specific implications at the RCA during this era) and deliberate typographical errors. As Green recalled:

> The cover of *ARK* 25 really drove Richard Guyatt up the wall because there's a couple of incorrect typefaces in there – quite deliberate of course. There were terrible rows about that ... we got away with it in the end. We convinced him we were interested in chance, randomness. (Seago 1995a: 133)

THE·ORIE
NT·LINE·C
RUISES·TO
THE·MED
I T E R R A N E A N
THIS·SUMM
ER·COMING

26-27 Cockspur Street London SW1 and 14 Fenchurch Avenue London EC3

5.17

Dennis Postle. Back cover of *ARK* 24.
Autumn 1959. © Royal College of Art
Archive.

ARKtwenty-fiveJOURNALof theROYALcollege ofART3s-75c

5.18

Terry Green. Cover of *ARK* 25. Spring 1960.
© Royal College of Art Archive.

As the 1950s morphed into the 1960s it was obvious to any reader of *ARK* that a major 'generation gap' had opened up. Robin Darwin for one was not amused:

> Ten or eleven years ago students were older than they are now, the sequence of their education had been interrupted by war or national service; they had known experiences and discharged responsibilities far outside the orbit of their interests … As artists they were less self confident, but in other ways they were more mature. By the same tokens perhaps they were less experimental in their ideas. The student of today is less easy to teach because the chips on his shoulders, which in some cases are virtually professional epaulettes, make him less ready to learn … This no doubt reflects the catching philosophy of the 'beat' generation. (Darwin quoted in Seago 1995a : 42)

The Rector's worst fears about the 'beat' generation were confirmed a few years later when he turned the pages of *ARK* 34 (Winter 1963). The contents, consisting of collages of violent and semi-pornographic imagery, including a montage of Princess Margaret in a bikini surrounded by Britannias brandishing 'Vote True Blue. Vote Conservative' placards, finally stretched the tolerance of the RCA's senior management to the limit. *ARK* 34 was censored and it was decreed that the entire print run should be pulped. As RCA college minutes noted, when Professor Guyatt saw the magazine he came to the conclusion that if it was 'not actually libellous and pornographic … it was most distasteful' (Guyatt 1963).

As the design historian Nigel Whiteley has commented: 'It was less than a decade from the end of rationing to the rise of Beatlemania but it seemed like a century' (Whiteley 1987: 5). By the early 1960s the 'generation gap' that Robin Darwin had noted opening up between 'the student of today' and his or her predecessors seemed absolute, but it is also possible to detect distinctly different attitudes between those students who were interested in Pop Art and Design who attended the RCA in the mid to late 1950s and those who entered the College from 1960 onwards. One of the first contributors to *ARK* to notice the difference was the painter Richard Smith, who had attended the Painting School from 1954 to 1957, and whose large-scale, sculpted canvases inspired by American billboard advertising epitomized the 'cool', slightly detached, intellectual stance of 'uptown Pop'. In 1962, having just returned from his first one-man show at New York's Green Gallery, Smith commented on the work of the recently graduated painters – David Hockney, Peter Phillips and Derek Boshier in particular – who would come to epitomize RCA Pop Art. This article, entitled 'New Readers Start Here…' was the first to be written about the young contemporary generation and featured black-and-white photographs of Peter Phillips' *Game Paintings*, Derek Boshier's *So Ad Men Became Depth Men* and David Hockney's *First Tea Painting* and (beneath a photograph of

5.19 (left)

Michael Foreman and Melvyn Gill.
Illustration for *ARK* 34 (original version).
Spring 1963. © Royal College of Art
Archive.

5.20 (right)

Michael Foreman and Melvyn Gill.
Illustration for *ARK* 34 (original version).
Spring 1963. © Royal College of Art
Archive.

the artist in drag) *I Will Love You At 8pm Next Wednesday*. Understanding the younger painters' terms of reference, Smith distinguished Hockney's 'highly successful, personalised statements' from the 'dark side of popular arts' on display in Phillips' work: 'Ray Charles rather than Bobby Vee ... leather jackets rather than après ski' (Smith 1963). Smith was also quick to recognize the differences between the 1959–61 generation's essentially unintellectual approach to Pop subject matter and his own:

> The field of popular imagery is wide, full of kicks and loaded with pitfalls ... A friend met a teenager who was dissatisfied with a pop record because there were too many cymbals. 'Too many symbols?' said my ICA-attuned friend. 'Yes, too many cymbals. They make too much noise.' Our attention is riveted on pop music in a more critical way than perhaps it warrants ... In using this material they are not saying 'We love it' or 'We hate it'. They accept it for what it is. (Smith 1963)

In the RCA's Painting School the key proponent of 'downtown Pop' during the mid-1950s had been Peter Blake, whose 1961 painting *Self Portrait With Badges* epitomizes his stance as 'artist as fan'. As Blake recalled:

> The difference between the ICA people and myself was that all my life until then had been working class. I'd been going to jazz clubs since I was 14 when I first went to Gravesend School of Art. I'd gone to wrestling with my mother since the age of 14 or 15. Down at Gravesend I'd drawn the fairgrounds. That was totally different from the Independent Group. Pop culture was the life I actually led. (Seago 1995a: 175)

An interest in collage and a collage aesthetic was an absolutely vital element which linked the early art school Pop to its 'high Pop' efflorescence in the 1960s. The influence of Kurt Schwitters (who ironically enough – as there seems to have been no meeting between the Schwitters and anyone from the RCA – spent the final years of his life in Ambleside in the Lake District at exactly the same wartime years as evacuated RCA students and staff) provided a direct link between the modernist avant-garde experimentation of the Central School, the ICA/Independent Group nexus and the exponents of RCA Pop in the 1950s and early 1960s such as Peter Blake, Joe Tilson, Richard Smith, Robyn Denny, Derek Boshier and Pauline Boty. Collage first crops up as a subject in *ARK* at the relatively late date of 1956 in an article devoted to Schwitters and illustrated with lithographed collages by Roger Coleman, Richard Smith, Robyn Denny and Peter Blake:

Collage can have a quality of humour and irony all its own, as in much of the work of Kurt Schwitters, the most poetic of collage artists, who wrote in 1920: 'I play off sense against nonsense, I prefer nonsense, but that is a purely personal affair.' (Hodges 1956)

Fusing fine art and graphic design, collage provided a particularly useful medium for exploring ideas across what Lawrence Alloway famously termed the 'long front of culture', the phrase perhaps doubly apt as at the RCA, the graphic designers' studios and the painters' studios were adjacent to each other in the same corridor. Also, as the RCA was a school of both design and fine art there was a constant 'two-way traffic' between students' interests. Although Darwin and Guyatt would have preferred the painters to influence the designers, as the 1950s morphed into the 1960s the influences often reversed. As Brian Haynes, art editor of *ARK* 32, recalled:

> We were always running up and down the corridors the whole time, borrowing things off each other, but there were a lot of other cross-overs happening too ... For example we had a graphics project on the theme of 'Love' , so some people went over to the Ceramics School and created a ceramic piece of liver in the shape of a heart on a butcher's slab ... Barrie Bates (later Billy Apple) went over to Industrial Design and designed teapots with intertwined spouts and heart-shaped tea caddies. You see graphics people had a job to do which painters didn't have. So we began to think, you know those 'loving tea pots' would make a really good ad for Typhoo tea. (Seago 1995a: 107)

Although a little overshadowed by the intellectual contributions of ex-Independent Group members, Roger Coleman's *ARK*s of 1956–7 also retained an element of 'downtown Pop'. *ARK* 18 (1956) featured *A Romantic Naturalist: Some Notes on the Painting of Peter Blake* written by Coleman himself, while *ARK* 20 (1957) features a photo essay by A.J. Bisley on *Wrestling at Lime Grove* – alluding to the long-standing connection between professional wrestlers and art students in 1950s London. However it was the *ARK*s of the 1961–4 period in which the 'downtown Pop' stance that characterized 'Swinging London' really blossomed. *ARK* 28 (Autumn 1961), edited by Ken Baynes and art edited by Alan Marshall, features photo essays by Marshall on the Beaulieu Jazz Festival, a concert by the Pop star Adam Faith and a striking cover photo of a motorcycle racer.

ARK 32 (Summer 1962), edited by Bill James and art edited by Brian Haynes, features a cornflake box-inspired section in which readers were invited to cut out and make their own political leader from a selection that included Fidel Castro, John F. Kennedy, Harold Macmillan and Nikita Khrushchev, a random collection of American logos and a free pull-out 'Kit of Images' for a do-it-yourself Pop painting. Pioneering the Pop-graphic

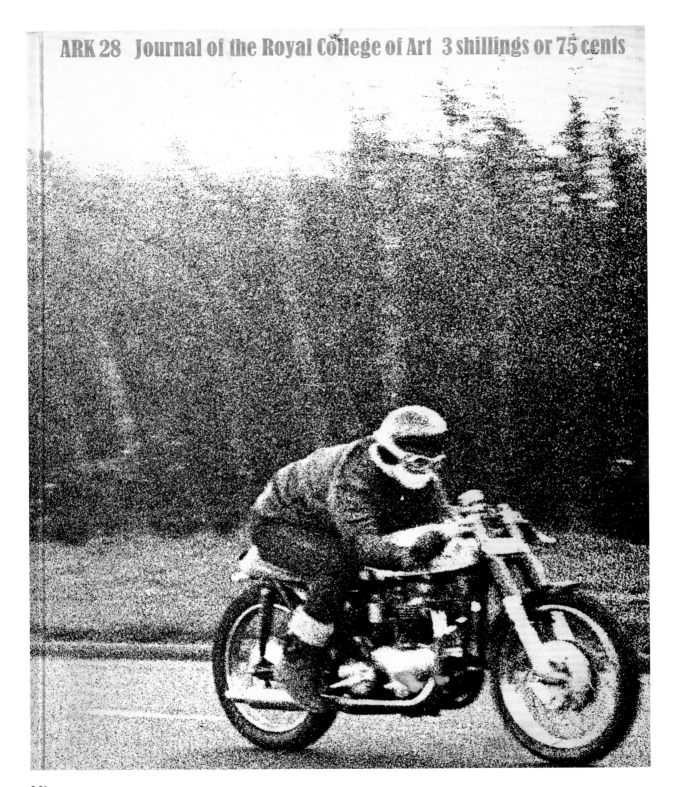

ARK 28 Journal of the Royal College of Art 3 shillings or 75 cents

5.21

Allan Marshall. Cover of *ARK* 28. Spring
1961. © Royal College of Art Archive.

5.22

Allan Marshall. Design for 'The Adam
Faith Show'. *ARK* 28. Spring 1961.
© Royal College of Art Archive.

5.23 (right)

Brian Haynes. Cover for *ARK* 32. Summer 1962. © Royal College of Art Archive.

5.24 (opposite, top)

Brian Haynes. Pull-out insert 'Kit of Images' in *ARK* 32. Summer 1962. © Royal College of Art Archive.

5.25 (opposite, bottom)

Keith Branscombe. Cover of *ARK* 33. Autumn 1962. © Royal College of Art Archive.

Journal of the Royal College of Art ☐ Summer 1962 ☐ 3s. or 75 c.

aesthetic which would characterize a myriad of British LP covers by the mid-1960s, including Peter Blake and Jann Haworth's iconic 1967 album cover for the Beatles' *Sgt. Pepper's Lonely Hearts Club Band*, Haynes recalls that the original aim was 'first to have a bit of fun, and secondly to try not to do what we did last year, to get a new style' (Seago 1995a: 196) – an approach which displays all the obvious strengths and weaknesses of Pop graphic design.

ARK 33 (Autumn 1962), edited by Bill James and art edited by Sashi Rawal, features *Twist Drunk* – a photo essay by Keith Branscombe about a cross-Channel Pop 'rave' and a feature on London's rocker 'ton-up boys'. *ARK* 36 (Summer 1964), edited by Michael Myers and art edited by Roy Giles and Stephen Hiett, is distinguished by an outstanding series of photo essays and features on Beach Boys-style Californian surfing and the 'teenage netherworld' of contemporary London mod subculture.

Praising Haynes' work in the catalogue to the 1963 'Graphics RCA' exhibition, Mark Boxer, recently appointed from Cambridge University's *Granta* to editorship of the *Sunday Times Colour Supplement*, pointed out that the 'pop graphic movement may be instant nostalgia, but this is the very guts

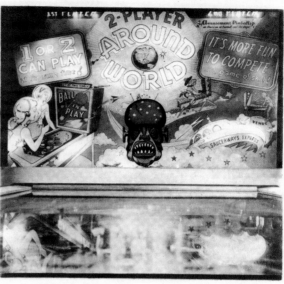

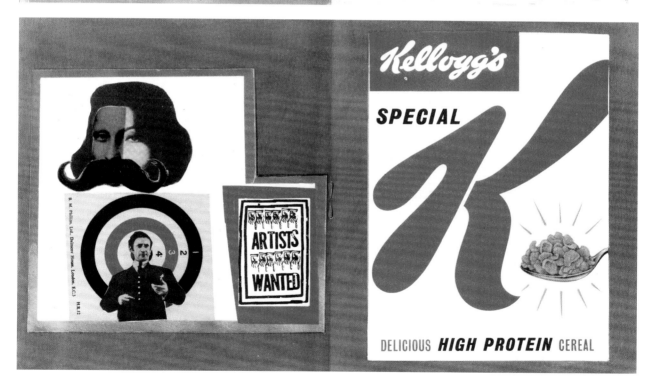

5.26 (right)

Keith Branscombe. Cover of *ARK* 33. Autumn 1962. © Royal College of Art Archive.

5.27 (opposite, top)

Keith Branscombe. 'Twist Drunk' in *ARK* 33. Autumn 1962. © Royal College of Art Archive.

5.28 (opposite, bottom)

Keith Branscombe. 'Twist Drunk' in *ARK* 33. Autumn 1962. © Royal College of Art Archive.

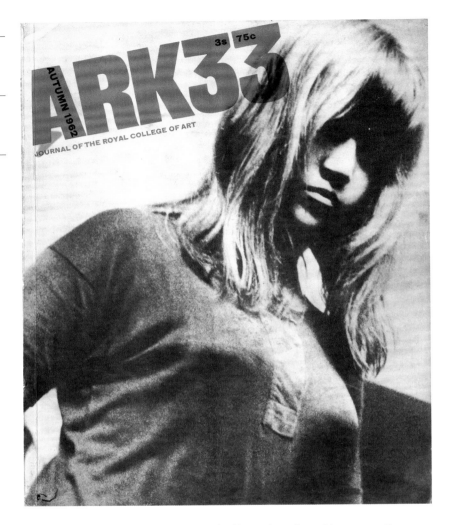

of visual magazines'. Representing the Pop voice of an older generation Reyner Banham, in a review of the same exhibition in the *New Statesman*, disagreed, claiming that the lack of serious thought behind the new Pop graphics was a grave shortcoming and threatened the credibility of *ARK* itself. While the content and layout of the magazine in the late 1950s had been witty, ironic, subversive and intellectually engaging, the latest issues seemed to Banham to be obsessed simply with rapid stylistic turnover and a vapid technical slickness facilitated by the introduction of high-speed web-offset printing technology, contriving 'to give the impression that the RCA is madly with-it, never misses a trick and is preoccupied with fashion' (Banham 1963: 687).

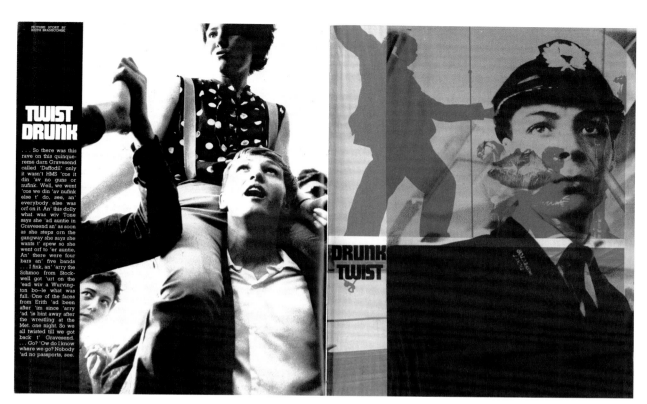

TWIST DRUNK

. . . So there was this rave on this quinque-reme darn Gravesend called 'Daffodil' only it wasn't HMS 'cos it din 'av no guns or nufink. Well, we went 'cos we din 'av nufink else t' do, see, an' everybody else was orf on it. An' this dolly what was wiv Tone says she 'ad auntie in Gravesend an' as soon as she steps orn the gangway she says she wants t' spew so she went orf to 'er auntie. An' there were four bars an' five bands . . . I fink, an' 'arry the Schmoo from Stockwell got 'urt on the 'ead wiv a Wurvington bo–le what was full. One of the faces from Erith 'ad been after 'im since 'arry 'ad 'is bint away after the wrestling at the Met. one night. So we all twisted till we got back t' Gravesend. . . . Go? 'Ow do I know where we go? Nobody 'ad no passports, see.

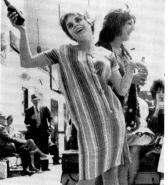

5.29 (right)

Roy Giles and Stephen Hiett. Cover of
ARK 36. Summer 1964. © Royal College
of Art Archive.

5.30 (opposite, top)

Richard Doust. Design for 'Plectrum'
in *ARK* 36. Summer 1964. © Royal College
of Art Archive.

5.31 (opposite, bottom)

Roy Giles and Stephen Hiett. Design for
'It Only Lasts a Second, But We Know
We're Really Alive' in *ARK* 36. Summer
1964. © Royal College of Art Archive.

ARK

Journal of the Royal College of Art Number 36 Summer 1964 3 shillings / 75 cents

Although this dedicated following of fashion was symptomatic of what Nigel Whiteley has dubbed the 'High Pop' years of the early to mid-1960s when the Pop aesthetic began to cross over into a myriad of different design fields from fashion to interior design, furniture and architecture, Banham's comment was astute because *ARK*'s obsession with Pop styling was causing its art editors to ignore the most significant contemporary developments in typography. By 1963 *Town and Queen*, both heavily influenced by Willy Fleckhaus' *Twen*, were already making *ARK*'s layouts seem imitative, while the new Sunday newspaper colour magazines, already employing RCA graduates such as Moore, Haynes and Romek Marber, seemed to contain more features on RCA artists and designers than the college's own magazine. Although *ARK*'s editors and art editors managed to keep their fingers on the pulse of Pop culture for a few more years, *ARK*'s historical moment had passed. It suffered a slow decline in quality and circulation until finally giving up the ghost in 1976.

By the mid-1960s, as *ARK*'s editorials were becoming bogged down in the familiar debate between Modernist advocates of social responsibility and advertising-oriented Pop stylists, an earlier generation of RCA graphic design students who had cut their professional teeth on the magazine were busy shaping the future of the British visual landscape. Commenting on the changes in cultural atmosphere which the issues of that era reflect, the artist and former *ARK* contributor Robyn Denny recalls that whereas the late 1950s was 'a time for busting out, for thinking differently and radically', by the mid-1960s, 'students were getting much more conscious of image, identity and presentation ... the edge was missing'. This graphic edge was *ARK*'s real cultural contribution to Pop, for at its brief best it was 'raw, vigorous, experimental, often crude and often very funny, sparky and bright' (Seago 1995a: 212).

References

Banham, R. (1963), 'Department of Visual Uproar', *New Statesman*, 3 May 1963.

Banham, R. and Hillier, B. (eds) (1976), *A Tonic To the Nation*, London: Thames & Hudson.

Booker, C. (1969), *The Neophiliacs: The Revolution in English Life in the Fifties and Sixties London*: Collins.

Critical Writing in Art and Design Programme Royal College of Art (2014), *ARK: Words and Images From the Royal College of Art Magazine*, London: Royal College of Art.

Darwin, R. (1954), 'The Dodo and the Phoenix', *Journal of the Royal Society of Arts*, (February).

Fletcher, A. (1957), 'Letter From America', *ARK* 19, London: Royal College of Art.

Frayling, C. and Catterall, C. (1996), *Design of the Times: One Hundred Years of the Royal College of Art*, Shepton Beauchamp, Somerset: Richard Dennis; London: Royal College of Art.

Guyatt, R. (1951), *Head, Heart and Hand in Anatomy of Design: Royal College of Art Inaugural Lectures*, London: Royal College of Art.

Guyatt, R. (1963), *Graphic Design at the Royal College of Art in Graphics RCA: Fifteen Years' Work of the School of Graphic Design*, London: Royal College of Art.

Hawkey, R. (1952), 'Advertising: The Skeleton In Whose Cupboard?', *ARK* 5, reproduced in Critical Writing in Art and Design Programme Royal College of Art (2014) *ARK: Words and Images From the Royal College of Art Magazine*, London: Royal College of Art.

Hodges, J. (1956), 'Collage', *ARK* 17, London: Royal College of Art.

Russell, J. and Gablik, S. (1969), *Pop Art Redefined*, London: Thames & Hudson.

Seago, A. (1995a), *Burning the Box of Beautiful Things: The Development of a Postmodern Sensibility*, Oxford: Oxford University Press.

Seago, A. (1995b), 'Seize the Sans Serif', *Eye* 16: 4.

Smith, R. (1963), 'New Readers Start Here...', *ARK* 32, London: Royal College of Art.

Whiteley, N. (1987), *Pop Design: From Modernism to Mod*, London: Design Council.

Prologue to Edward Wright, 'Chad, Kilroy, the Cannibal's Footprint and the Mona Lisa', First Published in *ARK* 19 (Spring 1957)

6

Ann Pillar

This prologue to the reproduction reprint of 'Chad, Kilroy, the Cannibal's Footprint and the Mona Lisa', below, an article first published in 1957 in the Royal College of Art's ARK magazine, examines how some key tensions relating to communication through images, signs and symbols coalesced around the figure of Edward Wright, during his tenure as Year Tutor in the School of Graphic Design, Royal College of Art, from 1956 to 1959. In drawing attention to this under-explored moment in the history of art and design the aim is to illuminate how attitudes and ideas that developed in the 1950s were drawn to a conclusion in the final years of the decade, and could thus be transposed onto Pop Art and Design in the 1960s.

In 1956 Edward Wright was one of the teachers brought over from the Central School of Art and Crafts to the Royal College of Art (RCA) by the principal, Robin Darwin, in a move to bolster the content and reputation of typographic and design teaching in the newly formed School of Graphic Design. Other notable figures who migrated from the Central School to the RCA included the typographers Herbert Spencer and Anthony Froshaug. Essentially an artist, of Ecuadorian-Chilean-Irish origins, born in Liverpool into a diplomatic family, and educated by Jesuits, Edward Wright (1912–1988) played a key part in activities in the graphic arts in Britain. Although scarcely present in the public record his influence on the teaching of design was formative, at the Central School in the early 1950s, subsequently at the RCA, and later through his tenure as Head of Graphic Design at Chelsea School of Art from 1963 to 1977, where he transformed a low-key vocational printing course into a fully fledged Department of Graphic Design.[1]

Wright's immediate and most visible impact on his arrival at the RCA in 1956 was on the student magazine, *ARK*. According to Alex Seago, 'Edward Wright's unique, quirky creativity had a profound influence on the

contents of *ARK* and it is no coincidence that his brief period at the college from 1956 to 1959 is also the period in which layouts of the magazine are at their most interesting, original and avant-garde' (Seago 1995: 100). Wright was not a prolific author or exponent of theory, however his article, published in *ARK* 19, enticingly headed 'Chad, Kilroy, the Cannibal's Footprint and the Mona Lisa', is a significant landmark in the history of graphic design in Britain. Emerging from commercial art in the late 1950s, graphic design became a recognized profession from the early 1960s, established and codified by, among others, Wright's first generation of students from the Central School, including Ken Garland, Germano Facetti, Robin Fior, Alan Fletcher and Theo Crosby.

Fascinated by human communication and the meaning of marks and signs, often found in streets and written on walls, Wright had begun to extend the repertoire of what was to become known as 'graphic design' through his *extempore* typography evening classes at the Central School from 1952 to 1956, sanctioned by Jesse Collins, Head of the Department of Book Design. Organized informally, rather in the spirit of midnight feasts, Wright's now legendary classes broke with established rules of trade and craft practice, and the typical standards of typographic design and presswork traditionally taught in all printing schools and art education institutions in relation to the design and production of books.

For the first time in typographic design education in Britain, Wright introduced early European modernist concepts of gesture-syntax, relating to Dada, and works by H.N. Werkman, W.J.H. Sandberg, Piet Zwart and Theo van Doesburg. The resulting experiments, created by students using relatively large wood types, were located in *gestalt*, or the perception of pattern and structure, and in the expression of sound and motion, and sound and time. Consonant with these ideas, and with wood letters laid freely on the bed of the press, and printed in a rough-and-ready manner, was Wright's introduction of a sense of play, influenced in large part by Johan Huizinga's seminal study *Homo Ludens* (1949).[2] By means of abstract notions of concept and play, made concrete through the disposition of striking graphic symbols, Wright was able to shift contemporary practice of typographic design as 'layout', towards a notion of design as an open, dynamic continuum, which he tempered with an uncompromising emphasis on process and analysis, and demand for playfulness without frivolity.[3] The classes at the Central School marked the formal beginning of Wright's examination of printed communication based on concepts or ideas, which appears to place him in opposition to the pre-war purist doctrine of modernist functionality in graphic communication, in which visual metaphor was avoided.

While teaching at the Central School Wright was loosely connected to the Independent Group (IG) at the ICA, many of whose members also taught at the Central School. In 1956, the year that he joined the RCA, Wright made significant contributions to the final IG-related exhibition, *This is Tomorrow*, at the Whitechapel Gallery, as an exhibitor and designer of the

catalogue, for which Richard Hamilton made his seminal collage, *Just What Is It That Makes Today's Homes So Different, So Appealing?* Although Wright did not subscribe to the IG's overwhelming fascination with Americana and consumerism and there is no evidence to suggest that he shared IG hostility towards Herbert Read's form of modernism, he appears to have played an active part in testing anti-art ideas, for example the symbolism of alternatives to logical order. In 1955 Wright shared a platform at the ICA with the art critic Lawrence Alloway, addressing the question 'Were the Dadaists non-Aristotelean?' (Whiteley 1987: 48). Alloway later proposed the idea of separately originated and transmitted messages that developed from his and IG interests in mass media, technology, and communication theory and cybernetics. These discussions eventually yielded to information theory and functionality in graphic design in the 1960s, and to the theory of semiotics, introduced into Britain by Tomás Maldonado from the Hochschule für Gestaltung Ulm (HfG Ulm). Maldonado's treatise on the subject was first published in the final issue of *Uppercase* 5 (1961), art directed by Wright.[4]

In starting with the letters of the alphabet, or basic elements of graphic communication, Edward Wright's experiments at the Central School may at first sight appear to emulate the more extreme experiments of the early modernist founders of graphic design. But the true context of his investigations, which distanced him from the IG discussions mentioned above and, more critically, from ideas that emanated from HfG Ulm, was his profound and lifelong interest in human communication, and the processes by which methods of communicating and receiving ideas are transformed into signs and symbols that contain meaning and value. 'Chad, Kilroy ... ' marks a significant shift towards the acknowledgement of both cognitive and affective experience in design, made evident through Wright's singular emphasis on sensory and emotive human experience.[5] His selection and arrangement of disparate images, or signs and symbols, summarized his long-held view that the spoken or written word is only one arrangement of symbols, and not necessarily the most important one. Wright demonstrates that each image in 'Chad, Kilroy ... ' has one or more subtexts. In effect he makes it clear that meaning and value are in continual states of flux, dependent on context and the circumstances of the spectator.

The immediate visual appeal of 'Chad, Kilroy ... ' resides in photographic images, which Wright introduced into *ARK* 19, supplanting the RCA's firmly established tradition of illustration in the magazine. Wright's inclusion of a version of Marcel Duchamp's *L.H.O.O.Q.* (1919), a mocking gesture against attitudes and art values embodied by Leonardo da Vinci's *Mona Lisa*, provided a timely opportunity for the art director Gordon Moore to rework the image for the front cover of *ARK* 19.[6] It was an apt metaphor for Roger Coleman's editorial stance, which was provocatively anti-fine art 'with a big capital F, capital A' (Coleman 1957: 3). By juxtaposing an electronic symbol and graffiti with images from literature, anthropology, film and fine art, Wright posed questions about the distinction between

images, signs and symbols – a subject endemic to the visual arts, and one which had increasing currency in press advertising as consumerism gathered pace during the 1950s.

Following the publication of 'Chad, Kilroy ... ' Wright pursued the question of signs and symbols in another published piece, 'The Painter', in which he examined the role of the artist in contemporary society (Wright in Todd 1958, 102–9).[7] Debate surrounding this key issue had been heightened to an extreme pitch following the impact of American abstract expressionist paintings exhibited at *Modern Art in the United States*, Tate Gallery, 1956. For the first time the artist's personal, emblematic gesture on the canvas became the subject of the work, thereby reorienting critical discourse on images, signs and symbols. The influence of American abstract expressionism and the parallel European movement, *Tachisme*, was strongly felt in the School of Painting at the RCA, particularly by students Robyn Denny, Richard Smith, Bernard Cohen, William Green and the situationist, Ralph Rumney.

Pop-based abstract art created by this small but influential and articulate group of artists was strongly supported and promoted by Lawrence Alloway,[8] and that Edward Wright was also close to several of the artists is undeniable. While the group's exploration of mass media and popular imagery owes much to their links to Alloway and other IG members, such as Richard Hamilton and Eduardo Paolozzi, the submerged letterforms and collages in works produced by Robyn Denny from 1957 to 1958 provide as yet unresearched but seemingly positive links to Wright. Indeed during his tenure at the RCA an unusual synthesis occurred between the School of Graphic Design and School of Painting, which became subject to robust public attack from Alloway, by then considered to be the most influential and best-informed commentator on modern art writing in the British Press (Lynton 1963: 10). In 1959 Alloway published a critical review of a one-man exhibition of paintings, collages and reliefs by Edward Wright at the Mayor Gallery, scathingly entitled *Art for the Symbol-Happy Tribe* (Alloway 1959). By dispensing with an evaluation of the works on show Alloway's real purpose, it seems, was to discredit Wright's teaching at the RCA by publicly warning against his practice as both artist and designer, and the evident cross-fertilization of ideas between the School of Graphic Design and School of Painting.

This under-explored episode in the history of art and design criticism inadvertently summarized and brought to a conclusion the tensions that had existed in British culture in the 1950s when, towards the end of the decade, it was becoming more difficult to distinguish between the work of the 'fine' artist, 'commercial' artist, and 'graphic' artist or 'designer'. Abstract expressionism had meant a shift in artistic activity from Paris to New York. In Britain it marked the end of the post-war isolationist phase of British art and signalled rich possibilities for artists. Edward Wright's response to the contemporary art scene was to endorse new non-hierarchical attitudes:

Most of us are now verbal and visual consumers. The painter is
still an image-maker but as a visual symbol creator he has now
been outpaced by graphic artists, anonymous package designers,
film directors and advertising men ... The graphic artist, the
designer, and the ad-man are influenced by the easel painter
on a stylistic level, and the easel painter is often influenced by
their day-to-day-choice of symbols ... One uses certain faculties
to absorb a painting which can only be made poorer if they are
not used on the everyday objects that surround us. Domestic
appliances, advertisements and people's everyday gestures
need not be placed in a caste system below that which includes
sculptures, easel pictures, mime. (Wright in Todd 1958: 104–5)

Wright's prescient challenge to the production of symbols was the catalyst
for Alloway's attempt to maintain the professional status of fine art and
the easel picture, despite his much-vaunted belief in a fine art/popular art
continuum, summarized in his 'Personal Statement' published in *ARK* 19
along with 'Chad, Kilroy ... '. Alloway defended his professional position
as art critic in the light of his engagement with popular art, stating, 'My
sense of connection with the mass media overcame the lingering prestige
of aesthetiscm and fine art snobbism ... the new role of the spectator or
consumer, free to move in a society defined by symbols is what I want to
write about ' (Alloway 1957: 28). Despite Alloway's professed stance, it is
Edward Wright who emerges as a pivotal figure here, in the forefront of fully
acknowledging new, democratic conditions for the reception of fine art/
popular art in which value judgements relating to aesthetics were becoming
less relevant. As the values of mass communication and accelerating
consumerism overwhelmed the traditions of fine art, creating the conditions
for the development of Pop in art, advertising and design in the 1960s,
Alloway's critical attack on Wright is of particular interest to art and
design historians.

In retrospect Alloway's seeming reversal of opinion, prompted by
Wright, can be attributed to his abrupt realization that the new generation of
artists at the RCA, which included the first true Pop artists – David Hockney,
Derek Boshier, Allen Jones, Pauline Boty and Peter Phillips – were taking
their standards from popular and graphic art or design rather than fine
art.[9] In effect they had dispensed with his and the IG's formal, theoretical
appraisal of popular art, which Alloway claimed, in his critique of Wright,
was embodied by Richard Hamilton, 'Another artist who works as an easel
painter and designer, and shares Wright's interest in fine and popular arts
... However he does not try to share the time (permanent or at least, long) of
the easel picture with graphics time' (Alloway 1959). The IG proposition of
a Fine Art/Popular Art continuum had, in Alloway's view, been subverted at
the RCA by close association between the School of Graphic Design and
School of Painting. His attack on Edward Wright and subsequent dismissal

of works by the RCA Pop artists, rested on an elitist art-historical tradition of iconography and the extent to which an artist transforms his material, whether literally or by appropriating ready-made images. It is perhaps ironic therefore that the history of the foundations of British Pop Art and Design, promulgated by Hockney's generation of artists, is almost without exception usually traced back to Richard Hamilton's collage of 1956, *Just What Is It That Makes Today's Homes Sso Different, So Appealing?*

Essentially an easel picture, a genre work, or indeed a conversation piece, Hamilton's collage is constructed according to the Renaissance tradition of perspective, affording a window on the world. Thus it reverses the theory and practice of abstract art since Cézanne and Cubism, which emphasize the flat surface of the canvas, epitomized in the 1950s by abstract expressionist works. *Just What Is it...* functions as a representative object. Almost medieval in concept its meaning can only be fully understood by privileged access to Hamilton's articulate system of notation, in which he lists objects and their meaning: 'Man, Woman, Humanity, History, Food, Newspapers, Cinema, TV, Telephone, Comics (picture information), Words (textual information), Tape recording (aural information), Cars, Domestic appliances, Space'.[10] In effect the collage is a schematic, a semantically precise representation that communicates selectively. The spectator is obliged to spend time and effort to unravel Hamilton's analogy between pictorial representation and verbal description. That Alloway sought to give 'Time' a higher dignity and deeper meaning in easel pictures than he felt it possessed in graphic communication is of profound importance when considering the convergence of Fine Art/Popular Art in the 1960s. His attack on Edward Wright is ultimately to do with differences in the consumption rate of symbols in separate 'channels of communication': Fine Art, Pop Art, Pop Design, Graphic Design and Advertising.

ARK 19 comprises articles on Americana, movies, television, popular songs and fashion. In his editorial comment Roger Coleman observed:

> If a new consciousness of design in our surroundings is to
> be, then it must come from within society itself, it must grow
> naturally out of social necessity ... It is no longer sufficient or
> even realistic to think of painting and sculpture as separate
> entities; they belong in a total scale of attempts to communicate
> to complex and shifting audiences today. (Coleman 1957: 3)

Thus can Lawrence Alloway, Richard Hamilton and Edward Wright, among other key figures in the art scene of the 1950s, be shown as actively seeking to move beyond simple aesthetic responses to new communications media. In 'Chad, Kilroy, the Cannibal's Footprint and the Mona Lisa' Edward Wright delicately transposed abstract expressionism's emblematic gesture on the canvas onto gesture in the age-old symbolizing processes of human communication, in which idea and form, thought and feeling intermingle and interact. As each image stares out of the page, making an immediate and simultaneous connection with the spectator, as does each of The Beatles in Robert Freeman's photograph on the cover of *With the Beatles* (1963), perhaps the most pertinent question to ask of 'Chad, Kilroy ... ' is who is doing the looking?

Notes

1 For accounts of Edward Wright's life and career see *Edward Wright, Graphic Work and Painting*, catalogue to a retrospective exhibition organized by the Arts Council of Great Britain, touring January–September 1985. Arts Council of Great Britain, 1985; also see Ann Pillar, *Edward Wright (1912–1988) Artist, Designer, Teacher*, unpublished PhD thesis, University of Reading, 2012.

2 Johan Huizinga, *Homo Ludens: A Study of the Play Element in Culture* [1938], first English translation, Routledge & Kegan Paul, 1949. For an exposition of the notion of play, which was influential in avant-garde circles in post-war London, see Ben Cranfield, 'All Play and No Work? A "Ludistory" of the Curatorial as Transitional Object at the Early ICA', Tate Papers no. 22, 12 November 2014.

3 The description of Edward Wright's pedagogy is based on interviews with Edward Wright's students at the Central School of Art and Chelsea School of Art, and the memoir by Ken Garland, 'Teaching and Experiment' in *Edward Wright, Graphic Work and Painting*, Arts Council of Great Britain, 1985, p. 58. Examples of students' work produced in Wright's *extempore* typography classes were published in 'Pattern, Sound, Motion' [anon.], *Typographica* 9, Old Series (1954), 15–18.

4 In 1959 Edward Wright was appointed design director of *Uppercase*, edited by designer and architect Theo Crosby (1958–61), who had attended Wright's classes at the Central School. Ostensibly the house journal of the Whitefriars Press, *Uppercase* was dominated by IG members, and the five issues published between 1958 and 1961 may be regarded as a postscript to *This is Tomorrow*, 1956, organized by Theo Crosby. Wright was also closely connected to *Architectural Design* under Monica Pidgeon, editor (1946–75), and Theo Crosby, technical editor (1953–62), which provided another key outlet for articles by IG members in the 1950s, as did *inter alia* the Royal College of Art's *ARK* magazine; the Central School's Department of Sculpture publication, *FIRST*; *Design* magazine; and the Cambridge University journal, *Cambridge Opinion*, edited by Robert Freeman, later famous for his photographs of 1960s society and culture, and notably of The Beatles.

5 For an exposition of symbolizing processes consonant with Edward Wright's attitude to the subject in 'Chad, Kilroy, the Cannibal's Footprint and the Mona Lisa' see Nelson Goodman, *Languages of Art*, Hackett, 1976, pp.27–67, 225–65.

6 The image on the cover of *ARK* 19 is not credited; it appears to have been made from a reproduction of Francis Picabia's *L.H.O.O.Q.* (1920, 1942), in which the moustaches were drawn by Picabia, and *barbiche*, or goatee beard, added later by Marcel Duchamp. Picabia first made the image in haste, forgetting to add the *barbiche*, to replicate Duchamp's 'rectified readymade', *L.H.O.O.Q.* (1919), for reproduction in the Dada magazine *391* (1920). Topically, on 30 December 1956 in the Louvre, Hugo Unzaga Villegas, a Bolivian student, had caused an international sensation by throwing a stone against the *Mona Lisa*, damaging the elbow.

7 Edward Wright gave a lecture on the topic of 'Painter's Task and Painter's Play', at the ICA on 6 June 1957, for which no paper or other record was published; his paper on the same topic entitled 'The painter' was given at a Downside Abbey Symposium, 1957, and published in John M. Todd (ed.), *Art, Artists, Thinkers: An Inquiry into the Place of Art in Human Life*, Longmans Green, 1958, 102–9. At the symposium Edward Wright spoke as 'The witness of the artists', describing himself as 'a painter who sees his painting as part of a whole life and not simply as an "isolated" art'.

8 Lawrence Alloway's demonstrably public support for the RCA 'first generation' of British Pop artists was in two key exhibitions, both held at the New London Gallery: *Situation*, August–September 1960, and *New London Situation*, August–September 1961.

9 Lawrence Alloway later tempered his reaction, see Lucy R. Lippard, *Pop Art*, Thames & Hudson, 1967, pp. 27–67. Alloway's initial reaction to 'Pop Art' rested on his use of iconography in his role as art critic, to discover shared themes, for example, between advertisements and art, movies and sculpture, science fiction and constructivism, which in his view the RCA group singularly failed to understand: 'Derek Boshier and David Hockney, for instance seem unable to translate their awkward arrays of different signs into one coherent format. A reason for this, I suspect, is the fact that they take their standards from graphic art rather than painting. In graphic art anything goes, measured only by an unchecked and mobile standard of vividness and charm'; see Lawrence Alloway, 'Pop Art Since 1949' (1962), reproduced in Richard Kalina (ed.), *Imagining the Present: Context, Content, and the Role of the Critic, Essays by Lawrence Alloway*, Routledge, 2006, 85–7.

10 See Richard Hamilton, 'Man, Machine and Motion' in *Collected Words 1953–1982*, Thames & Hudson, 1982, 24–5, in which he concludes his paragraph on *Just What Is It That Makes Today's Homes So Different, So Appealing* by stating, 'The image should therefore be thought of as tabular as well as pictorial'.

References

Adams, H. (1984), *Art of the Sixties*, London: Peerage.

Alloway, L. (1959), 'Art for the Symbol-Happy Tribe' in *Art News and Review* XI, no. 10 (June).

Alloway, L., Banham, R. and Lewis, D. (eds) (1956), *This is Tomorrow*, catalogue published on the occasion of an exhibition at the Whitechapel Gallery, 9 August–9 September 1956. London: Whitechapel Gallery.

Booth-Clibborn, E. and Baroni, D. (1980), *The Language of Graphics*, London: Thames & Hudson.

Coleman, R. 'Introduction' in *ARK* 19 (spring 1957).

Finch, C. (1980), *Image as Language*, London: Penguin.

Francis, M. (ed.) (2005), *Pop*, London: Phaidon.

Garland, K. (1996a), 'Graphic Design in Britain 1951–61: A Personal Memoir' (1983), reprinted in *A Word in Your Eye*, University of Reading.

Garland, K. (1996b), 'The Wright Stuff Writ Large' (1988), reprinted in *A Word in Your Eye*. University of Reading.

Goodman, N. (1976), *Languages of Art*, Indianapolis: Hackett.

Hamilton, R. (1982), 'Man, Machine and Motion' in *Collected Words 1953–1982* (1982), London: Thames & Hudson.

Harris, J., Hyde, S. and Smith, G. (1986), *1966 and All That: Design and the Consumer in Britain 1960–1969*, published on the occasion of an exhibition at The Whitworth Gallery, Manchester, 1986, London: Trefoil.

Harrison, M. (2002), *Transition: The London Art Scene in the Fifties*, published on the occasion of an exhibition at the Barbican Art Gallery, 31 January–14 April 2002, London: Merrell.

Hoffman, B. (2002), *The Fine Art of Advertising*, New York: Stewart, Tabori & Chang.

Hollis, R. (2012), *Writings About Graphic Design*, London: Occasional Papers.

Huizinga, J. (1949), *Homo Ludens: A Study of the Play Element in Culture* (1938), first English translation, Routledge & Kegan Paul.

Kalina, R. (ed.) (2006), *Imagining the Present: Context, Content, and the Role of the Critic, Essays by Lawrence Alloway*, London: Routledge.

Lewis, P. (1978), *The 50s*, London: Book Club Associates.

Lippard, L. R. (1967), *Pop Art*, London: Thames & Hudson.

Lynton, N. (1963) 'British art and the new American painting', in *Cambridge Opinion* 37.

Massey, A. (1996), *The Independent Group: Modernism and Mass Culture in Britain 1945–1959*. Manchester: Manchester University Press.

Massey, A. (2013), *Out of the Ivory Tower: The Independent Group and Mass Culture*. Manchester: Manchester University Press.

Mellor, D. (1993), *The Sixties Art Scene in London*, published on the occasion of an exhibition at the Barbican Art Gallery, 11 March–13 June 1993, London: Phaidon.

Pillar, A. (2012), *Edward Wright (1912–1988), Artist, Designer, Teacher*, unpublished PhD thesis, University of Reading.

Rancière, J. (2007), *The Future of Images* [2003], London: Verso.

Russell, J. and Gablik, S. (1969), *Pop Art Redefined*, published in relation to an exhibition on Anglo-American Pop Art, organized by the Arts Council of Great Britain, Hayward Gallery, July–August 1969, London: Thames & Hudson.

Schneede, U.M. (1976), *Pop Art in England*, published on the occasion of an exhibition at the Kunstverein, Hamburg, touring 7 February–4 July 1976, Hamburg: Kunstverein.

Seago, A. (1995), *Burning the Box of Beautiful Things: The Development of a Postmodern Sensibility*, Oxford: Oxford University Press.

Stonard, J.P. (2007), 'Pop in the Age of Boom: Richard Hamilton's *Just What Is It That Makes Today's Homes So Different, So Appealing?*' in *The Burlington Magazine*, CXLIX, (September).

Sturt-Penrose, B. (1969), *The Art Scene*, Feltham: Hamlyn.

Thompson, P. and Davenport, P. (1980), *The Dictionary of Visual Language*, London: Penguin.

Todd, J. M. (ed.) (1958), *Art, Artists, Thinkers: An Inquiry into the Place of Art in Human Life*, London: Longmans Green.

Whiteley, N. (1987), *Pop Design: Modernism to Mod*, London: The Design Council.

Woods, G., Thompson, P. and Williams, J. (1972), *Art Without Boundaries 1950–70*, London: Thames & Hudson.

Wright, E. (1957), 'Chad, Kilroy, the Cannibal's Footprint and the Mona Lisa' in *ARK* 19 (spring).

Wright, E. (1985), 'The Elm Tree' in *Edward Wright, Graphic Work and Painting*, published on the occasion of a retrospective exhibition organized by the Arts Council of Great Britain, touring January–September 1985, London: Arts Council of Great Britain.

ABOVE: Still from the Luis Bunuel film *The Adventures of Robinson Crusoe*

ABOVE, RIGHT: Positive and negative sine curves

OPPOSITE: New Hebridean wooden gong

Chapter 6: Chad, Kilroy, the Cannibal's Footprint and the Mona Lisa | Edward Wright

Chad, Kilroy, the Cannibal's Footprint and the Mona Lisa

Edward Wright

We have recently lost track of Chad and Kilroy. Like naughty dogs during the war years, they left their cards everywhere. Slogans such as 'Kilroy slept here' and the doodled Chad sign with its sarcastic enquiry mushroomed on walls overnight. They were anonymous popular gestures of survival. Chad may have been the earlier of the two, this is immaterial, but one can imagine the process through which he became a graphic symbol. The positive and negative sine curves which make the symbol for an alternating current are the beginnings of Chad. The plus signs are his eyes (this is an old strip-cartoonist's convention for the eyes of someone who has been hit on the head). Eventually he grows hands and to the top of his head, indicating his nature, a questioning hair is sometimes added. Chad is a technological science hero. He must have been born in a factory producing war material which included electronic equipment. His success as a survival myth depended on his alertness in answering back on the occasions when bombs fell or supplies were interrupted. The critical lack of something essential merely provoked an impudent 'Wot, no - ?'

Kilroy's beginnings are more difficult to trace although seven articles about him have appeared in various American magazines between 1945 and 1948. He was assumed to be in the US Army Air Force and must have personified the US serviceman in the guise, bewilderingly new at that time, of a global invader. 'Kilroy was here' slogans always sprouted 'just before' the first arrivals on a lonely or dangerous atoll. Like Chad he was a popular myth to which everyone made a sly contribution. In the serviceman's duffle bag Kilroy was truly more present than was ever that famous filed marshal's baton in the Napoleonic soldier's haversack. Who was Kilroy? His name has a punning sound suggestive of a daring regicidal hero. Kilroy's mark was a slogan. The myth did not apparently produce an image and when Americans are shown a Chad they usually identify it as a Kilroy. Chad and Kilroy were used to claim particular places during a time of danger and conflict, after the war they gradually disappeared, although defiant and protesting messages are still written on walls in towns as this is an older activity than writing on paper.

6.1

© Royal College of Art Archive.

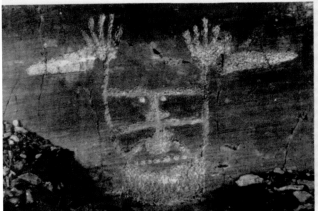

'Sorcerer' Tende, France

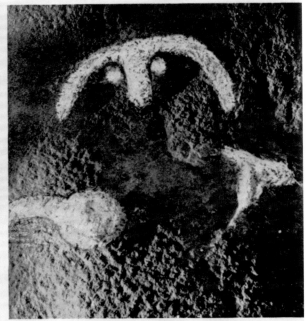

'Dolmen de Soto' Huelva, Spain

Picabia after Duchamp 'Mona Lisa'

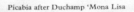

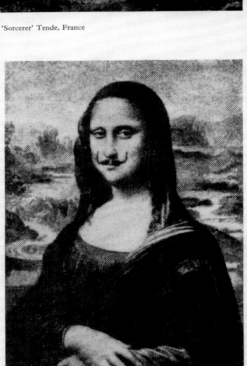

I H O O Q

Colchester Chad

6

If printing has its foreshadowing, this must have been a footprint. The mark of a bird's claw on the ground is supposed to have given a clue to the inventor of Chinese characters. The cannibals who invaded Robinson Crusoe's island had their Kilroy. His message, a single footprint, alarmed poor Crusoe and killed his royal mood: *'Then to see how like a King I din'd too, all alone, attended by my servants. Poll, as if he had been my favourite, was the only person admitted to talk to me. My dog, who was now grown very old and crazy, and had found no species to multiply his kind upon, sat always at my right hand, and two cats, one on one side of the table and one on the other, expecting now and then a bit from my hand, as a mark of special favour'.* The footprint took possession of the island and changed its very nature. *'It happen'd one day about noon going towards my boat, I was exceedingly supriz'd with the print of a man's naked foot on the shore, which was very plain to be seen in the sand. I stood like one thunderstruck, or as if I had seen an apparition; I listn'd, I look'd around me, I could hear nothing, nor see anything; I went up to a rising ground to look further; I went up the shore, but it was all one, I could see no other impression but that one.'*

Chad and Kilroy were used as symbols of defiance as the footprint in Defoe's novel was used against Crusoe. An act of defiance against a symbol can also occur. This happened on the third of December last year when Hugo Unzaga Villegas threw his stone at the Mona Lisa. Leonardo's painting of the Gioconda is still capable of provoking vandalism or denunciation. It was stolen in 1911 (an act of homage on this occasion). In 1921 *L'Esprit Nouveau* put the question 'Should we burn the Louvre' to its readers and a variety of serious or witty replies were received from Juan Gris, Maurice Raynal, Léonce Rosenberg and others. The shortest answer, from Solé de Sojo, was 'No, in spite of the Gioconda'. Marcel Duchamp had already signed a photograph of the Mona Lisa to which he added a moustache and the letters *L.H.O.O.Q.* giving it an impudic double meaning and making this a Dadaist 'anti-masterpiece' object. Léger also put the Mona Lisa 'in her place' when he incorporated her with postcardish matter-of-factness into a composition together with a bunch of keys and other objects. These were symbolic protests by Duchamp and Léger directed against the official attitude to painting which chose the Gioconda as its symbol.

'La Joconde aux cles', by Fernand Leger, 1930

New Hebridean Stone Ring

6.2 (opposite)

© Royal College of Art Archive.

6.3 (above)

© Royal College of Art Archive.

Pauline Boty: Pop Artist, Pop Persona, Performing Across the 'Long Front of Culture'

Sue Tate

Pauline Boty (1938–1966) was a founder member of the British Pop Art movement. She trained at the Royal College of Art, the very epicentre of emergent Pop, where she befriended and went on to exhibit with leading figures in the movement including David Hockney, Derek Boshier and Peter Blake. She produced a fascinating and vibrant body of collages and paintings that, in both celebratory and critical mode, give form to a woman's experience of popular culture.

In 1959 Lawrence Alloway (a founder of the Independent Group and key promoter of Pop) coined the term 'the long front of culture' to describe a non-hierarchical, democratic embrace of the whole gamut of cultural expression from (low) mass culture to highly respected fine art. Alloway was challenging the 'elite' 'keepers of the flame' of high culture – a challenge that Pop artists, including Pauline Boty, also took up. What makes her life and work of particular interest in this context is that she was situated both as an artist commenting *on* popular culture and an active participant *in* it. She embraced a Pop persona with relish: identifying with Marilyn Monroe; being chosen as a named dancer on a trendy TV Pop music show; posing as a model for a fashion portfolio; working as an actress on stage and screen and promoted in the popular press as a 'starlet'. At the same time she was also an educated artist, conversant with modernist styles; well read in French avant-garde literature; knowledgeable about new wave cinema (as well as Hollywood movies); and, politically radical, she was an active participant in the 'New Left' that emerged in the post-war era. She was also commissioned as a graphic designer – for advertising and the theatre – a 'lower' form of art. All her interests find form in her paintings and collages where Elvis rubs shoulders with Lenin, Proust with Marilyn Monroe, the Cuban Revolution is celebrated and American politics critiqued (Tate 2013).[1]

Taken at face value, Boty's life and work can be presented as a happy story of the very embodiment of Alloway's 'long front of culture' across which she performed with élan, a performance in fine art practice and popular culture activity that could be celebrated as postmodern *avant la*

7.1 (right)

Picture Show c. 1960/1, mixed media on cardboard (collage, gold gilt paint, sequins), 35.5 × 25.4 cm. Courtesy of the Pauline Boty Estate / Whitford.

7.2 (below)

My Colouring Book 1963, oil on canvas,152.4 × 121.9 cm. Courtesy of the Pauline Boty Estate / Whitford.

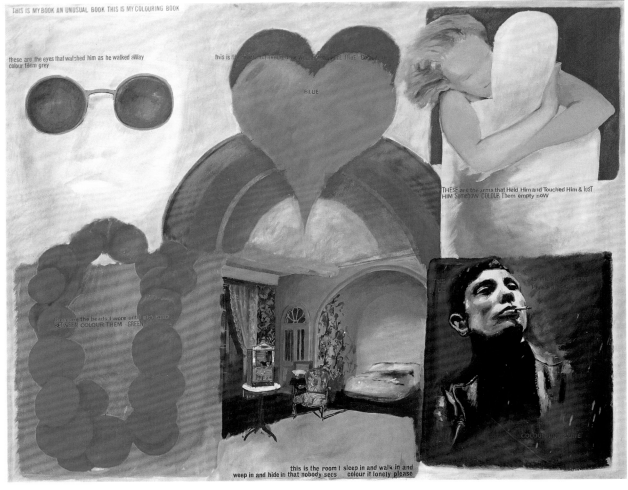

lettre. However, on her tragically early death from cancer in 1966, aged only 28, Boty all but disappeared from cultural view for nearly thirty years, a fact that must give pause for thought. Indeed the whole question of the deeply gendered relationship between women and mass culture, especially within Pop as a genre, is both far more complex and more interesting than a simple description suggests. It proved problematic for women Pop artists, going some way to explain their marginalization in or exclusion from historical accounts of the movement, but also held a rich productive potential that has only recently begun to be recognized.

Pop Art drew its energy and avant-garde status from breaching the high/low cultural divide, transgressively bringing its source material, mass cultural imagery, into the hallowed halls of the museum and art gallery. In *After the Great Divide* Huyssen (1986) argues that Modernism and mass culture, both emerging from the socio-economic conditions of the Industrial Revolution, were engaged in a 'compulsive *pas de deux*' (p. 47). In the chapter 'Mass Culture as Woman: Modernism's Other' (pp. 44–62) Huyssen establishes how absolutely gendered that dance was, arguing that while women have always been excluded from high culture, the context of the Industrial Revolution produced new connotations. From the nineteenth century:

> aesthetic discourse ... consistently and obsessively genders
> mass culture and the masses as feminine, while high culture,
> whether traditional or modern, clearly remains the privileged
> realm of male activities. (p. 47)

The 'masses' (hysterical, engulfing, destabilizing, out of control) were a threat to 'civilization' and 'culture' and were constantly characterized as and identified with, the feminine in newspapers and magazines and in cultural analyses (Huyssen, 1986, 52–3).[2] The projection of male fears of 'engulfing femininity' on to the metropolitan masses were conflated with the perceived need to achieve cultural autonomy from inferior mass culture. Thus:

> the gendering of an inferior mass culture as feminine goes hand
> in hand with the emergence of a male mystique in Modernism
> (especially in painting). (p. 47)[3]

In this light he sees the core features of the modernist aesthetic not as the heroic autonomous acts that have been associated with the myth of Modernism,[4] but as 'warding off' gestures to gain distance from the products and inauthentic experiences of bourgeois industrial modernization (i.e. from mass culture).

Pop was popular and found success quickly in the art market, but it struggled to gain serious critical acceptance. Cocking a snook at the arbiters of good taste Modernism, gleefully walking the line between high and low culture, it risked falling out of the art game altogether – and Pop

was dismissed by critics like Kozloff (1962) and Greenberg (1969) (a hugely influential figure at the time) who saw its producers as 'delinquents' at worst and 'banal' at best. Of course the use of mass culture imagery, described by Hebdige as 'a most soiled and damaged currency' (1988, 117), was intrinsic to Pop so in order to gain critical approval, early critics and historians who supported Pop went out of their way to distance the genre from its mass cultural sources, placing stress on its 'formal qualities'.[5] A 'detached', cool, position-taking was also expected of the artist who could be seen to work on, yet not subsumed within, mass culture. In Huyssen's terms, this call to abstraction and formal qualities and for a detached pose by the artist can be seen as 'warding off gestures'; in fact until recently Pop historian Marco Livingstone, who has to a great extent defined the field, has maintained that 'detachment' was the essential characteristic of Pop.

For the young male Pop artists there was a wonderfully transgressive frisson in going 'down among the women', as it were, to work with the low, trivial, ephemeral imagery of mass culture, gendered female. It was more problematic for women artists; newly arrived on the arts scene and needing acceptance, many turned away from the transgressive Oedipal game. A range of women Pop artists *did* make names for themselves in Pop at the time but, over-identified with mass culture, they threatened the delicate strategizing and anxious border controls of Pop and have been marginalized in or excluded from its subsequent narratives – used, as Cecile Whiting (1997) has pointed out, to define a male core. Early histories of Pop simply did not notice the near absence of women artists from their accounts. In the wake of the impact of feminist art history in the 1970s and 80s, writers in the 90s, such as Livingstone (1990) and Madoff (1997) could no longer ignore it but were at a loss for an explanation. In a 1991 major retrospective of Pop at the Royal Academy in London, curated by Livingstone, only one out of 202 Pop Art works was by a woman (Niki de St Phalle).

The vibrant visual environment of 1960s mass culture (advertising, TV, film) was, of course, deeply gendered: constructing, reflecting and circulating gender stereotypes. Furthermore, women did (and do) take pleasure in highly gendered, mass cultural experience – fashion, film fandom, interior design and so on. Thus female Pop artists were inevitably differently positioned in relation to its popular culture source material (a cultural not an essentialist argument) and from that different position made a distinct and important contribution. In recent years attention has turned to that contribution with important exhibitions like *Seductive Subversions: Women Pop Artists 1958–68* that toured the USA in 2009–10 (Sachs and Minioudaki, 2010), and the work of women artists is now routinely included in exhibitions and publications.

However, quite how to place women artists in the context of Pop is still not resolved. In his recent book *The Long March of Pop: Art Music and Design 1930–1995* (2014) Thomas Crow reveals a fascinating story of the productive interface between the vernacular and fine art in the evolution of Pop to

revive 'some of art's oldest signifying functions and allegorical ambitions' and reach a wider audience. However, he also notes the potentially 'soul destroying' difficulties for the artists in finding 'realistic ways to reckon with this image world', not only in order to achieve a career in the 'art world' with their work 'but more profoundly in discovering a satisfying and valid way to live' (Crow 2014: vii). These were, of course, particularly crucial questions for women Pop artists who found themselves confronting such a highly gendered 'image world', but as no gender analysis is offered there is thus no acknowledgement that dilemmas facing women artists and their possible solutions were not and could not be the same as those for their male counterparts. In this context there is little or no space for the women Pop artists, with the exception being the serious attention given to Pauline Boty (Crow 2014: 343–9), aspects of which I find questionable (more on this later).

Hal Foster's *The First Pop Age* (2012) is more deeply problematic. Focusing on five male artists he 'regrets the lack of women'. 'To be sure' he continues:

> there were female artists involved in Pop (for e.g. Pauline Boty, Vija Celmins, Niki de Saint Phalle, Rosalyn Drexler, Lee Lozano) yet finally women could not act as its principle *subjects* in large part because they were conscripted as its primary *objects*, even its primary fetishes. (my emphases) (p. 14)

Foster certainly puts his finger on a key dilemma for women Pop artists. From its early days Pop has been seen as an 'art of objects' (see Finch, 1968) and lists of objects deemed appropriate always included the sexy woman or pin-up – a difficult subject matter for most women artists. Yet, given that Foster's key concerns are Pop's response to 'a deepened imbrication of image and subjectivity' within the shift 'in the status of image and subjectivity alike' (2012: 4–5) it is striking that at the point where this is perhaps most intense (the over-identification of women with mass cultural imagery) he denies women artists agency (they 'can not act').[6] I will argue that by performing right across the 'long front of culture' and insisting on occupying the subjective position of the dolly bird and sexual woman as intellectual, proactive artist Boty's work lies at the heart of what many writers have noted are Pop's often ambiguous and paradoxical dynamics (see Mahsun 1981 and 1989).

From student days we find Boty negotiating the gendered Great Divide. Growing up in unusual family circumstances (that produced a particularly determined and gender-aware young woman) she won a scholarship to the Wimbledon School of Art in 1956. There she was fortunate to study under Charles Cary, a young and energetic tutor who was in touch with the newly emergent Pop sensibility of the late 50s and which he encouraged among his students, including the use of collage. Evidently talented, Boty experimented with Modernist styles, studied on trips to Paris, read widely, developed an

interest in avant-garde French literature and European film and collected for and made collages (see Tate, 2013, 11–30). She had work accepted for the prestigious *Young Contemporary* exhibitions in 1957 and in 1959 alongside Bridget Riley, Richard Smith and Robyn Denny.

Riley, developing her style of purely abstract Op Art and hoping the fact that she was a woman might be ignored, adopted what I have termed the 'surrogate male' strategy (which was indeed successful) protesting that in the studio she was a hermaphrodite. Boty, on the other hand, regaled in the new fashions, danced to rock music and was, for the times, unusually assertive and open about sex and, with her stunning blonde good looks attracted the soubriquet *The Wimbledon Bardot*. Bardot was, of course, a 'low culture' sex symbol, an identity Boty apparently enjoyed playing up to including making and wearing a 'Bardot-esque' dress. However, according to Jennifer Carey, Charles' wife, 'she was aware of being a thing to most men, not a soul, brain, potential'. She was truly saddened by this and, as she told a fellow student, Beryl Cotton, was determined that 'women should fight back, should be more than just sex symbols, should be able to do more, achieve more'. Refusing to relinquish either her right to a proactive, autonomous sexuality or her ambition as a serious artist, she was, as Jennifer Carey put it, wanting to 're-establish the kind of woman one could be'.

Boty left Wimbledon for the Royal College of Art, confident and well equipped to catch the rising wave of Pop that was about to burst from the College. However, in the context of the institutional sexism prevailing at the RCA, her development as a Pop artist stalled. She had been advised not to apply to the School of Painting despite the fact that painting, seen as having the highest kudos, was her real love, her brother told me that painting was 'considered too difficult for a mere girl to get in'. The statistics support that view. For example, in 1958, the year that Boty applied, only eight of the thirty-two students who graduated in Painting were women, but half of them were given first-class degrees; something achieved by only three of the twenty-four men. Clearly by the college's own standards women had to be better than men to be granted a place. Instead, Boty opted to study Stained Glass and threw herself into student activities: the film club, student reviews, parties, love affairs, and is vividly remembered for her bold personality, life-enhancing laugh and good looks. However, outside the maelstrom of Pop activity in the School of Painting, her interest in collage and contemporary imagery was not encouraged and she lost confidence in her work, pursuing her painting and collage at home and out of sight.

ARK, the prestigious student magazine, promoted the ideas that underpinned Pop (see Seago, 1995) and in the 50s, published a range of articles by Independent Group members (later acclaimed as 'the Fathers (sic) of Pop').[7] These included key 'Personal Statements' by Alloway and the Smithsons who argued for the need to properly understand and respond to the power of advertising imagery, titling their piece 'But Today We Collect Ads' (1956). Boty had poems and intellectually witty pieces included in

the roneoed student Newsheet but in the far more prestigious *ARK* whose contributors and editorial and design teams were almost exclusively male, she only appears in photographs: twice not 'collecting' or commenting *on* ads, but *in* them. She is the pretty girl in advertisements for the London Press Exchange and then for Rowney Artists' Materials in which she takes care to be photographed with her own paintings – a ploy she would use again to keep her identity as an artist visible. A critique of the role of women is already evident in the distorted, over made-up female faces in the paintings.

Editions of *ARK* in the early 60s reflected the tastes of the second generation of Pop artists – David Hockney, Peter Phillips, Allen Jones among others – who took a 'deliberately anti-intellectual stance', wilfully challenging the College hierarchy. Issue 25 (1960) typified this approach with an image of Brigitte Bardot on the cover and in a centre-fold pull-out. Members of the senior common room were duly 'incensed'. It was however, an institutionally supported *neo*-avant-garde transgression as Postle told Alex Seago in 1989: 'a phone, an office and the freedom to do what you liked ... was a considerable virtue' (Seago 1995: 131). This 'mythic' rather than actual challenge to the powers that be is the same as that observed by Anne Massey in relation to experience of the Independent Group at the ICA (Massey and Sparke 1985; Massey 1995; Tate 2010).

The young men, commenting on feminine mass culture could, as it were, march with impunity under the banner of Bardot's sexualized body to assert their neo-avant-garde rebellion. Boty, however, was seen as Brigitte Bardot and identified *with* Marilyn Monroe whom she felt had been exploited by the film industry. In College reviews she performed as Monroe, sashaying down the stage to the tune of *I Wanna Be Loved by You*; mixing high and low culture she also sang, in mock coyness, 'Daddy Wouldn't Buy Me a Bauhaus'. A third photograph of Boty, by Geoff Reeve, appeared in *ARK* 33 illustrating an article on whacky students. Blonde and beautiful – head back, smiling, eyes half closed – the image is remarkably (almost disturbingly) like the photograph of Monroe from *Town* magazine that Boty would later use in an important painting, *Colour Her Gone*, which registered her devastation at Monroe's death. The *ARK* double-page spread also featured a wonderful cacophony of 'low'-culture ads, visualizing a sense of how embedded art students were in mass culture. However, the difficulty for a beautiful young woman in *also* being accepted as an intellectual and serious commentator on that culture, as were the young men, is underlined in an anecdote recounted to me by Boty's boyfriend of the time, Jim Donovan. He had been offered the editorship of *ARK* by Basil Taylor, but he turned it down, and proposed Boty (who had come up with a number of good ideas) instead:

> Taylor didn't even consider the idea for one moment. I forget his actual words, but what he effectively said was that being a gorgeous young girl automatically disqualified her, it was just not possible.

The 'gorgeous young girl' stuck to her artistic guns, however. She used collage as the basis of her stained-glass work and a piece was accepted for an influential Arts Council touring exhibition in 1960, *Modern Stained Glass*, alongside the work of leading figures in the field.[8] She also worked on and developed a distinctive style of collage and, after leaving the RCA, Charles Carey invited her to exhibit at the A.I.A. Gallery in London in 1961 with three others, including Peter Blake. The show was greeted as the first for Pop. Blake, who like Boty was yet to have a solo exhibition, showed six works, while Boty exhibited nineteen, including at least one of her large colourful abstracts (*Gershwin*) and a body of collages that were well received in the broadsheet press (Tate 2013, 49–50). Many of Boty's works have since been lost but their titles *Is it a Bird, is it a Plane* or *Target for Twisters* clearly show her Pop culture interests.

In her collages Boty drew on 'low'-culture imagery from fashion, current affairs and 'girly' magazines[9] and in the spirit of Schwitters[10] incorporated flotsam and jetsam such as a target or book of matches. So far, so typical of the Pop of her generation. However, while the young male artists could perform a wilful anti-intellectualism as an 'avant-garde gambit' (Pollock 1992) young women students on the whole were not overburdened with intellectual respect, as Boty had learnt in the context of *ARK*, and she deliberately integrated images that registered her intellectual interests. The title for *Picture Show*, for example, comes from a popular movie magazine that featured Hollywood stars. This she conflates with 'the idea of pictures in a gallery' and parades her intellectual grasp in a knowledge of politics, avant-garde French literature and Freudian symbolism. Here we find Proust *and* Marilyn; the politics of a Cypriot freedom fighter and President Roosevelt; avant-garde poet, Rimbaud (from a painting by Fantin-Latour) near portraits of intellectual and beautiful salon hostesses (Mme Pompadour by Boucher and Mme Récamier by David). With a knowing nod to Freudian symbolism, a phallic finger presses a bell alongside an image of Collette, who was clearly a role model for Boty. All are set against a luscious gold background and feminine coded sequins.

Early in 1962 Ken Russell started filming *Pop Goes the Easel*, a highly influential documentary for BBC's prestigious arts series *Monitor*, in which Boty featured with Peter Blake, Derek Boshier and Peter Phillips. At the time it boosted her visibility and confidence as an artist and subsequently it maintained her cultural visibility during the lean decades when no work was exhibited. The influence of 1930s musicals on Boty's bold and vibrant abstract paintings is brought out well; however, while the men's work is discussed seriously, there is no voice-over with her collages that could, for example, have provided the Freudian analysis of *Darn That Dream* and *Siren* which she discussed with Russell in the pre-production interview. Instead they are accompanied by tinkling music or are held by the avuncular Peter Blake who asks repeatedly 'What's this Pauline?' as one would to a child. The intellectual artist is barely visible.

More interesting is the way that Boty interposes herself into a play on filmic tropes in a manner that unquestioningly presages postmodern interventions. She had a keen, well-informed interest in film and would discuss in detail filmic techniques such as cutting and panning. A number of friends believe that, had she lived, she would have gone on to pursue a career in film-making – behind the camera rather than in front of it. In *Pop Goes the Easel* she acts out a nightmare sequence in horror-movie mode, something which initially I had supposed to have been imposed on her. However, her close friend Jane Percival assured me that it was Boty's own recurring nightmare that she wanted to explore filmically and that it was she who suggested it to Russell with whom she then collaborated as to how it should be captured. She also mimes to Shirley Temple singing *The Good Ship Lollypop* dressed in top hat and tails (as was the little girl Temple) yet as a grown, sexual woman this performance also calls to mind Marlene Dietrich in *The Blue Angel* (1930) – in a brilliant layering and clashing of references. This is the artist *as* popular culture in an intertextual play with imagery and identity comparable to Cindy Sherman's postmodern exploration of subjectivities constructed through media tropes.

Scene magazine[11] picked up on Boty's disruption of cultural stereotypes. It featured her on the front page in November 1962 with a lead-in declaiming:

> '*Actresses often have tiny brains, Painters often have large beards. Imagine a brainy actress who is also a blonde and you have*
> **PAULINE BOTY**.'

A nearly full-page photograph by Michael Seymour shows Boty reclining on her brass bed and the article, written by her friend Derek Marlowe, asks, in parody of the Superman adage, *Is it an Actress, Is it an Artist?* The potential for a truly innovative collapse of the binary opposition between these gendered identities is palpable. However, at the time and before the emergence of the postmodern episteme, there was no discursive context for Boty's intertextual performance *as* art. *Scene* does reference her paintings, but in considering the impact of *Pop Goes the Easel* on the careers of the artists featured, her 'success' is measured in terms of the acting roles; that of the men, Blake and Phillips, in exhibitions and the rising sale prices of their work.

Acting and modelling were, of course, the only cultural spaces readily available to women on the swinging London scene. In the wake of Russell's film, Phillip Saville gave her a lead in the BBC's Armchair Theatre's *North City Traffic*, which was followed by further parts in TV dramas for both ITV and the BBC.[12] Boty had reservations about acting and was always more committed to her painting but, with money short it paid well and she was enthused by the pulse and energy of mass cultural experience in TV, film, fashion and music.

Believing that the 'dolly bird' in her daring new fashions had revolutionary potential, Boty told her radio audience:

> A revolution is on the way and it's partly because we no longer take our standards from the tweedy top. All over the country young girls are starting, shouting and shaking and if they terrify you, they mean to and they're beginning to impress the world. (*The Public Ear*, 15.12.63)

She was not alone in thinking of fashion as a weapon in sexual politics. Cathy McGowan described her trouser suit as 'rather like a sexual combat outfit' (Bailey 1969: 8) and Mary Quant claimed 'my designs gave women courage – courage to be livelier, more extrovert, more daring, more original' (Bailey 1969: 165). Boty made no distinction between 'originality' of the dolly bird and the Pop artist and when she asked top photographer Lewis Morely to take fashion photographs for a portfolio she posed with her paintings, in her workspace, the tools of her trade visible; the identities of popular culture model and proactive artist commenting on popular culture collapsing into each other, with a grinding of semiotic gears.

Boty spoke, in the first person, of the affirmation that mass cultural experiences can bring:

> *Our* fears, hopes, frustrations and dreams, *we* can pin them on a star who shows them to millions and if *we* can do that *we* are no longer alone. (*The Public Ear*, 1963 – my emphasis)

Describing Pop as 'a nostalgia for now', she believed its job was to 'colour the myths' of the film star gods and goddesses – myths that people need, she argued, to enrich their lives. Having regained her confidence, and only after leaving the RCA, Boty finally found her full Pop voice in paintings made in 1962/3.

The Only Blonde in the World gives an empathetic sense of the film fan's experience whilst also playing sophisticated pictorial games. Knowingly rejecting the Greenbergian imperative that painting should be non-figurative and flat she appears to split open one of her own abstract paintings to reveal a glimpse, in pictorial depth, of Hollywood glamour with Marilyn shimmying across the space. Boty appropriated a black-and-white PR photo of Monroe in *Some Like it Hot* from *Life* magazine and, much as film fans use their imaginations on such images, she uses a tactile painterly style and licks of colour to bring the image to life. Then, bringing her knowledge of art history into play, she adopts the Futurist use of multiple lines to give movement to Monroe's leg and the impressionist 'cut-off' technique to evoke a sense of continuous space beyond the revealed image of Monroe. On the lower right an arc of grey paint that initially appears to be part of the abstract of the 'foreground' melds indistinguishably with the

7.3

Pauline Boty at Battersea Fun Fair.
Photograph by Michael Seymour.

grey of the ground on which Monroe wiggles along; a classic Cubist trick known as *passage*, used to disrupt pictorial space. The painted gold frame within the frame (usually cropped erroneously in reproductions) appears to sit behind the abstract panels at the top, yet it is in front below, further confusing our reading of the space and in another witty visual trick the top corner of the diagonal band in the upper right is turned down in a tiny *trompe l'oeil* to reveal raw canvas. These sophisticated techniques are a reminder of the artificiality of this 2D painted image – as artificial as the media induced pleasures for the fan of film stars.

At the time of making such works John Schlesinger was looking to cast *Billy Liar* and Boty was shortlisted for the part of Liz, the free-spirited girl who stands for the rejection of traditional mores in the emerging 'liberation' of the 60s. Albert Finney and Tom Courtney visited, discussed and ran through the part with her, but in the end Julie Christie was chosen for the role. However, friends are unequivocal in asserting that the persona of Liz was modelled on Boty – the bohemian artist, re-establishing what a woman could be – a striking segue between lived experience and filmic representation. It is a perfect example of the 'deepened imbrication of image and subjectivity', to borrow Foster's phrase, which is also nicely encapsulated in another photograph by Michael Seymour. For the photo shoot Boty and Seymour chose Battersea Fun Fair – the raucous, vernacular, low-taste face of the otherwise tasteful and highbrow 1951 Festival of Britain. Boty, beautiful, perfectly made up and recently heralded as 'The Wimbledon Bardot', looks calmly at a poster for the *Crazy Cottage* (a slightly bizarre, deliberately wonky faux Tudor building) advertising one of its salacious delights – 'Brigitte's Bikini' (another was 'see the lady in the bath'). The image chimes well with Crow's interest in the interface between Pop and the vernacular – particularly with British experience of the fairground or circus.[13]

The year 1963 was Boty's *annus mirabilis*; full of optimism, she conducted a productive and innovative segue between all points along the 'long front of culture'. The swinging 60s were getting into their stride; *Ready Steady Go*, a generation-defining Pop music programme, broadcast on Friday evenings, was launched. With its anarchic informality, wandering cameras and trendy audience dancing in the studio it captured the new mood, placing the Pop music fan at the centre of the experience. Boty's Pop persona had registered on the scene and she was invited to participate in the very first episode which aired in early August – one of only two listed as dancers.[14] The programme opened with Pop imagery (bold numerals, a target that shatters and so on) that flashed onto the screen to the beat of Manfred Man's *5-4-3-2-1* – the countdown to the weekend. Boty appropriated the song's title to make a work that expressed her subjective, pleasurable experience of dancing to Pop music and the erotic anticipation that it aroused. She was aware that Monroe, *the* symbol of sexuality was (as Dyer later pointed out in his book *Stars*) '*sexual for men*' and that she herself was often no more than a sexy 'thing' to them. She talked very openly about sex and discussed with her boyfriend how a female orgasm might be pictured and *5-4-3-2-1* is an overt statement of an autonomous female desire. Below the numerals, in decorative fairground style on a vivid red background, a banner declares *Oh For a FU...* This was truly radical, pre-dating by two years Ken Tynan's first ever use of the 'f' word on TV, which prompted questions to be asked in the House of Commons. Below the banner a girl throws her head back in Dionysian laughter, behind her a swirl of pink and black in which we can see an elongated version of the rose that Boty used repeatedly as a symbol of female sensuality and desire. Overpainted in flesh tones and surrounded with black cross-hatching there is more than the suggestion of labia, clitoris and pubic hair, with the white area to each side representing the thighs. This is an amazingly innovative attempt to find a visual language within the tropes of Pop culture for an embodied and autonomous female sexuality. It completely ignores the objectification of both pornographic and much Pop imagery to speak of the female sexual *subject*, not object.

In the party scene in *Pop Goes the Easel* Boty, wearing a huge grin, outdances all around her, winking cheerfully at the camera – an experience reflected in an untitled painting where, against a clear blue sky and a line of jutting mountains a gyrating, beaming girl dances with her arms raised; an image that pre-figures 1990s works by Tracey Emin and Gillian Wearing.[15] However, Boty goes further and fills the girl's body with black-and-white images of the modern world: factories, a gangster, the crash of the Hindenburg, the grille of a Mercedes, the owl of history scowling from her thigh. In brilliant orange, the orgasmic explosion of a sunflower bursts across her belly while the Hindenburg rises as a phallic form from her crotch. The dancing Pop 'girl' is both sexual and knowing subject, formed by and informed about the social history of her time.

Untitled (dancing girl) c. 1963, oil on canvas, 78 × 95 cm. Courtesy of the Pauline Boty Estate / Whitford.

7.5 (right)

With Love to Jean Paul Belmondo, 1962,
oil on canvas, 122 × 152 cm. Courtesy of the
Pauline Boty Estate / Whitford.

7.6 (opposite)

Programme design for *The Knack*,
The Royal Court Theatre, 1962. ©The
Royal Court Theatre, image courtesy of the
collector.

For *My Colouring Book* Boty once again appropriates the title of a
song in the charts[16] and pursues the conceit – 'colouring in' the emotions
of a relationship break-up. A grid of images appropriated from mass-
produced photographs illustrate the lyrics applied to the canvas, line by
line, in transfer lettering.[17] By using her distinctive style of painted collage
Boty draws attention to the workings of mass-media imagery, but unlike
Warhol's repeated screen prints or Lichtenstein's Benday dots, she is not
looking for distance/detachment. Instead, she passes these images through
a subjective, painterly sensibility to get under the skin of the emotions,
indulging in and communicating the melancholic pleasures of heartbreak
when shared with 'millions' through the medium of a Pop song.

With Love to Jean Paul Belmondo combines, rather satisfyingly, Boty's
sophisticated knowledge of French new wave film-making with the pure lust
of the female film fan, describing the star as 'the dish with the ravey navel
… oh indescribable joy and lechery and slurp, slurp he's lovely just lovely'.
A photo appropriated from *Twen* – a cutting edge, stylish German lifestyle
magazine – is rendered in black and white (we are not to forget this is a

mediated pleasure), then crowned with a ludicrously huge and quivering version of her red rose of desire. Lush strokes of orange and red almost envelop his face while jaunty Pop hearts top the composition. This is not a painting about Belmondo as such; dedicated *to* him 'with love', it is an expression of the pleasurable indulgences of the movie fan.

Just as Warhol and Rosenquist worked in graphic art (the former as an illustrator, the latter as a billboard painter) and are celebrated for it in Pop histories, particularly in Crow's recent analysis, Boty also produced graphic designs, including an advert for the Container Corporation of America. During 1963, she took further roles in TV dramas including Ken Russell's 'high art' movie *Béla Bartók* (1964) and acted in plays at the culturally innovative venues of the New Arts and the Royal Court Theatres and designed programmes for the latter. Her design for *The Knack*, a proto-feminist play by her friend Anne Jellicoe is striking; against a vibrant blue background with simple, Modernist sans-serif lettering, Rita Tushingham is pictured, wrapped only in a towel, cringing and smiling coyly while pointing

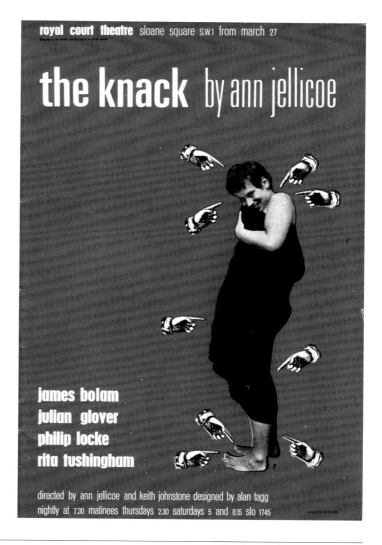

It's a Man's World II, 1964/5, oil on canvas,125 × 125 cm. Courtesy of the Pauline Boty Estate / Whitford.

fingers (a manifestation of the male gaze?) attack her from all sides. Interestingly Boty both acted in the play *The Day of the Prince* and designed the accompanying programme, which included a witty, satirical board game based on the play. Aligning 'inferior' graphics with fine art was already breaking the high/low boundary but Boty added another layer – as actress, graphic designer and fine artist all in one she conflated and compressed accepted cultural hierarchies.

In 1963 Boty also started to work on a trendy, magazine-style radio programme, *The Public Ear*[18] where she interviewed and mingled with celebrities across the whole gamut of cultural life, from Benjamin Britten to

the Beatles and delivered a series of intelligent, witty monologues that both celebrated and critiqued mass culture with splendidly articulated feminist invective. At last her opinions were being heard. She met and quickly married Clive Goodwin, who 'accepted me intellectually which men find very difficult' (Dunn, 1965, p. 15). In recognition of her fine art practice, where her Pop culture experiences found expression in paint, she was given a solo exhibition at the Grabowski Gallery. An *annus mirabilis* indeed.

Boty's acting roles and her good looks attracted the interest of the popular press and increasingly she emerged in the public eye as that paradigmatic, gendered mass cultural figure, the 'starlet'. In 1963 *Town* magazine commissioned Lewis Morley to take 'tasteful pin-up' images and *The Evening Standard* sent photographer Michael Ward to take photos for their 'Show Page'. While the 'starlet' role was culturally risky, Boty's confidence was running high and she took over and managed both photo shoots to make the photographs a statement of her radical intent to collapse the binary oppositions between sexual woman and serious artist, subject and object. In libertarian spirit she posed naked for Morley with her painting of her own object of desire, Belmondo, ironically adopting the attitudes of famous nudes from art history, Velázquez's *Rokeby Venus* and Boucher's *Louise Murphy* – Louis XIV's mistress. Simultaneously sexual object and proactive subject, she demands the right to the autonomous sexual energy that has long been the privilege of the male artist. For Michael Ward she again posed with her own paintings – this time dressing up and performing as their subject matter, for example wearing dark glasses and a straw hat *as* Belmondo. In another, dressed in a lacy blouse and push-up bra, Boty looks very like her portrait *Celia with Some of her Heroes* which depicts her friend the textile designer Celia Birtwell. In the photograph Boty stands beside the portrait, creating a wonderfully chameleon-like conflation of subject/object positions.

Her attempt to 'speak' transgressively in the language of photography, however, was thwarted. Morley's photographs were never published and Ward's found their way, in 1964, via a photo agency into the soft porn magazines *For Men Only* and *Titbits* where the picture editor cut away the paintings leaving only the sexy girl as the object of the gaze, for the delectation of a male audience. She couldn't escape the inexorable tug of the 'despised', low-culture identity for women, especially that of the sexual woman. Most articles in the popular press dwelt on her appearance and were patronizing in tone describing her as 'a pet, darling and symbol' of the Pop art group (*Men Only* March 1963). In her acting work she was locked into the role of the objectified, sexualized woman[19] and her popular culture identity had a damaging effect on her reception as a serious artist. While her solo exhibition in 1963 was well received in *The Times*, while praising aspects of the work Norbert Lynton, writing in *Art International*, also found fault with the 'diffusion of talent' due to her career as an actress – a fact that he thought was suppressed in the catalogue to the show, as if it were a dirty secret he had flushed out. This negative impact reverberated down

the decades; in 1993 discussing her work on *The Late Show* Waldemar Januszczak, then arts critic of *The Guardian*, opined that she would always be 'popular with the media because she was a dolly bird. But her painting was derivative. She painted very badly.' Clearly for him the identities of dolly bird and artist were mutually exclusive.

Crow (2014) is appreciative of Boty's place in the web of high/low culture that 'provided her with a perspective perhaps unique among Pop artists' (p. 344). He sees 'an act of identity theft' (p. 346) in the portrayal of Liz in *Billy Liar* and, as we shall see below, elsewhere he has brought a sharp appreciation to her work. Yet the lack of a gender analysis in his recent book inflects the text. For example the institutional sexism of the RCA School of Painting is described merely as 'unfriendliness' (p. 344) while Punk is more 'friendly' to women – a term that obfuscates the seismic cultural shift brought about by the impact of feminism. David Bailey's photographs of Boty are assumed to be for a modelling assignment while in fact they were for his book *A Saraband for the Sixties* where she is clearly listed as 'artist'.[20] And, perhaps in line with this slippage, Crow describes her as an 'earnest amateur' – when, as a result of her talent and training at Wimbledon and the RCA, she made sophisticated use of her knowledge of the tropes of modernist painting and conscious choices in her shifts in register between, for example, the high photorealism of *Portrait of Derek Marlowe with Unknown Ladies* or the crude school girl generic rendering of *Celia and some of her Heroes* (see Tate, 2013: 118–19).

Boty herself became increasingly aware of her reception as no more than the glamorous girl; as *Vogue* put it in 1963, in an article entitled 'Living Doll' and illustrated with one of Bailey's photos, 'she was beautiful therefore she could not be clever' (September, 59). In a long interview with Nell Dunn (1965) she discussed the problem and in her witty radio monologues, while celebrating her pleasure in mass cultural experiences, she also exposed the negative and limiting effects of advertising, women's magazine fiction and the misogynist attitudes of 'the Englishman'. Clearly it was a real struggle for a woman to find a 'satisfying and valid way to live' within 'this image world' and the publication of Ward's mutilated photos in *Titbits* must have been the last straw.

A critique of the representation of women runs throughout Boty's work from her student days, via fascinating stage designs for Genet's *The Balcony* and *Portrait of Derek Marlowe with Unknown Ladies*, the very title of which demonstrates her engagement with gender politics. That critique reached a climax in *It's a Man's World II*, 1966, Boty's penultimate painting, a skilful and highly prescient proto-feminist exploration of the representation of women. In a vertical panel images of the female nude, appropriated from the high art of the life drawing class and the low of soft porn, are trapped within a picturesque landed estate with neo-classical folly. Already questions of cultural value, gender and class are at play, then, in a highly skilful use of painted collage, Boty takes us deeper into the issues. The composition is

dominated by the headless, pale body of a young woman, her pubic hair at its very centre as if *this* is the point for men who in her experience, as she told Nell Dunn, 'often only want a quick fuck' (1965, p. 27). In an earlier version of the painting (visible in a David Bailey photograph) this figure, complete with head, is striding purposefully towards the viewer, arms swinging. Now static and anonymous, at first glance it appears to be a representation of a 3D body, standing in front of a wall collage of rectilinear, 2D images – the 'collage' can be seen in the gaps between her arms and body and between her legs. Look closer, however and see that the apparently 2D depiction of a reclining nude covers the girl's head and another her legs. Pictorial space is disrupted as Boty uses the language of paint to reveal how women are implicated in and interwoven with their media representations. In the 'imbrication of identity and image' (Foster 2012: 4) the ubiquity of sexualized representations affect how women are received (as Boty had recently learnt) and how they experience themselves. Boty does not launch a critique by making the women grotesque but handles them gently. The woman in the bottom right, a pin-up, the quintessential fetishized 'object' of Pop, looks out, almost wistfully; holding the viewer with her eyes we are jolted into seeing her as a subject.

After nearly thirty years languishing first in her father's attic then in an outhouse on Boty's brother's farm *It's a Man's World II* was rediscovered and exhibited in 1993 by David Alan Mellor.[21] In a review in *Artforum* Thomas Crow (1993) noted how, with its 'simultaneity of different visual codes', the work presages postmodern practice and wrecked a 'quiet demolition' on adjacent works like Blake's *Girly Door* or Allen Jones' *La Sheer* (p. 81).

Conclusion

An over-identification with mass culture has had a negative effect on Boty's reception, yet it is exactly that which makes the work so interesting and challenging. Boty, is the fetishized 'object' who, as fine artist in both critical and celebratory mode, speaks the 'object's' subjectivity. As a woman and in her performance across the whole length of Alloway's 'long front of culture' she collapsed the binary opposition between sexual woman and serious artist, triggering what Rebecca Schneider has termed 'binary terror' – when the very structures of meaning are at risk (1997: 13). It is a 'terror' that surely underpins Foster's erroneous insistence that 'conscripted as its primary *object*' women 'could not *act* as its principal *subject*'.

Painter, collagist, actress, graphic designer, 'starlet', intellectual, dolly bird, feminist; Boty's life and work resonates with current concerns where, in an ever more pornified culture, young women are claiming their right to mass cultural pleasures and sexual autonomy and also to professional and cultural respect. Most fully 'imbricated' in the image, most challenging to the gendered line between high and low culture from which Pop drew its avant-garde energy, Boty was operating from a place of highest tension at the very heart of Pop and enabling a fascinating body of work that enriches while it destabilizes the established narrative.

Notes

1 *Cuba Si* responds to the Cuban revolution; *Count Down to Violence* is her gendered critique on political events of 1963.

2 Huyssen quotes, for example, Gustave Le Bon's 'hugely influential' 1895 study *The Crowd* (*La Psychologie des foules, 1895*) which 'summarises arguments pervasive in Europe at the time' and in which 'crowds everywhere are distinguished by feminine characteristics' and 'the male fear of woman and the bourgeois fear of the masses become indistinguishable' (Huyssen 1986: 52–3).

3 Feminist scholars (notably Pollock 1987; Duncan 1993; Betterton 1987) have also explored the male gendering of the paradigm of the modernist artist and the implications this has had for women artists – implications heightened in the context of Pop.

4 The 'autonomy' of the artwork, the privileging of form over content, the validation of the expression of the individual over the zeitgeist, the pseudo-scientific characterization of 'experimentation' and so on.

5 Gablik and Russell for example, comment that 'our primary intention in this exhibition has been to assert the stylistic affinities of Pop Art with certain contemporary abstract art, in the hope of expanding the framework within which Pop has so far been considered' (Gablik and Russell 1969: 10).

6 This could be seen in terms of the silenced position of the 'subaltern', or oppressed groups, that Gramsci identified in the ongoing processes of hegemony. Spivak asks 'Can the subaltern speak?', Forster's answer would seem to be 'no'.

7 Commonly used phrase that originates in a 1979 Arts Council documentary film of that title which explored the Independent Group directed by Julian Cooper with research by Penny Sparke.

8 For example, Patrick Reyntiens and both Boty's tutors, Keith New at the RCA and Charles Carey at Wimbledon.

9 'Look and *Life* and *Nugget* and *Elle* and *Esquire* and *Paris Match* and of course *Vogue*' and 'of course girly magazines' she told Russell in the pre-production interview for *Pop Goes the Easel*.

10 Charles Carey introduced his students at Wimbledon School of Art to the work of Kurt Schwitters.

11 *Scene* itself is an example of the increasing fluidity of cultural boundaries with articles ranging from Hollywood film stars to fine art, wrestling to classical music.

12 Acting roles:
1962
• July: Anna in ITV Armchair Theatre plays: *North City Traffic*, *Straight Ahead* and *North by North West*.

• November: Rona in *The Face They See*, a BBC drama.

1963
• February 14 (recorded) December 17 (transmitted): Josie in *Maigret: Peter The Lett* for the BBC.

• May: Virginia in *Day of the Prince* by Frank Hilton, directed by Keith Johnson at The Royal Court Theatre (designed the programme).

• August: Lola in *Afternoon Men* (adaption of an Anthony Powell novel) at New Arts Theatre, London.

• October: a prostitute in *Béla Bartók* directed by Ken Russell.

1964
• February: small part in 'The Frantick Rebel', an episode of *Espionage* for ATV.

• May: *Bartók* broadcast by the BBC.

• July/August: Pauline in *Short Circuit– The Park*, a BBC drama.

1965
• January: a part in *Day of the Ragnarok*, by John McGrath, for BBC2.

• May/June: Maria Gallen in *Contract To Kill*, a six-part BBC TV serial.

• June: small part in *Day Out for Lucy* for BBC2.

13 Seen in the opening of *Pop Goes the Easel*, in Peter Blake's imagery and as the inspiration for both music and cover design for the Beatles' *Sgt Pepper*.

14 The other was Georgina Burgess, a trained dancer. The programme aired on 9 August.

15 Tracey Emin, *Why I Never Became a Dancer* (1995) and Gillian Wearing *Dancing in Peckham* (1994).

16 Words and music of *My Coloring Book* by Fred Ebb and John Kander. Recorded by Kitty Kallen and Barbra Streisand in 1962. Covered by Dusty Springfield in 1964.

17 In the top right she appropriates Richard Avedon's photo of Monroe with her arms around Henry Miller (here she is faceless, he is painted out in white These are the arms that held him ... colour them empty now say the lyrics). The black-and-white image 'the boy' ('colour him gone') is based on a photograph of singer songwriter Alan Klein, again from Town magazine, taken by Don McCullen before he was famous – Boty had an eye for the best photographs.

18 *The Public Ear* ran from October 1963 to March 1964 and described itself as '60 minutes of news, comment, music and opinion. From the people who know to the people who want to know'. Boty is credited in all thirteen editions. Extracts from her monologues are reproduced in Chapter 5 'It's a Man's World' in Tate S. (2013), *Pauline Boty Pop Artist and Woman*, Wolverhampton: Wolverhampton Art Gallery.

19 In the TV thrillers she was the 'Irish tart Anna' in ITV's Armchair Theatre plays or 'the seductive Maria' in *Contract to Kill*; even in the more avant-garde milieu of the Royal Court she played 'a romantic blonde teenage virgin' and in *Bartók* was again a prostitute.

20 Discussing *The Only Blonde in the World* Crow erroneously describes the figure as a 'Monroe/Bardot surrogate' when it is specifically Monroe from a particular photograph from the set of *Some Like it Hot* that appeared in *Life* magazine (20 April 1959). The painting itself was then reproduced in a later edition of the magazine – an interesting instance of the interpenetration of mass culture and fine art that is overlooked.

21 In a survey exhibition *The Sixties Art Scene in London* at the Barbican, 1993.

References

Alloway, L. (1956), 'Personal Statement', *ARK* 19, Summer, p. 28.

Alloway, L. (1959), 'The Long Front of Culture', *Cambridge Opinion*, No 17.

Bailey, D. (1969), *Goodbye Baby and Amen, a Saraband for the 60*, Condé Nast.

Betterton, R. (1987), *Looking On: Images of Femininity in the Visual Arts Media*, London: Pandora Press.

Crow, T. (1993), 'London Calling', *Artforum*, vol. 31 p.81 (review of Barbican show *The Sixties Art Scene in London*).

Crow, T. (2014), *The Long March of Pop: Art Music and Design 1930–1995*, London: Yale University Press.

Duncan, C. (1993), *The Aesthetics of Power: Essays in Critical Art History*, Cambridge University Press.

Dunn, N. (1965), 'Chapter 1 Pauline Boty', in *Talking to Women*, 11–31, London: Macgibbon & Kee.

Dyer, R. (1979), *Stars*, British Film Institute.

Finch, C. (1968), *Pop Art: Object and Image*, London: Studio Vista/Dutton.

Foster, H. (2012), *The First Pop Age*, Princetown and Oxford: Princetown University Press.

Greenberg, C. (1969), *Avant-Garde Attitudes: New Art in the 60s*, (The John Power Lecture in Contemporary Art, delivered at the University of Sidney, Friday 17 May 1968. Published by Power Institute of Fine Arts University of Sydney).

Hamsun, C.A. (1981), *Pop Art and the Critics*, Ann Arbor/London: UMI Research Press.

Hamsun, C.A. (1989), *Pop Art: The Critical Dialogue*, Ann Arbor/London: UMI Research Press.

Hebdige, D. (1988), 'In Poor Taste: Notes on Pop', in *Hiding in the Light*, London: Routledge.

Huyssen, A. (1986), *After the Great Divide*, Bloomington: Indiana University Press.

Kozloff, M. (1962), 'Pop Culture, Metaphysical Discussed, and the New Vulgarians', *Art International*, March, 35–6 (reproduced in Madoff, 32).

Livingstone, M. (1990), *Pop Art: A Continuing History*, London: Thames & Hudson.

Madoff, S.H. (1997), *Pop Art: A Critical History*, University of California Press.

Massey, A. (1995), *The Independent Group: Modernism and Mass Culture in Britain, 1945–59*, Manchester: Manchester University Press.

Massey, A. and Sparke, P. (1985), *The Myth of the Independent Group*, Block 10. p48–56.

Pollock, G. (1987), 'Feminism and Modernism', in *Framing Feminism*, London: Pandora Press.

Pollock, G. (1992), *Avant-Garde Gambits 1888–1893*, London: Thames & Hudson.

Sachs, S. and Minioudaki, K. (eds) (2010), *Seductive Subversion: Women Pop Artists 1958–68*, New York and London: University of the Arts, Philadelphia and Abbeville Press.

Schneider, R. (1997), *The Explicit Body In Performance*, London: Routledge.

Seago, A. (1995), *Burning the Box of Beautiful Things: The Development of A Post Modern Sensibility*, Oxford: Oxford University Press.

Smithson, A. and Smithson, P. (1956), 'But Today We Collect Ads', in *ARK*, 18 Nov, p. 49.

Tate, S. (2010), 'A Transgression Too Far: Women Artists and the British Pop Art Movement', in *Subversive Seduction: Women and Pop Art*, Sachs, S. and Minioudaki, K. (eds), (New York: Abbeville Press).

Tate, S. (2013), *Pauline Boty Pop Artist and Woman*, Wolverhampton: Wolverhampton Art Gallery.

Whiting, C. (1997), *A Taste for Pop: Pop Art, Gender and Consumer Culture*, Cambridge: Cambridge University Press.

Unpublished materials

Pre-production interview with Ken Russell – from BBC archives, kindly made available by Adam Smith.

Now You See Her unpublished biographical text by Adam Smith.

The Public Ear (October 1963–March 1964) transcripts from BBC archives.

Author's interviews with Arthur Boty (1996), Jennifer Carey (1997), Beryl Cotton (1998), Jim Donovan (1997).

A Dedicated Follower of Fashion

Alistair O'Neill

Richard Hamilton's recent retrospective at Tate Modern presents a useful opportunity to reconsider his 'interest in popular culture and the transformation of images through modern media' (text panel, room 10, Richard Hamilton, Tate Modern, 13 February–26 May 2014). Hamilton's use of fashion photography for instance, drawn from a broad array of commercial imagery, is an aspect of his work that continues to resonate with a contemporary audience. The cover of *Aperture* magazine's Fall 2014 fashion issue, which was guest edited by fashion photographers Inez van Lamsweerde and Vinoodh Matadin, reproduced Hamilton's *Fashion-plate* (1969–70) as the cover image. The fashion photographers noted:

> In Hamilton's *Fashion-plate* collages, art and fashion are combined into a single image – it's both photography and painting. It's old school yet it anticipates the digital. ... Hamilton's work is about cutting through notions of what's real and what's not in a photograph, and what's special about the *Fashion-plate* works is how you see the light and the stand: the typical photography studio setup. The faces are so big, proportionally, and distorted through the use of different images taken from fashion magazines – it's fantastic. Pop art has been a big inspiration for us; you might say that fashion photography is the ultimate Pop art. (van Lamsweerde and Matadin 2014: 82)

In making an explicit connection between Hamilton's analogue artistic experiments and their own commercial digital practice, Lamsweerde and Matadin neatly demonstrate the profound influence of Hamilton's enquiries into the production of commercial imagery, and its relation to fine art printmaking techniques, on a digitally driven, twenty-first century account of image-making.

In *Fashion-plate*, Hamilton addressed the image of the modern woman portrayed in contemporary fashion magazines through a suite of prints (Verlag 2003). The print series combines silk screen and offset lithographic printing processes, hand-colour tinting and the application of both lipstick and nail varnish, melding the materials and techniques of the fashion

Aperture magazine, 216, Autumn 2014.

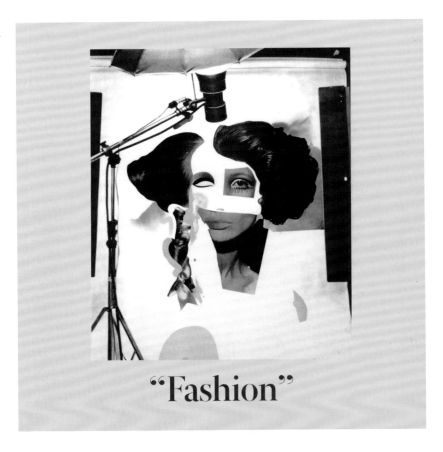

photography studio (as signposted in the consistent background of the studio in all of the prints, taken for Hamilton by fashion photographer Tony Evans), with those of the fine art printmaking studio. Images of models including Veruschka, Penelope Tree and Jean Shrimpton were intended to be drawn directly from the coated stock of actual fashion magazines, but Hamilton managed to secure direct transparencies from David Bailey, allowing him to print them to commercial standards in the printmaking studio. The emblematic use of the fashion model in Hamilton's work is, according to curator Mark Francis, 'particularly well suited to exploring the relationship between painted markings and photography within a pictorial composition' (Verlag 2003: 100).

The representation of women as fashionable commodities was a trope that had been explored in the work of other members of the Independent Group. Toni del Renzio discussed the subject in a talk he gave at the ICA in 1956, subsequently published in the *Ambassador* magazine and as an ICA publication under the title 'After a Fashion…'. Del Renzio was ideally placed to discuss the representation of fashionable women; in addition to his work writing about and curating art, he held the position of Art Director for the National Trade Press from 1948 and was soon to join *Harper's Bazaar* as art director in 1958. He defined its emblematic connection to fashion so:

It is, then, that the restlessness of our age, its apprehensions, its nervous hypersensitivity to the accelerations of change, find in fashion's rosy mirror a reflection of our instability in its least frightening aspect – a defence mechanism as reassuring as humour? Its feckless frivolity, its shiftless progress, its almost despicable exploitation of vanity, are perhaps fashion's means of finding acceptance and of shaping as well as being shaped by the image of woman by which our age identifies itself.
(del Renzio 1956: XII)

On the occasion of Hamilton's Tate Gallery exhibition in 1992, del Renzio published a short article in *Art Monthly*, identifying *Fashion-Plate* (1969–70) not only as a key Pop work for Hamilton, but also as a 'a sort of manual' for understanding the representation of women in fashion and a commentary on commercial films of the day that portrayed the world of fashion, such as Michaelangelo Antonioni's *Blow-Up* (1966) and William Klein's *Qui Etes-Vous Polly Maggoo?* (1966).

What is particularly interesting about Hamilton's investigation into post-war representation is his awareness that these representations of women also had repercussions for the visual representation of masculinity and as a result, on the way that men subsequently performed their gender. It is not a coincidence that British Pop runs parallel to a resurgence of male peacockery in post-war London. Hamilton's citation of men's clothes and men's bodies was not solely employed as visual subject matter to apply to printed image alteration technologies; they were also image alteration technologies of masculinity and the male body in themselves, reflected in a burgeoning print culture directed at men at this critical juncture.

Some of Hamilton's works engage directly with this theme. For example, the title of his 1962 series *Towards a Definitive Statement on the Coming Trends in Menswear and Accessories* echoes a men's fashion feature in *Playboy* magazine, although Hamilton added the word 'towards', arguing that 'fashion depends on an occasion, season, time of day and, most importantly, the area of activity in which the wearer is involved. A definitive statement seemed hardly possible without some preliminary investigation into specific concepts of masculinity' (Hamiton 1982: 154). It can be argued that in this period, concepts of masculinity were modified by the promotion of men in connection to the commerce of men's fashion. As fashion designer Hardy Amies noted in 1964: 'In fashion today there are no old men, only the young and the dead' (Amies 1964: 126).

Hal Foster's recent study of *The First Pop Age* identifies Hamilton's 1962 series as amongst his tabular paintings, which typically make use of the representation of women in post-war consumer culture, 'as a way to update the female figure in painting'. For Foster, the *Towards a Definitive Statement* series represents men as being 'as much slaves to fashion as the women

are', the difference is simply in the type of products with which they choose to surround themselves:

> a particular accessory – a transistor, a telephone, a chest expander, and a jukebox, respectively – which is to say, a particular mechanism of media, communications, exercise, and entertainment, all instruments of spectacle. (Foster 2011: 50)

Foster reads this visual representation of newness with Baudelaire's description of the 'pageant of fashion', claiming both as expressive of modernity. Indeed it was whilst flicking through a series of old fashion plates that Baudelaire found inspiration for his famous essay 'The Painter of Modern Life' (1863). Looking at the plates, each depicting a fashion from the past, allowed Baudelaire to distinguish between the prevalent style of history painting, which conventionally represented subjects in the drapery of the past, and those that represented the fashions of the present day. 'The pleasure which we derive from the representation of the present is due not only to the beauty with which it can be invested', he stated, 'but also its essential quality of being present' (Baudelaire 1995 [1863]: 3).

Hamilton's study of men in the Pop age includes an example drawn from a similar approach; in that it does not concern Hamilton anticipating fashion directed at men (as is *Towards a Definitive Statement*), but in recalling it in pictorial form as a reflection on men's dress as a past style. In 1980 Hamilton produced the print *A Dedicated Follower of Fashion*, its title a direct reference to The Kinks' popular single of the same name released in 1966. The song gently mocks the sartorial aspirations of the young man about town in mid-1960s London: 'He flits from shop to shop just like a butterfly/ In matters of the cloth he is as fickle as can be/ 'Cause he's a dedicated follower of fashion' (Davies 1966). The print is based on a photograph the artist found at the photographic company Creative Colour in Hamburg around 1969, which had been sent unsolicited by the subject in the hope of getting a modelling job. The young man's self-consciously fashionable pose and clothing, including a Beatles-style jacket – commonplace by then as a fashionable item – clearly caught Hamilton's eye.

Hamilton extended these ideas around fashion, from the representation of fashionable clothing into the broader context of the fashionable interior. Here we find other self-consciously fashionable objects, such as the Robert Motherwell print *Art* hanging on the wall (even though made in 1970–1), and the subject in the act of being photographed 'doing something', in this instance talking on the telephone (that mechanism of media and communication; the artifice of this pose being exposed by the fact that it is actually disconnected). Hamilton added two pieces of non-descript 'brown' furniture of his own to the scene, to add a jarring quality to the projected stylishness of the interior, which is echoed on the opposite

8.2

A Dedicated Follower of Fashion, 1980, Richard Hamilton (1922–2011). All Rights Reserved, DACS 2015.

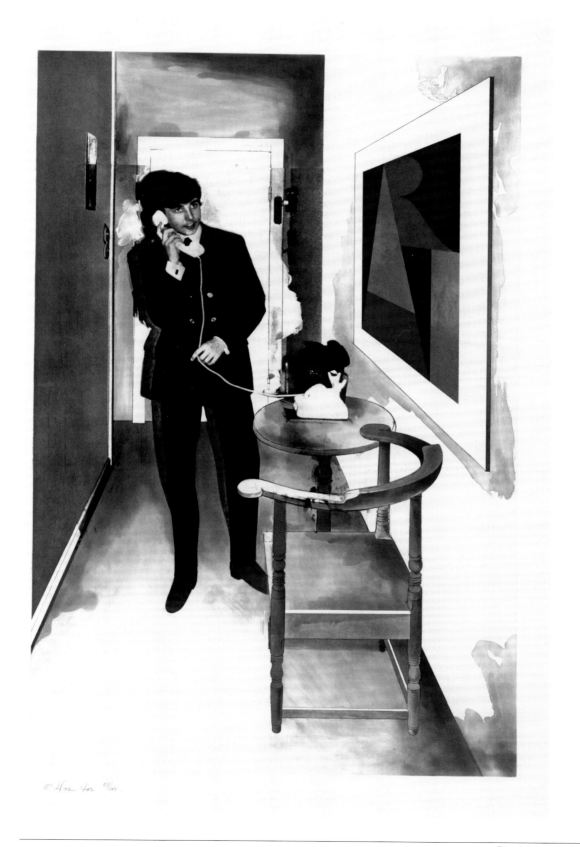

R. Ham Hon 57/100

wall by a small plate mirror set too high on the wall for the young man to be able to see his face reflected fully.

Like the imagined Pop interior Hamilton created as the environment for the young man represented, this chapter provides a framework to analyse the connections that can be drawn between Hamilton's mode of image construction and the construction of masculinity informed by 1960s men's fashion. It is an attempt to map what Hamilton described as 'the great visual matrix that surrounds us' (Hamilton 1973: 50), but in this instance, it is a visual matrix pertaining to men's fashion and masculinity, a technological environment that once swirled around the dedicated follower of fashion. It is about the transmission of these progressive ideas, through a newly diversified British press reporting on men and menswear.

Toni del Renzio recognized that successful commercial fashion imagery relied on achieving 'a dramatisation of the garment' (del Renzio 1956: XI), and we can appreciate how Hamilton's print performs this admirably. The print not only appears as if a commercial image first and an artist's print second, it also offers an amalgam of subject matter and technique. Hamilton's print certainly draws upon the representational strategies of a range of commercial image-makers connected to men's fashion in the mid-1960s and as we will see, the essentially image-based economy of influence that defined a progressive model of British men's fashion; the kind that the Kinks, and perhaps Hamilton, too, were keen to call into question.

Hamilton's permitted borrowing from Bailey in *Fashion-plate* is underscored by his reputation at the time as a leading fashion and portrait photographer, established by his first publication, *Box of Pin-Ups* (1965) with text by Francis Wyndham.

Considered by many as a 'who's who' of fashionable London in the mid-1960s, *Pin-Ups* was one of the first publications to document this shift in the perception and representation of the fashionable man, despite the fact that erotically charged images of professional men reads as camp. Social commentator George Melly identified it in *Revolt Into Style* as the conveyance of homosexual aesthetics into heterosexual taste, typified by the shift in the status of the male fashion photographer: from the likes of John French (1950s, gay and 'U'), being superseded by his assistant, David Bailey (1960s, straight and 'non-U') (Melly 1970).

Box of Pin-Ups captured the innovative styles being adopted by men working in the newly defined creative industries. As a critic and editor at *Queen* magazine before moving to the *Sunday Times* in 1964, Wyndham's precise prose captures, 'A period obsessed by the look of things (when designers, photographers and models were assuming a new status in English life)' (Bailey 1965: n.p.). This included figures like hairdresser Vidal Sassoon, who 'shares in the general concern with appearance, especially his own; now in his late thirties, he gives as much care to his body as to his clothes' (Bailey 1965: n.p.). Amongst the young men photographed we find an interior decorator, a milliner, art directors, music managers and

impresarios. Bailey's portrait of Andrew Loog Oldham, eyes impenetrable behind dark sunglasses, with inflated balloon shirt sleeves and his hands resting on the waist of his belted black hipster jeans, acts as a visual riposte to traditional representations of the brawny male physique; a statement of a new configuration of masculinity.

The debate around the visual identity of the modern man was neatly captured by music journalist Nik Cohn, who at the age of twenty-five published a survey on British Men's Fashion in 1971, prosaically titled *Today There Are No Gentlemen*:

> Does it really make any odds what men wear, whether they are
> sexual or shapeless, glossy or plain? In the end, isn't it a sign
> of direst decadence that men should even think of such things,
> let alone write books on them? On those terms, the answer
> must be dismissive; no, it doesn't matter in the least; But clothes
> exist on another level, beyond fashion. Even if they are trivial
> in themselves, they are not meaningless. More than any other
> area of taste, they are statements – complex expressions of
> self-image, of how one sees oneself and what one hopes for.
> However one dresses, it carries one's own dreams of oneself
> and this applies just as much to dowdiness as peacockery.
> (Cohn 1971: 1)

The attire and attitude of the models in Bailey's *Box of Pin-Ups* convey this self-awareness, each exuding the sense that they are perfectly conscious of how their clothes convey messages about their identities.

Another journalist covering British men's fashion in the period is Rodney Bennett-England, who published *Dress Optional: The Revolution in Menswear* (1967). After writing men's fashion columns in several national newspapers, Bennett-England became the first fashion editor of *Penthouse* magazine in its earliest incarnation as a British soft-core pornographic magazine published by Bob Guccione. In *Dress Optional*, the author is reproduced in photo-mechanical terms wearing a suit he designed and handmade at Lew Rose of Savile Row; he stands whilst speaking on the telephone, addressing the camera in a manner similar to Hamilton's dedicated young man. If, as Baudelaire once noted 'every age has its own gait, glance and gesture' (Baudelaire 1995 [1863]: 13) then this image perfectly conveys the tone of the times.

Hamilton was right to draw attention to soft-core pornographic magazines as a feature of the new visual landscape available to men in the post-war era. Beyond just pin-ups they offered articles and features on a range of topics for their male readership, amongst which those on fashion were most important. The fact that the first editorial role credited on the masthead after that of editor-in-chief was Bennett-England's post as fashion editor also reveals the status given to the subject.

The sense of experimentation offered by the adoption of men's fashion is captured in the editorial 'Swinging in Savile Row', in which Bennett-England photographed John Walker of the Walker Brothers in clothes by Kilgour, French and Stanbury on the Row and its progressive men's fashion store, Number 10 Shop, established by Kilgour tailor and Deputy Chairman Louis Stanbury, on Dover Street. Rodney Bennett-England's editorial draws attention to the competing demands on the fashionable male:

> So here's a progress report on two 'swingers'. John soared up
> the charts with Annabella, losing sleep dashing all over the place
> making personal appearances. (His wife, Kathy, stays at home
> with their two Alsatians.) The Number 10 Shop is doing quite
> well, too, in the popularity charts. Better watch those clothes,
> John. The boys, not the girls, will want to take them off your back.
> Louis Stanbury designs clothes to make men look like men.
> (Bennett-England 1971: 47)

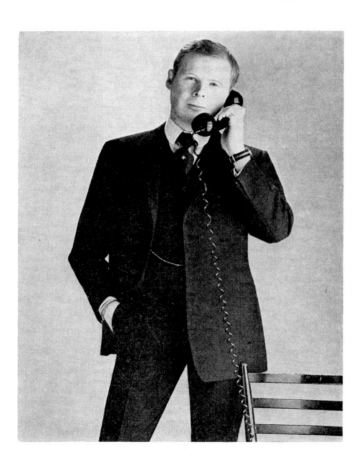

*The author in a suit designed by himself and made by Lew Rose of Savile Row
(by postal instruction only).*

The adoption of fashion by men equated here with personal attraction and success. Images like those in *Penthouse* held out a promise to readers; offering men the chance to become like Pop stars themselves by adopting the same fashions as celebrities. Paul Jobling has described menswear advertising in the post-war period as defined by 'the imbrication of sex and pleasure in objectifying the male body' (Jobling 2014: 9); we can read these images in the same way, despite the fact that in this case they are encountered in the pages of a magazine primarily designed to objectify women's bodies.

Louis Stanbury also features in *Dress Optional*. Unusually for the period Stanbury advocated both the virtues of bespoke Savile Row tailoring and those of cheaper machine-made fashion-led clothing from his off-the-peg boutique, The Number 10 Shop. Stanbury combined both techniques in his hobby of making pictures from the cloth remnants of bespoke customer orders, which he then hung in the Dover Street boutique. As a tailor he regarded the design of men's clothing as a technology intimately linked to the proportions of the male body; one that he felt had too often been employed in concealing its imperfections. He believed that:

> Proportions are more important than fashion. Anybody can make fashion. Pleats are better than vents on jacket and coats. Vents emphasize a man's bottom. There is nothing more ugly than a man's bottom. Pleats came back via Pierre Cardin. So many things start in this country but nothing really happens until they come back from the Continent in bulk. (Bennett-England 1967: 64)

French couturier Pierre Cardin started a menswear line in 1960 and by 1967 Cardin had '250 men's boutiques in France and 1500 throughout the world' (Bennett-England 1967: 90). In Britain, his designs were produced under Associated Tailors for the Neville Reed and John Temple shops at a competitive price. The Beatles star jacket worn by Hamilton's dedicated man is, in part, informed by Cardin's work in the early 1960s (appropriated by Dougie Millings for the band's stage costumes in 1963), but by 1966 Cardin had branched out, experimenting with a more progressive and futuristic style which made use of man-made fibres. Materials such as Dacron were not only lightweight and could stretch, they could also accommodate zip fastenings and concealed poppers which gave a clean modern look. In 1966 *The Times* reported on a charity gala fashion show staged at London's Commonwealth Institute dedicated to Cardin's latest designs for men and women. The event garnered particular attention because – rather than separating his designs according to gender – Cardin presented a unisex show.

> One gentleman at the show was moved to declare in ringing tones: 'God knows I go to the best tailor in London but he simply can't touch this man for style!' When pressed, however, he said

nothing on earth would make him wear them because he was certain they could not be lived in like British bespoke clothes; he was equally certain that this thing he called 'style' was Cardin's prerogative. Perhaps he does both Cardin and his royal tailor an injustice, but there you are, men are now as dotty and inconsistent about fashion as women once were. (Lennard 1966: 15)

Dress Optional is a useful marker of the terrain for men's fashion in mid-1960s London. In addition to interviews with tailors and high-end designers in and around Savile Row, it also features interviews with middle-market retailers along Regent Street, and the fashionable boutiques appealing to a more youthful audience on Carnaby Street and in Chelsea. In addition to these interviews there follows a chapter discussing the development of man-made fibres and its implications for the clothing industry, promoted by ICI and Courtaulds. Another chapter addresses the expanded range of titles catering to men's fashion and the emergence of a range of new professional identities for the creative practitioners in this commercial field. It is this chapter which Bennett-England titled 'The Image Makers' that is of most relevance.

The 1960s in Britain was a period of great expansion for the advertising of menswear and in editorial focusing on men as fashion-informed consumers. While the development of broadsheet colour magazines from 1962 aided a broader reception, there was also a growth in demand for specialist consumer magazines directed at men, many developing from earlier trade publications. These included consumer titles *Man About Town* (founded 1954, titled *About Town* in 1960, and then *Town* in 1962), *Men Only* (1960), *Vogue for Men* (1965–8) and the trade journals *Men's Wear* and *Tailor & Cutter*. Further, menswear was also aired in commercial television and cinema advertising.

This new-found visibility of men's fashion is illustrated by a double-page advertisement placed in the trade journal *Men's Wear* by London cloth merchants Holland and Sherry for their new cloth, Impact (a blend of natural and man-made fibres; fifty-five per cent Terylene, forty-five per cent Super 90s worsted). It confirms the promotion will appear in 'large scale press advertising, aimed directly at the men you tailor for, begins 6 March 1967' (*Tailor & Cutter* 1966: 1239). On the left-hand page a man marvels at the cloth sample book he holds in his hand; the cloth is so dazzling that he is wearing sunglasses to signpost how he is visually dazzled by the prospect. The impact here is really how the advertisement is able to collapse the distinctions between the differing forms of material culture relating to the print promotion of men's clothing into a single, all-embracing concept.

Fashion, in this instance, is conveyed as spectacle, recalling Marshall Berman's description of Baudelaire's vision of modern life as 'a great fashion show, a system of dazzling appearances, brilliant facades, glittering triumphs of decoration and design' (Berman 1982: 136). The 'impact' of the cloth lies not in its weave, but in the impression that will be made through

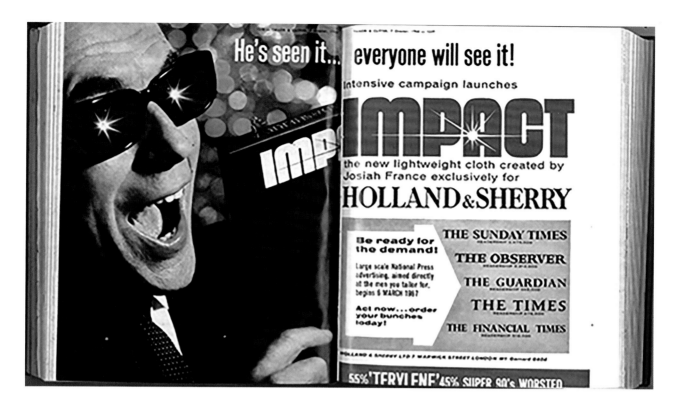

8.4

Impact advertisement, Holland & Sherry,
Tailor & Cutter, 7 October 1966.

its reproduced and disseminated image, through its advertisement on the
printed page; the moment of impact (its modernity) lies not in the cloth
being worn as a garment, but in its visual apprehension as a commercial
representation of fashion.

Hamilton's representation of the *Dedicated Follower of Fashion* draws
upon the conventions of commercial imagery used in men's fashion in
the mid-1960s. In '10 Methods to Model a Fashion Shot' published in the
trade journal *Tailor & Cutter* in 1966, ten different methods are identified
for creating a successful male fashion shoot: The Mysterious Glamour
Method; The Special Background Method; The Terribly Normal Method; The
Sexy Method; The Romantic Method; The Whimsical Method; The Minority
Method; The Slightly Absurd Method; The Gimmick Method; The Unusual
Cloth Method (*Tailor & Cutter* 1966: 1069).

The article is useful in pinpointing how approaches to image-making
were often targeted at particular demographics. The Terribly Normal Method
for example, appeals 'to the average, middle-class, middle-taste, middle-
price range men', while the Slightly Absurd Method 'endeavours to acquire
its impact by shock rather than by elegance ... which is the motivation of
much of the younger generations' styling nowadays' (*Tailor & Cutter* 1966:
1070). The specific appeal of publicity photographs amongst different age
groups are also discussed; the Romantic Method for example, which aims
to explode the conditioning 'deep down in the Id of modern man, which
prevents him from wearing Pirate, Cavalier or Heroic clothing' might 'have

a definitive sales effect on young men under the age of about Twenty Five Years – it will evoke only nostalgia among middle-aged, or even sneers' (*Tailor & Cutter* 1966: 1071). Significant consideration is also given to the tension between the all-over effect of the photograph on the one hand, and the readability of the details of the garment on the other.

The promotion of wool clothing by the International Wool Secretariat in the 1960s, at a time when man-made fibres were being promoted as the future of textiles, provides a useful illustration of the efficacy of commercial imagery in the field of men's fashion. The Secretariat offered copyright-free images of men's fashion for editorial use in exchange for a credit stating 'either pure new wool or the Woolmark'. This was complimented by an ongoing advertising campaign promoting the Woolmark logo, confirmed in a trade press advertisement in 1965:

> You can't miss it. Neither can your customers. The Woolmark, symbol of pure new wool, is everywhere. They'll see it on the season's zippiest advertising – a continuation campaign giving massive support to the successful Woolmark launch. They'll see it in fabulous full-colour pages and spreads; superbly photographed, bright and brilliant – and highly persuasive. They'll see it in the national press, the men's glossies, the hard-selling provincial newspapers. They'll see it all over the country on potent window and in-store displays. They'll see it on television this Autumn; Woolmark's first ever commercial – 445 seconds that will get the Woolmark message loud and clear. (*Men's Wear* 1965: 66–7)

IWS editorial imagery was circulated across the span of print media and was widely reproduced. A photograph of 'the space-age as interpreted by Pierre Cardin in pure new wool' can be analysed as a hybrid of the Slightly Absurd Method and Gimmick Method; 'The gimmick arrests the eye – but the rest of the suit suggests that good shape and silhouette is readily available, even if you don't want to go way-out in funny revers' (*Tailor & Cutter* 1966: 1073). In a touch that aims to reinforce the modernity of the image, the accompanying press release issued by the International Wool Menswear Office credits the release date simply as 'now' (International Wool Secretariat 1966). Cardin was in high demand in the mid-1960s for the progressive styling of his menswear, which offered a futuristic vision that chimed with the aspirations of the space-race age. Cardin himself saw this as a logical development from the design of the Beatles jacket worn by our *Dedicated Follower*, but the connection to the wearing of his designs by British bands now raised a different design direction that was far from forward-looking:

> The Beatles were the first to wear my square neck six years ago. The Rolling Stones come here and buy. They wanted something

antique-looking at first. I told them I couldn't do it but would make something new for them. The past is not interesting for me. I asked the Stones why they wanted to dress in the past when they were modern young people playing modern music. (Bennett-England 1967: 92)

After the Pop design experiments of the first half of the 1960s, fashion's trajectory began to shift from the middle of the decade, exchanging futurism for historicism in a bid to disband the heightened pace of renewal in clothing styles. The roots of this change lie in a small group of young, often aristocratic men including Nigel Waymouth, Michael Rainey, David Mlinaric, Robert Fraser and Christopher Gibbs, who imbued the second hand, the antique and the heirloom with a new design and retail currency. Effectively, they managed to bring the landed gentry of the previous generation into contact with the young new rulers of London's creative meritocracy. The Stones are central to this account, but the professional friendship between Cecil Beaton and David Bailey marks the culture of fashionable dress in the late 1960s primarily as a matter of image-making rather than design.

In 1966 the tailoring trade journal *Tailor & Cutter* celebrated its one-hundredth year in print. For its anniversary issue it reflected on its history with an approach reminiscent of Baudelaire and Hamilton. It turned to fashion plates from its own archive to get a sense of what direction contemporary men's fashion was taking. The journal was explicit in its belief that the past should be used to inspire the present: the plates were offered 'to any bright and original designer as clear basics for adaption or adoption into modern terms' (*Tailor & Cutter* 1966: 754). They also highlighted an affinity between the Victorian designs of the 1860s and those of the 1960s, which was used to legitimize dandyism: 'In order to assure the trade that flamboyance is not necessarily a perverted or decadent aspect of the nineteen sixties only, we are illustrating this issue largely with fashion plates from the notoriously "respectable" era of Queen Victoria' (*Tailor & Cutter* 1966: 754). From the back issues of the journal sprang a design language that felt very familiar, even modern:

See the stitched stripe down the side of the trousers which was regarded with surprise for his courage when Cardin ventured to bring it back. See – come to think of it – the square-toed shoes which are the thrusting attempt at fashion in every Mod shoe shop in London currently. How can the archaic defenders of current formality pretend that they want only a return to Victorian splendour when, by Gad, that is all they are getting all the time? (*Tailor & Cutter* 1966: 767)

Tailor & Cutter's anniversary issue certainly set the peacockery of men's fashion in the 1960s in historical context through the consideration of printed

images, but parallels between these eras was a theme picked up elsewhere too, noticeably in the under-examined contributions of Christopher Gibbs to the short-lived *Men in Vogue*, first published in November 1965.

In the inaugural issue, Gibbs is presented as the quintessential Englishman, 'dressing to please himself ... Christopher Gibbs, who has an antique shop in Elystan Street, has a great assortment of suits and ties and linings, and often wears three patterns at once – his shirt, the lining of his suit and his tie' (Men in Vogue 1965: 52). Although editor of the title, little is overtly credited to Gibbs, with the exception of the shopping guide. The heady style of prose used in the guide reveals Gibbs as a modern-day flâneur, journeying across the fashionable districts of London in search of new and rarefied tastes, objects and experiences. The guide 'describes the best, the most beautiful, extraordinary, most edible, drinkable and wearable things in the shops'. However what is most interesting here, given that this is a magazine devoted to men's fashion, is how little the subject actually features:

> Claridges towered up before me through a forest of colonial flags, then the ghost of Deniza the Lady Newborough's Hat Shop and, hurray, I am safe in the Robert Fraser Gallery, digging the new Jim Dine show ... But oasis time can only be momentary today, there is Miles' new Indica bookshop in Southampton Row to be cased Then on to Karma, Gosfield Street, W.1, where Christopher Case and the Dutch painter Simon Posthuma run, besides a centre where raves, exhibitions and happenings do occur at regular intervals, a shop full of things that every young person needs to make his search for wisdom and tranquillity as agreeable as can be, books, records, clothes for lovely ladies designed by Marijke Posthum, objets trouves. Go there. I floated away from this garden of delights and turned the tape recorder on to 'Eleanor Rigby'... We listened to the Goldberg variations and left, with psycho-delicious Kim Fowley belting out 'The Trip', for a sandwich at Fortnum & Mason's and a visit to the Guru of 1 Reeves house, Reeves Mews (MAY 3194), Mr Andrew Harding, who for 42s, purged us of all our poisons, and left me fresh and ready for yet another night of abandon and excess. (Gibbs 1966: 91)

Even the most dedicated follower of fashion would surely have trouble keeping pace with this frantic itinerary. It is reminiscent of Baudelaire's Monsieur G who, when botanizing on the asphalt, 'absorbs it all pell-mell; and in a few moments the resulting 'poem' will be virtually composed' (Baudelaire 1863 [1995]: 11). Gibb's prose poem to fashionable consumption is gloriously untethered. As he roves across London, in search of trifles with distractive lustres, he maps a territory once described by Walter Benjamin: 'Fashion has the scent of the modern wherever it stirs in the thicket of what has been' (Lehmann 2000: 240). Like Hamilton's use of the model photograph

rescued from a wastepaper basket, or Baudelaire's rifle though the fashion plates of yesteryear, Gibbs's preference for the antique, outmoded and artistic over the latest fashions is still, importantly, a striving for the modern.

What Gibbs anticipates in his wanderings is the notion of lifestyle; a shared sensibility that runs across fashionable clothing, interiors, furniture and art, precisely the unified elements with which Hamilton surrounded *Dedicated Follower of Fashion*. Hamilton's mixed-media image, using photogravure, etching, pencil, acrylic and Indian ink deliberately draws attention to the fact that it has been constructed and staged, reflecting the similarly constructed image of modern man.

According to Baudelaire, the representation of the present 'imprints itself on his whole attire, crumples or stiffens his dress, rounds off or squares his gesture, and in the long run even ends by subtly penetrating the very features of his face' (Baudelaire 1863 [1995]: 2). For Hamilton and Gibbs, the difference is that this imprints across an even wider frame. For today's dedicated follower of fashion, clothes are only the start of it.

References

Amies, H. (1964), *An ABC of Men's Fashion*, London: George Newnes Ltd.

Bailey, D. (1965), *Bailey's Box of Pin-Ups*, London: Weidenfeld & Nicolson.

Baudelaire, C. (1995), *The Painter of Modern Life and Other Essays* [1863], London: Phaidon Arts and Letters.

Bennett-England, R. (1967), *Dress Optional: The Revolution in Menswear*, London: Peter Owen.

Bennett-England, R. (1971), 'Swinging in Savile Row', *Penthouse*. Vol 2, No 10.

Berman, M. (1982), *All That is Solid Melts into Air: The Experience of Modernity*, New York: Simon & Schuster.

Cohn, N. (1971), *Today There are No Gentlemen: The Changes in Englishmen's Clothes since the War*, London: Weidenfeld & Nicolson.

Davies, R. (1966), 'Dedicated Follower of Fashion', performed by *The Kinks*, lyrics Ray Davies, London: Pye.

del Renzio, T. (1956), 'After a Fashion', ICA Publications no. 2, London: ICA.

del Renzio, T. (1992), 'Richard Hamilton' in *Art Monthly*, September.

Foster, H. (2011), *The First Pop Age*, Princeton, N.J; Oxford: Princeton University Press.

Gibbs, C. (1966), 'Shopping Guide' in *Men in Vogue*, November.

Hamilton, R. (1973), *Richard Hamilton*, New York: The Solomon R Guggenheim Foundation.

Hamilton, R. (1982), *Collected Words: 1953–1982*, London: Thames & Hudson.

Jobling, P. (2014), *Advertising Menswear: Masculinity and Fashion in the British Media since 1945*, London: Bloomsbury.

Lehmann, U. (2000), *Tigersprung*, London: MIT Press.

Lennard, P. (1966), 'Fashion International for Men' in *The Times*, 7 March.

Melly, G. (1972) *Revolt into Style: Pop Arts in Britain*, London: Penguin.

Men in Vogue, (1965), November, London.

Men's Wear: Trade Journal (1965), 18 September. London.

Tailor & Cutter: A Trade Journal and Index of Fashion, (1966), London.

van Lamsweerde, I. and Matadin, V. (2014), 'Photography into Painting: Notes and Selection by Inez & Vinoodh', *Aperture*, (216) Fall.

Verlag, R. (2003), *Richard Hamilton: Prints and Multiples 1939–2002*. Kunstmuseum Winterthur and the Yale Center for British Art in association with Richter Verlag, Düsseldorf.

Where is this Pop? In Search of the British Pop Poster

Rick Poynor and Alex Seago

The following chapter is based on an interview between Alex Seago, co-editor of this volume and Rick Poynor, writer on visual culture and founder of *Eye* magazine. Structured loosely around the periodization of 'early', 'high' and 'late/post' Pop developed by Nigel Whiteley in *Pop Design: Modernism to Mod* (1987), the chapter aims to interrogate and challenge assumptions about the relationship between British graphic design and Pop Art.

AS: What should we expect to see in a fully realized example of Pop graphic design?

RP: There has to be something specifically 'Pop' about the choice of imagery, use of colour, choice of typeface, how the typefaces are combined and the way the type is integrated into the imagery. We could also look for the concerns of Pop Art itemized by Richard Hamilton: popular, transient, expendable, low cost, mass-produced, young, witty, sexy, gimmicky, glamorous and big business. By its nature though, graphic design often exhibits many of these qualities – that doesn't make it all Pop. We are looking for design that uses a recognizable Pop graphic style to express a Pop spirit.

Do you think Nigel Whiteley's periodization of the Pop movement into 'early', 'high' and 'late/post' Pop is useful here?

It imposes a framework on the material that may be too schematic, especially when it comes to the existence (or not) of the British 'Pop poster'. This field is very under-researched – to the extent that I'm not sure we can accurately refer to 'early', 'high' and 'late' Pop phases in relation to graphic design. The book *17 Graphic Designers London*, a key visual survey from 1963, has very little work even tenuously connected to Pop and the word is not used in the introduction. Whiteley shows only one piece of putatively 'Pop' British graphic design in his 'Early Pop' chapter and there are only a handful of graphic pieces – two Beatles sleeves, a *Town* magazine cover, some souvenir mugs and some Carnaby Street merchandise, but no posters – in his 'High Pop' chapter. The term Pop seems more apt in the case of the later stages of Pop when British Pop *graphics* developed into something essentially different from British Pop *Art*. To address the validity of Whiteley's periodization with any precision, researchers would

Poster by Richard Hamilton featuring his collage 'Just What Is It That Makes Today's Homes So Different, So Appealing...?' for 'This Is Tomorrow' exhibition at the Whitechapel Gallery, 9 August to 9 September 1956. © Whitechapel Gallery / Whitechapel Gallery Archive.

need to study the archives of major organizations and brands, and chart the history of the use of Pop motifs and the Pop spirit in advertising, packaging, information programmes and so on. I suspect there would be comparatively few fully developed examples until the later 1960s. In terms of the mainstream graphic design profession, there is relatively little evidence in what has been published so far, of a sustained interest in Pop style and Pop concerns until well into Whiteley's 'Late and Post Pop' period of the late 1960s and into the early 1970s.

This would appear to be a good example of early Pop graphics. It is obviously an iconic image of early Pop – representing the Independent Group's fascination with US consumer culture.

Richard Hamilton's collage, *Just What Is It That Makes Today's Homes So Different, So Appealing?*, remains a highly fertile icon of its time but it's the work of someone primarily identified as an artist. Hamilton was engaged in design, such as his projects for the ICA. He understood the typographic developments of the time and had a considerable level of typographic competence. But if we are to treat this poster as an early example of Pop graphics, then we have to understand that it's the work of someone operating from outside the graphic design profession. It may or may not point to things that were developing within the profession at the time. To understand the degree of take-up of the Pop aesthetic within graphic design we have to focus on what was happening among graphic designers.

I carried out detailed research on *Typographica*, a seminal graphic design magazine published between 1949 and 1967 – the era of Whiteley's 'early', 'high' and 'late' Pop, during which London was described as 'swinging' and Pop supposedly constituted a *zeitgeist*. One would have expected to find regular references to Pop in a leading graphic design magazine of this period, but I found very little. This might seem surprising in a publication that identified itself strongly with the avant-garde and progressive contemporary work. I asked Herbert Spencer, *Typographica*'s founder and editor, about this and his response was very clear. He said he supposed that the lack of attention his magazine paid to Pop was because, throughout the 1950s, he looked to Europe for examples of progressive design and typographic practice. Pop appeared to him to be a product of the USA, which embodied American values and an American idea of the exciting, fulfilling, consumerist 'good life'. Although it wasn't Spencer's style to mount a sociological critique of US consumer culture, his attitude towards Pop was one of ever so slightly aloof distaste and I think other colleagues in the emerging design profession probably shared this attitude. It may be telling that in 1956, when *This Is Tomorrow* was staged at the Whitechapel Gallery, there was no reference to the exhibition in *Typographica* by Spencer or his contributors (although Hamilton did later publish in the magazine).

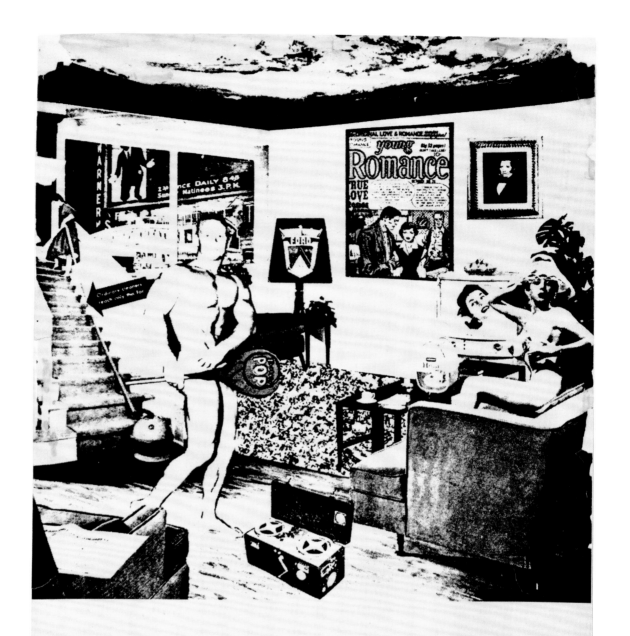

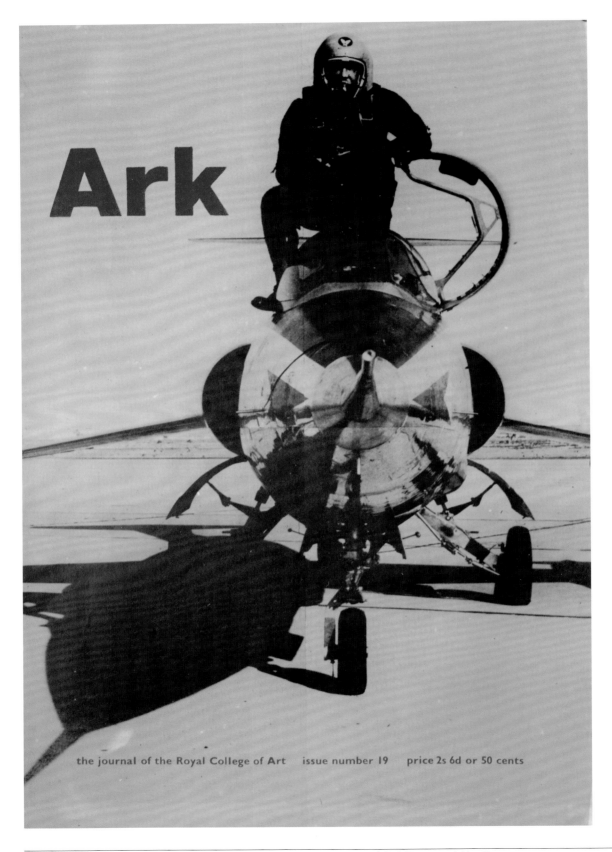

Ark

the journal of the Royal College of Art issue number 19 price 2s 6d or 50 cents

This appears to exemplify the problems involved when one assumes that developments in art history necessarily precede and influence the history of design. When I was researching into the history of the Royal College of Art's student magazine *ARK* I interviewed Alan Bartram, one of the graphic design team responsible for the design of the 1956–7 editions of the magazine edited by Roger Coleman and widely recognized as producing an original mouthpiece for members of the Independent Group including Peter Rayner Banham, Lawrence Alloway, Peter and Allison Smithson, Toni Del Renzio and Frank Cordell. Bartram surprised me by stating that at the time he was less interested in Pop and much more interested in the latest developments in Swiss typography, which were ignored by the faculty in the School of Graphic Design. As art editor of *ARK* 20 he saw it as his job to fuse his editor's interests in Americana with his own professional interest in the European avant-garde.

Poster by Gordon Moore advertising the Royal College of Art's magazine *ARK* 19, 1957. © Royal College of Art Archive.

This is why we have to be careful when dealing with the history of British Pop graphic design and with Whiteley's framework of 'early', 'high' and 'late/ post' Pop. In the case of the *This Is Tomorrow* poster we might use the term early Pop but I'm questioning how much awareness, outside of a few RCA students, there was of Pop in the British design community. There were plenty of other things going on in the art and design scenes of the 1950s and Pop had yet to establish itself as a genre. The idea that in 1956 or 1957 many graphic designers would have been influenced by the kind of intellectual Pop being produced by the Independent Group is a bit far-fetched. Hamilton's collage for the *This Is Tomorrow* poster is certainly remarkable, but seen from a graphic design perspective the poster is just a picture with a white space at the bottom and some vaguely futuristic condensed type floating in it. In graphic design terms it's pretty basic. To place it in its contemporary context we only have to turn to the contemporary Swiss graphic design that was so appealing to Herbert Spencer, Ken Garland, Alan Bartram, Romek Marber, and others of their generation. Ken Garland's article 'Typophoto', published in *Typographica* in 1961, shows that for British designers the appeal of Swiss graphic design lay in the dynamic, engineered integration of type and image. There is no sign of this in the *This Is Tomorrow* poster – the type is like a simple label. It has a rough charm and it's not a graphic failure but it's not a particularly remarkable piece of graphic design either.

I remember interviewing Roger Coleman in the late 1980s regarding the choice of contents for *ARK*. He told me that as long as the subject was 'American, went fast and was made of aluminium' it got in; if it was about 'Toby jugs, folk dancing and the weaving department' it was out. This image seems to epitomize that aesthetic – an aggressively American, photographic image of a USAF test pilot stepping out of the cockpit of his jet fighter – the sort of scenario described later by Tom Wolfe in *The Right Stuff*.

This is an emblem of macho American ultra-modernity. In the mid-1950s, at the height of the Cold War, the idea of the jet fighter travelling at incredible speed had a science-fiction-like excitement and allure. The poster is a good example of what might be better termed proto-Pop. Harking back to Futurism, there is an excitement about machinery and technology and the design is distinguished by the precision of the framing, with a fantastic crop of the wings that thrusts the plane's nose towards the viewer for maximum frontal drama. The typographic simplicity, with the single word 'Ark' in red, cantilevered against the monochrome image of the pilot, is very powerful. This is a classic graphic design strategy: ridding the image of clutter to accentuate its impact. It's an aggressive design and it's revealing to place it beside later Pop jet-fighter pictures such as Roy Lichtenstein's *Whaam!* (1963) or James Rosenquist's *F-111* (1965), which can be interpreted as critiques of what C. Wright Mills referred to as 'the military-industrial complex'. But this is still the 1950s and the RCA image of the fighter is presented in an unproblematic spirit of futuristic admiration.

There are links here with Eduardo Paolozzi's work in terms of provocative juxtaposition, but graphic designers during this period were quite slow to pick up on and reflect what was happening in new fine art. In both conceptual and visual terms, artists like Paolozzi and Hamilton were way ahead of anything the graphic designers were doing and you don't see designers catching up until the mid-1960s. Historically, graphic designers have constantly looked towards fine art and borrowed ideas but there is often a delay. During the 1950s, the priority for influential figures, such as Herbert Spencer, was to establish typographic design as a form of planned, professional practice carried out by highly trained individuals – rather than in the clumsy, ad hoc fashion of the printing trade. If early Pop was a big influence on graphic designers, then you would expect to see it in the work of RCA-trained figures like Alan Fletcher and Dennis Bailey. There are a few mild traces, such as Fletcher, Forbes and Gill's advertising images for Pirelli around 1961 – on the cusp of high Pop – but not much. Where a Pop artist like Peter Blake embraced Victorian and Edwardian imagery, forward-looking British graphic designers of the late 1950s regarded Victoriana as twee, provincial and retrogressive. Not until the mid-1960s did it become fashionable to embrace Victoriana again in a camp, ironic and slightly mocking fashion. By that time graphic designers had absorbed what they needed from the rigour and structure of Swiss typography and could begin to express themselves in a distinctly 'British' fashion.

INGMAR BERGMAN SUMMER WITH MONICA RCAFS NOV8 7-30

BRIAN DENYER

This RCA poster was produced in the high Pop period during the same year as *ARK* 32, the issue of the RCA magazine which contained the Pop art 'Kit of Images'.

Brian Denyer's poster for the Royal College of Art Film Society really does look like a Pop Art painting, though in a purified graphic form. The big purple heart captures popular sentiment and the rupture is sharply graphic. The idea of summer is distilled down to a yellow disc and the two elements are deftly separated and balanced by the wide line of type. This is a great example of Pop graphic design and it has the Pop qualities – it's popular, transient, young, witty, sexy and gimmicky. Graphic designers tend to simplify their communications to achieve a strong, clear, immediate message and in graphic terms this image is just as progressive as the Pop Art of the period was in painterly terms. One has to remember though, that its intended audience was students within the RCA and not the general public. If Pop graphics and the Pop poster were really flourishing in the early 1960s, one would expect to find a lot of design for clients like this. As well as being a rare example of fully realized Pop design, the poster retains a strong modernist element. It still looks fresh.

Eduardo Paolozzi's graphic work of the mid-1960s seems to provide an important bridge between the early Pop and the Pop graphic work of the later 1960s when Pop posters, LP covers, etc. started developing visual languages of their own – directly reflecting the synesthesia-inducing influence of the psychedelic era.

Paolozzi was influenced by surrealism and the strongest Pop element of this image is his bold use of colour and the technique of screen printing, which was the emergent medium of the new Pop graphics. *Wittgenstein in New York* is one of the *As Is When* series of screen prints based on the life and writings of Ludwig Wittgenstein. This was a transitional work that marked Paolozzi's move away from his more brutalist style of the 1950s towards the collage-based experiments of *Moonstrips Empire News* of the later 1960s. Every print in *As Is When* is printed in different colours – this was something completely new in screen printing and a new kind of total Pop graphics. *Wittgenstein in New York* is a complex, collage-based engagement with the pulsing energy of the contemporary city condensed into an image with fantastic graphic force and heat and its own kind of glamour. It's not surprising that these images have been used to illustrate the idea of science fiction on book covers; they describe the present, but a present that anticipates a deliriously exciting future. They seem to express a new state of mind that is about the simultaneous perception of all these interconnecting forces – the media landscape, technological networks, robotics and cybernetics, all delivered in super-vibrant colour that makes the work almost hallucinogenic. We don't see this kind of visual complexity in mainstream graphic culture for another two or three years. Paolozzi's *As Is When* series could be regarded as proto-psychedelic: psychedelia as experienced by a modern cybernaut.

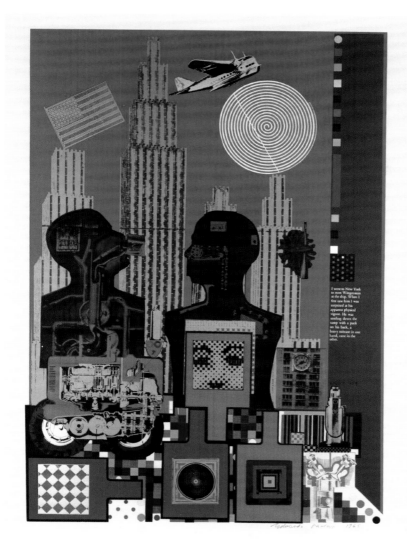

Eduardo Paolozzi 'Wittgenstein in New York' from *As Is When* (Editions Alecto) 1965. © Trustees of the Paolozzi Foundation, licensed by DACS 2016.

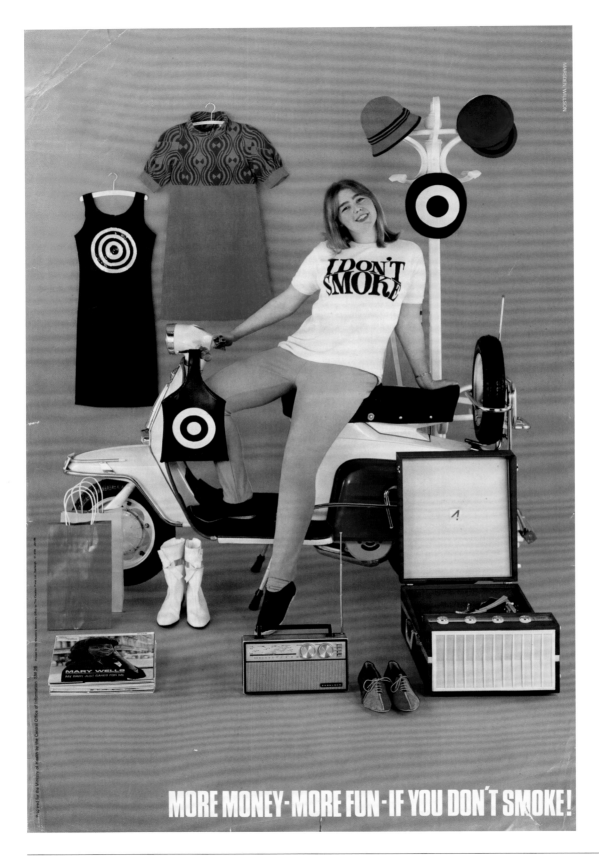

MORE MONEY - MORE FUN - IF YOU DON'T SMOKE!

This anti-smoking poster published by the Central Office of Information in 1966 is an example of the use of Pop graphics outside the Pop music/Pop fashion/Carnaby Street axis. It was produced shortly after the link between smoking and cancer had been conclusively confirmed and during an era when tobacco companies had massive advertising penetration in youth markets. Is it a clumsy attempt to employ the 'immediate/now!' visual language and consumer orientation of 'high Pop'?

I wonder how clumsy it would have seemed at the time? People of all ages were more used to the idea of paternalistic messages from on high advising them about how to behave, even if they chose to ignore the advice. The poster goes to elaborate lengths to get on its young audience's wavelength and not to appear patronizing. The image is conceived, art directed, staged and shot like a piece of advertising in a trendy magazine; it's fresh, direct and unstuffy. It assumes Pop's style to be pervasive in a young person's life – in the transistor radio and record player; the copy of Mary Wells' *My Baby Just Cares for Me* LP; the trio of monochrome targets, which knit together nicely; the colour statement of the shopping bags; the mode of transport and the T-shirt deployed as a message space both personal and public. The clashing colours are as vibrantly Pop as a Paolozzi screen print. In the male version of this COI poster, using many of the same props, the dominant colours are reduced to blue for the clothes and red for the background and the 'mod' inflexion is stronger. The copy line in white condensed capitals, like a punchy magazine headline, is also Pop, without overstating it. It's fascinating to see the Ministry of Health (as it was then) embracing the imagery of Pop – that tells us something about the social changes well under way by 1966. But this is still more of an ad agency interpretation, using photography to build the image, rather than being a purely graphic treatment.

9.5

Marsden/Willson. Poster for Central Office of Information. 1966. © Science Museum / Science and Society Picture Library.

9.6 (top left)

Cover of *Observer Colour Magazine*
3 December 1967 © Patrick Ward.

9.7 (top right)

Photograph of 'Poster Scene 1967',
featuring posters by the GPO, British
Transport and the producers Osiris
(Visions) Ltd from George Melly 'Poster
Power' *Observer Colour Magazine*
3 December 1967 pp. 14–15 © Patrick Ward.

9.8 (bottom right)

Michael English. UFO 'Love Festival'
poster 1967. © Jaki English.

It would appear that British Pop graphics really come into their own during the later 1960s – as a co-product of the hippy 'underground' music and fashion scenes and creative influence of the synesthetic effects of hallucinogenic drugs. Although it's probably fair to say that the psychedelic poster art produced in Britain could not rival the work of the California-based masters of this genre – Kelley and Mouse, Victor Moscoso, Wes Wilson, Rick Griffin and Gary Grimshaw – the posters produced in 1967 by Michael English and Nigel Weymouth (known collectively as Hapshash and The Coloured Coat) for the UFO Club and Brian Epstein's Saville Theatre pioneered a new graphic language which was purely Pop in conception and form.

Those pictures are from the December 1967 article by George Melly in the *Observer* magazine and that article, and indeed the entire issue of the magazine, represents a significant moment in the reportage of Pop when the colour supplements became important conduits of Pop culture to the cultural mainstream. The badges on the cover of the *Observer* magazine absolutely capture the spirit of the time. Michael English's *Love Festival* poster from 1967 is a great example of pure Pop graphics. The huge lips and shiny teeth are close cousins to *Smoker, 1 (Mouth, 12)* (1967) by the American Pop artist Tom Wesselmann. The image floats in a white void and the lettering, like a swirly doodle, makes this an instance of early Pop psychedelia rather than the full-on fantasy style of late/post Pop. It retains the simple graphic power of early 1960s high Pop and, like Brian Denyer's *Summer with Monika* poster, it achieves maximum graphic impact from a minimal number of elements. It's a knowing riff on Pop Art, taking it for granted that the Pop cognoscenti, who attended these concerts, would appreciate the classic elements of high Pop and the irony of the deliberately artless type and lettering. The red and mauve were chosen to be as harsh and dissonant as possible and to vibrate under ultraviolet light. This kind of bright, playful design quickly found its way on to Pop ephemera like Carnaby Street mugs and T-shirts.

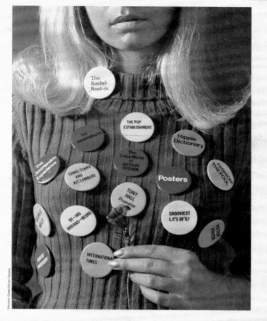

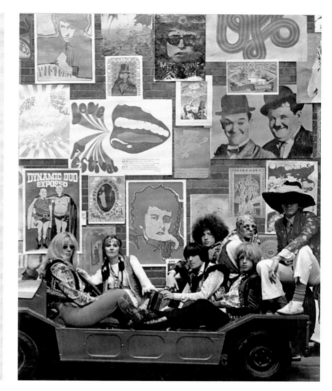

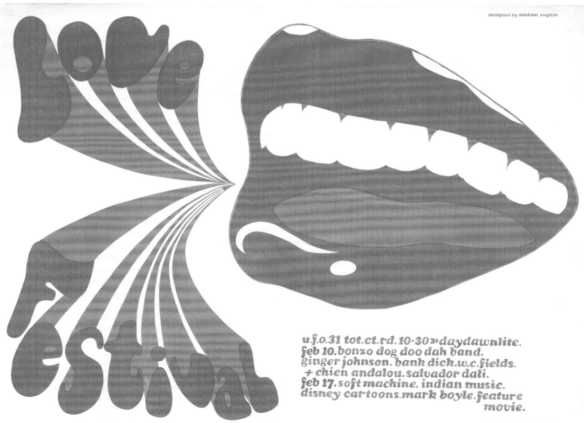

designed by michael english

u.f.o.31 tot.ct.rd.10·30»daydawnlite.
feb 10.bonzo dog doo dah band.
ginger johnson. bank dick.w.c.fields.
+ chien andalou. salvador dali.
feb 17.soft machine. indian music.
disney cartoons.mark boyle.feature
movie.

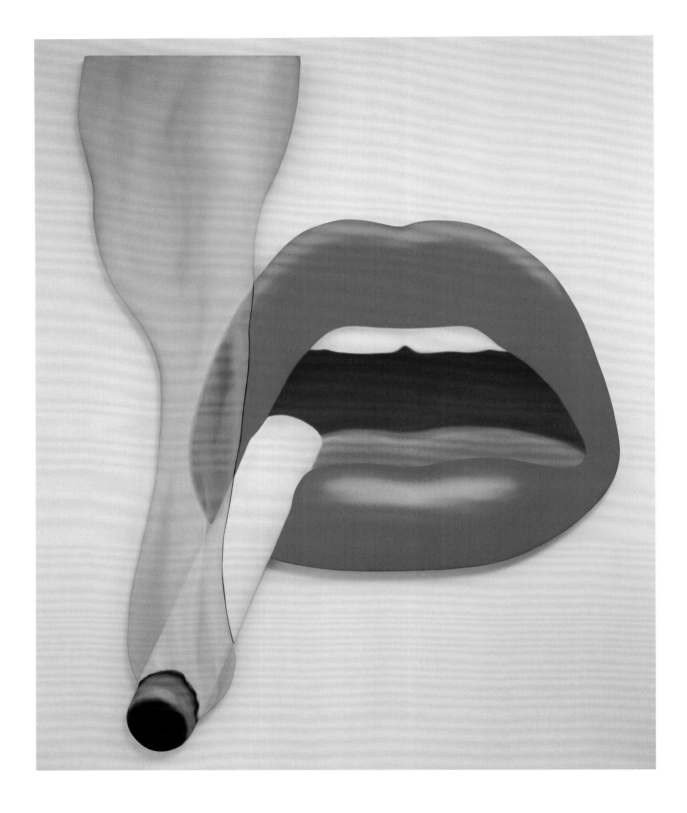

In *Revolt Into Style: The Pop Arts in Britain* (1972) George Melly
pointed out that it was not until the mid-1960s that graphic design
became a central medium of Pop expression:

> The Underground is the first of the pop explosions to have
> evolved a specifically *graphic* means of expression ...
> the Underground consciously set out to evolve a graphic
> imagery which would provide a parallel to its musical,
> literary and philosophical aspects. (Melly 1972: 137)

**One of the things that fascinates me about his work is what could be
described as graphic synaesthesia – the ability to capture musical
sound/vibrations in graphic form. In retrospect Sharp's late 1960s
posters, LP covers and graphic design for *Oz* seem to represent
a creative pinnacle of Pop graphic design.**

Martin Sharp's graphic image-making is in a different league. In my
estimation he was one of the most notable graphic designers working
in Britain in the late 1960s and perhaps the most 'Pop'. Sharp was
an artist with his own vision and the technical ability to make highly
idiosyncratic statements about contemporary culture. He combined his
facility as a cartoonist with the visual resources of psychedelia to develop
a satirical graphic style that was both barbed and hip. His work has a
curdled perspective that is very distinct from the rapturous, summertime
psychedelia of contemporaries such as Hapshash and the Coloured
Coat. So, for example, while Sharp's UFO poster performs the function
of announcing a groovy gig at the Roundhouse, he turns the figure of the
guitar hero into a grotesque, literally brainless monster spaced-out on
God-knows-what, viewing the audience from his eye on a stalk and blurting
out psychedelic gibberish from obscenely bloated lips. The image has an
incredible pulsating graphic energy. Sharp unites every element, including
the hand-drawn lettering, into a style of image that is all his own while
adhering, in the most contemporary manner, to almost every one of the
definitions of Pop Art supplied by Hamilton ten years earlier.

9.9

Tom Wesselmann (1931–2004): *Smoker 1
(Mouth 12)*, 1967. New York, 10 × 12 (1) (A)
Museum of Modern Art (MoMA).
Oil on shaped canvas, in two parts, overall
9' ⅞' × 7' 1' (276.6 × 216 cm). Susan Morse
Hilles Fund. 226.1968 © 2016. Digital image,
The Museum of Modern Art, New York/
Scala, Florence.

Martin Sharp. Poster for UFO at the
Roundhouse, 1967. © Estate of Martin
Sharp.

Although these are startlingly intense pieces of graphic design, the
question of where a Pop artist/designer like Sharp fits into the history of
British graphic design has yet to be addressed. His affiliation with the
underground and swift return to Australia have tended to exclude him from
the professional canon of British graphic design. A comprehensive history
of British graphic design has yet to be written and a key problem here is
the issue of professional identity. Sharp was producing some of the most
original graphic work of his era but he was doing it outside the profession.
I doubt his work was ever noticed by the D&AD's annual awards. Sharp's
work is interesting partly because it demonstrates that graphic design can
be used as a mode of communication by anyone with talent who wants to
develop their own means of visual expression. D&AD was established by
formally trained designers to represent their professional interests and gain
credibility with potential clients. Sharp shows how someone can be outside
that culture and those concerns and yet create graphic work that might come
to define its era. When the time comes to write the history of British graphic
design, how will a Pop designer like Sharp be assessed from the perspective
of professional practice?

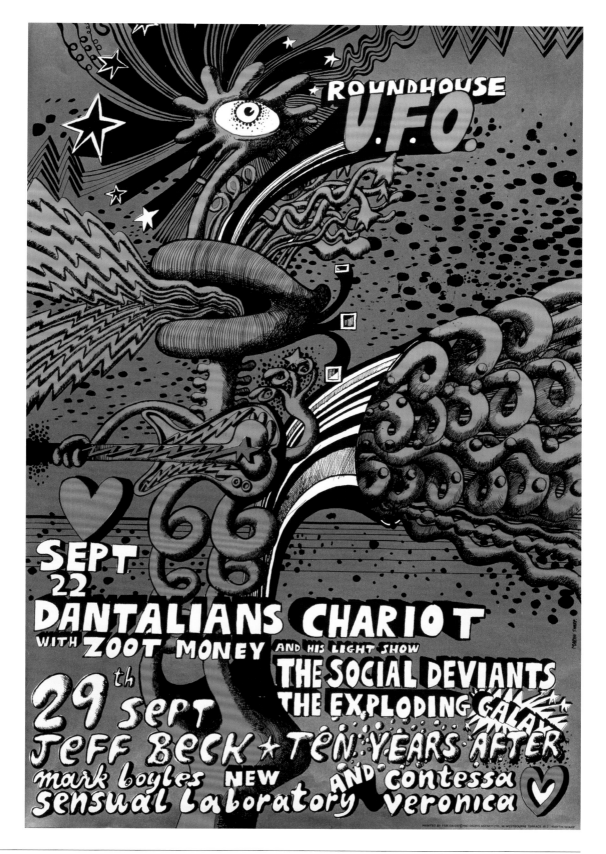

There seems to be an interesting conundrum regarding the relationships between graphic design and **Pop** culture in Britain during the 1960s. On the one hand numerous **Pop** celebrities were the products of **British** art schools and many trained originally as graphic designers or were at least heavily influenced by **Pop** art-oriented art school tutors – **John Lennon, Ray Davies, Pete Townshend, Keith Richards, David Bowie, Bryan Ferry** or **Brian Eno** are obvious examples – but on the other hand, outside of the realm of **LP** covers, the underground press and gig posters, **Pop**'s influence on the **British** graphic design profession remained marginal. You have the example of graphic designers like **Paul Clark,** who silk-screened the **Union Jack** onto mugs, tin trays and so on and helped to create the look of **Carnaby Street,** but this seems to be in contrast to the **USA** where **Pop** design broke out of the **Pop** ephemera and rock album sleeve bubble and became increasingly mainstream by the late 1960s and early 1970s – I am thinking here of **Mary Wells'** and **Emilio Pucci's** work for **Braniff Airlines** or the widespread influence of **Peter Max** or **Milton Glaser** and the other **Push Pin Studio** designers. Perhaps this was related to the fact that the **USA** was far more affluent than the **UK,** and that, by the latter 1960s the baby boomers, who recognized **Pop** as their own distinct culture, were becoming affluent middle-class consumers? This is the argument developed by **Thomas Frank** in his **1998** book *The Conquest of Cool: Business Culture, Counterculture, and the Rise of Hip Consumerism.*

We set ourselves the challenge of focusing on the question of the British Pop poster. Had the focus been on graphic design in general, then it would have been easier to demonstrate that Pop had some kind of diffuse impact across British graphic design in the mid-1960s – in, for instance, Harri Peccinotti's art direction of *Nova* magazine, or Alan Aldridge's cover designs for Penguin. I say diffuse because Pop's stylistic traces in editorial design and advertising design are often fairly subtle. Professional designers whose task was to serve their clients' communication needs were not free to explore a style, in this case Pop, for its own sake. Pop was useful to them in as much as it connoted a trendy contemporary mood. In the *Design and Art Direction* annuals for 1966 and 1967, which show the previous year's

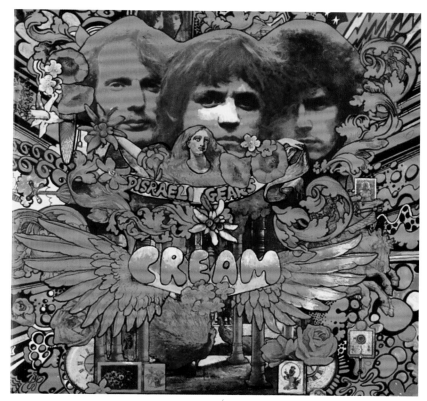

9.11

Martin Sharp. LP cover design for
Cream's 'Disraeli Gears,' 1967.
© Estate of Martin Sharp.

work, the Pop influence and spirit can certainly be detected but it's not
especially pronounced. The problem with posters as an everyday means of
communication, before the psychedelic explosion in 1967, is that the medium
had become much less significant in Britain compared to its continuing
street presence and accepted status as an art form in some other European
countries. The D&AD annuals I cited, which supposedly represent the best
of British work in those years, contain barely any posters. So I don't think the
issue has much to do with the USA's greater affluence. It's more to do with
the changing nature of communication in a culture increasingly dominated
by television commercials and the advertising billboard, which was a very
different entity from the advertising poster created by an earlier generation
of commercial artists. Only in the rebellious medium of the music poster
could the Pop designer find total graphic freedom.

Index

Page references to images are in *italics*; references to notes are indicated by n.